Sign Graphics

Sign Graphics

Marta Serrats

COLLINS DESIGN

An Imprint of HarperCollinsPublishers

SIGN GRAPHICS
Copyright © 2005 by COLLINS DESIGN and maomao Publications

All rights reserved. No part of this book may be used or reproduced in any manner whatsoever,
without written permission except in the case of brief quotations embodied in critical articles and reviews.
For information, address Collins Design, 10 East 53rd Street, New York, NY 10022.

HarperCollins books may be purchased for educational, business, or sales promotional use.
For information, please write: Special Markets Department, HarperCollins Publishers Inc.,
10 East 53rd Street, New York, NY 10022

First Edition

First Edition published in 2006 by:
Collins Design
An Imprint of HarperCollins Publishers
10 East 53rd Street
New York, NY 10022
Tel.: (212) 207-7000
Fax: (212) 207-7654
CollinsDesign@harpercollins.com
www.harpercollins.com

Distributed throughout the world by:
HarperCollins Publishers
10 East 53rd Street
New York, NY 10022
Fax: (212) 207-7654

Packaged by
maomao publications
Via Laietana, 32 4.° Of. 104
08003 Barcelona, Spain
Tel.: +34 932 687 270
Fax: +34 932 680 425
mao@maomaopublications.com

Editor:
Marta Serrats

Art Director:
Mireia Casanovas Soley

Layout:
Jonathan Roura

Translation:
Jay Noden

Library of Congress Cataloging-in-Publication Data

Serrats, Marta
 Sign graphics / Marta Serrats.—1st ed.
 p. cm.
 ISBN 0-06-085966-0 (hardcover)
 1. Signs and signboards. I. Title.
 HF5841.S47 2006
 659.13'42—dc22

 2005028245

Printed by:
Cayfosa-Quebecor. Spain.

D.L: B-1591-2006

First Printing, 2006

1 Graphic Identity

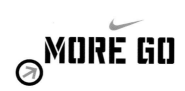

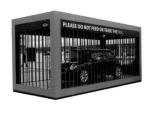

KOSHINO HIROKO
EXHIBITION 2004

la ratonera

IOO%**DESIGN**

R|A|M

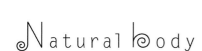

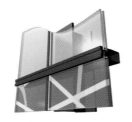

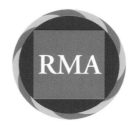

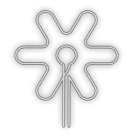

MATSUYA GINZA

11|restaurant_bar_club

2 Interior Graphics

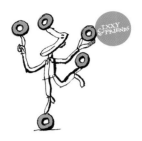

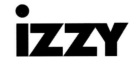

3 Urban Graphics

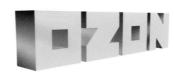

Introduction

As Ronald Shakespear describes it in his book "Sign of Design", making the city legible implies, among other skills, deciphering its codes. Our surroundings are full of signs, billboards, vinyls, murals, banners, and digital screens, and it is the designer's task to convert this chaos into information. Transforming this complex reality into intense and agile communication is no easy job, especially if we take into account that this information can be found in a multitude of physical and conceptual contexts.

"Sign Graphics" visually delves into this graphic production that is submerged in our daily lives: in establishments, museums, parks, theaters, libraries... never-ending spotlights of attention that attract us for their visual quality and moreover, for the coherence of their messages, which allow us to directly process the information.

The first chapter, Graphic Identity, explores the graphic representation of a company. The creation and management process of a corporate image acquires special importance when we consider the massive quantity of information that we perceive and the lack of time we have to decode it. A solid and representative image of the activity and philosophy of the company constitutes a fundamental value when it comes to differentiating oneself from the competition. Taking into account that the root of the company's image is its logo, this chapter shows different examples of branding applied in vinyls, billboards, and neon lights, among other strategic media, that help consolidate the brand.

The second chapter, Interior Graphics, is a compilation of the best graphic representations applied in a space's interior. Interior murals, posters, vinyls applied to floors and walls, and logos that refresh the consumer's mind are some of the examples that can be found in this chapter. All of these are vital graphic elements to cultivate and strengthen the identity of an image.

Finally, Urban Graphics, is a compilation of the best graphic representations applied in landscape environments. Each of the projects colonizes the exterior through some graphic resource that infiltrates the landscape to attain a visible and coherent relationship. The designer, in this sense, becomes not only a communicator but also a creator of the landscape promoting the integration and the transparency of the surroundings.

Communication design is not easy, and neither is creating a visual language that receives an emotional response from society. Each example that appears in this book contains a unique element that ensures the consistency of its image. As Jorge Frascara describes it in the prologue of the aforementioned book, "The task of designing must never be seen as the construction of mere bridges between the public and the information. It must be an amazing experience to cross those bridges." That is the case with the projects presented in this book.

Graphic Identity

The power of the brand is reflected today in one of the most important ways for a company to consolidate itself in the market and differentiate itself from the competition: branding. Understanding the brand as a differentiating elements means a company's graphic identity needs to achieve an intangible reflection of element, such as its philosophy, values, credibility, and singularity—components that convert it into something unique within its sector. These qualities are reflected in the design of the logo and the business card of any company, which are then adapted to other corporate media such as leaflets, advertising brochures, advertisements, promotions, stationery, merchandising, and so on. The designs presented in this chapter are examples of the best branding applied to vinyls, billboards, neon lights, and banners that, thanks to provocative and direct design, help to consolidate the brand in the market and make contact with the receiving public.

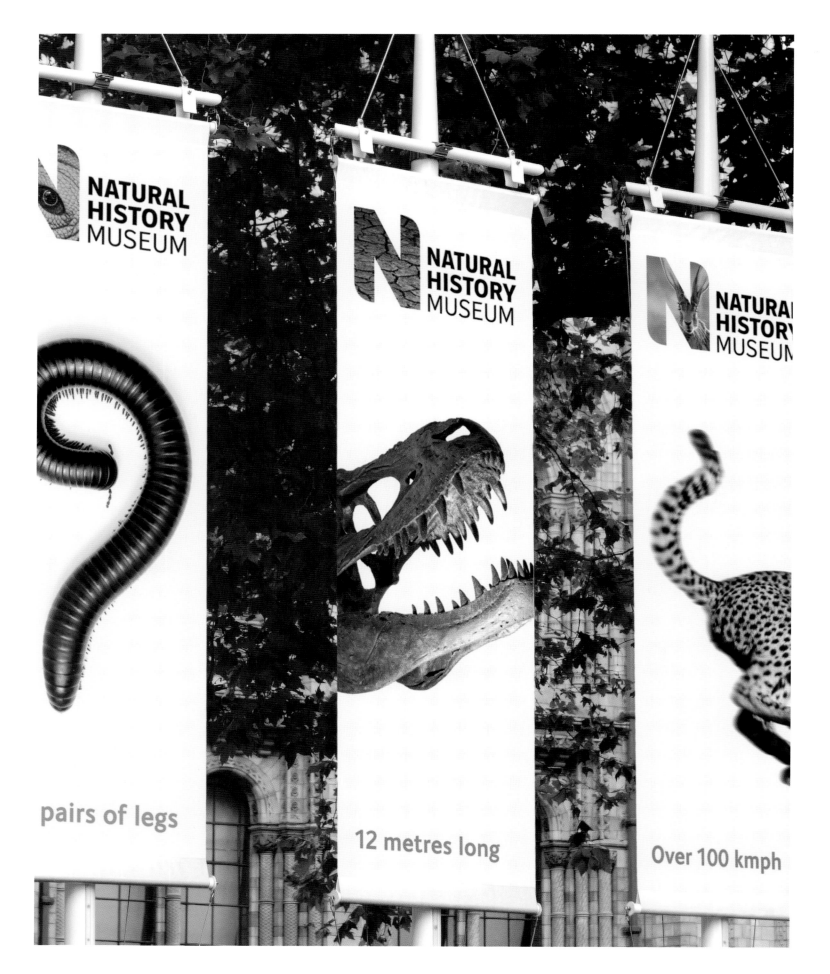

Design: **Hat-trick** Photography: © **Hat-trick** Location: **London, UK**

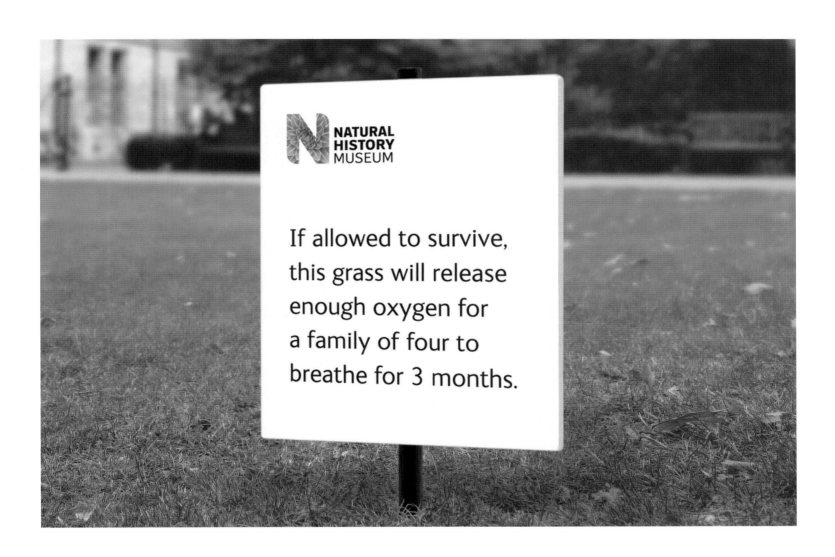

NATURAL
HISTORY
MUSEUM

If allowed to survive,
this grass will release
enough oxygen for
a family of four to
breathe for 3 months.

Hat-trick designed the graphic identity of the Natural History Museum inspired by the power of nature. The museum's new corporate image, based on a giant N whose background changes depending on its subject, is applied to bags, banners, water bottles, leaflets, stationery, and so on. On the exterior stands a board with the clear and powerful message: "If allowed to survive, this grass will release enough oxygen for a family of four to breathe for 3 months."

 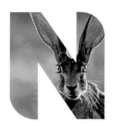

 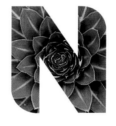

 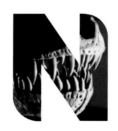

 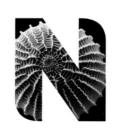

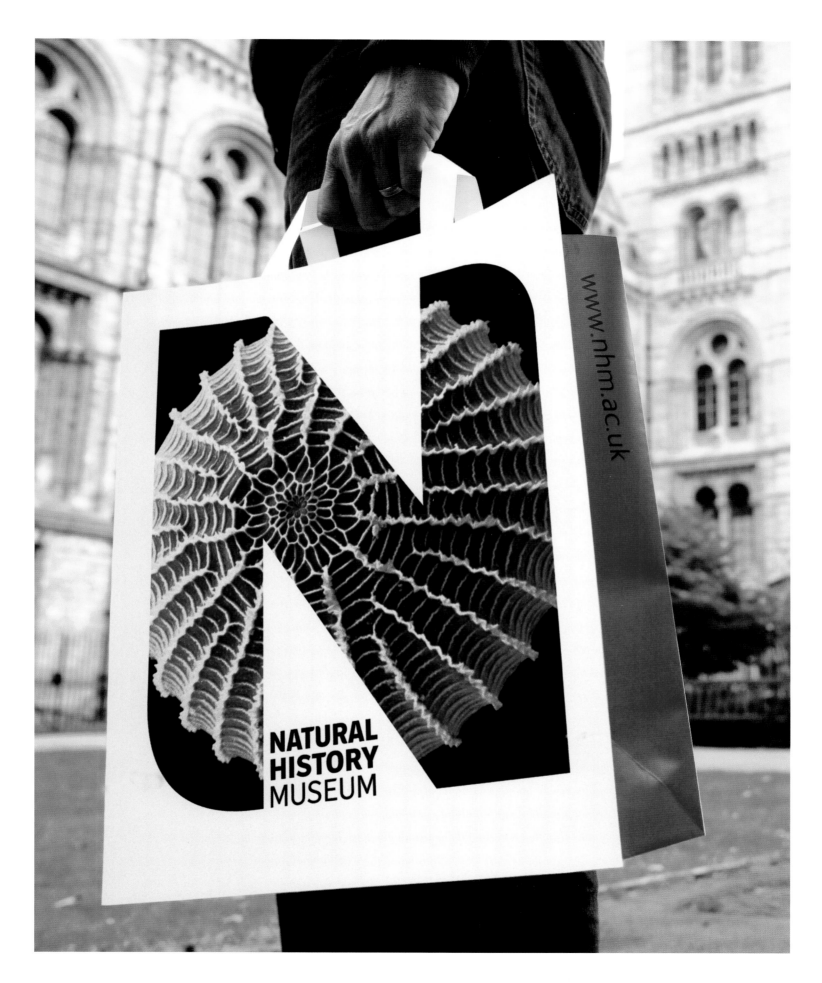

MORE GO

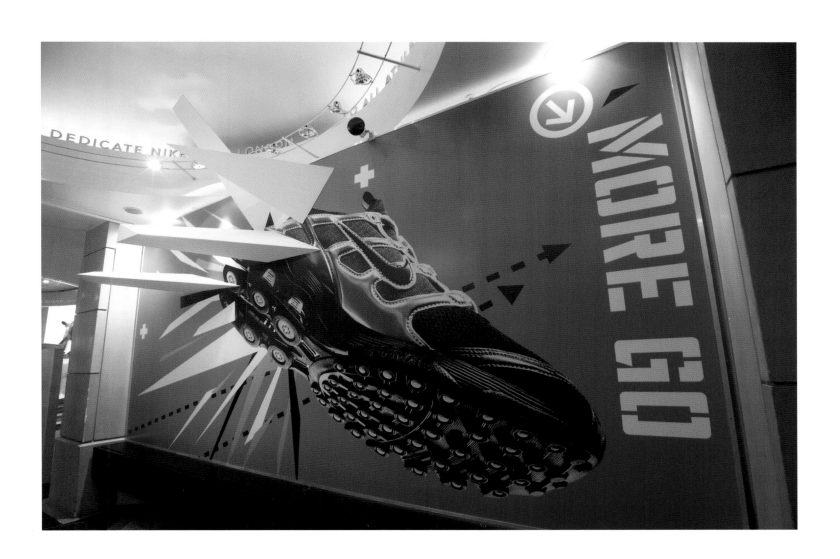

The Why Not Associates team was tasked with creating the graphic and visual identity of the new Niketown space in London. They started with the creation of a new logo, "More go," beneath Nike's traditional logo. The company was also responsible for the interior graphics, the display stands, and the visual identity of all Nike shops in Europe, characterized by a graphic that is attractive and immediately identifiable.

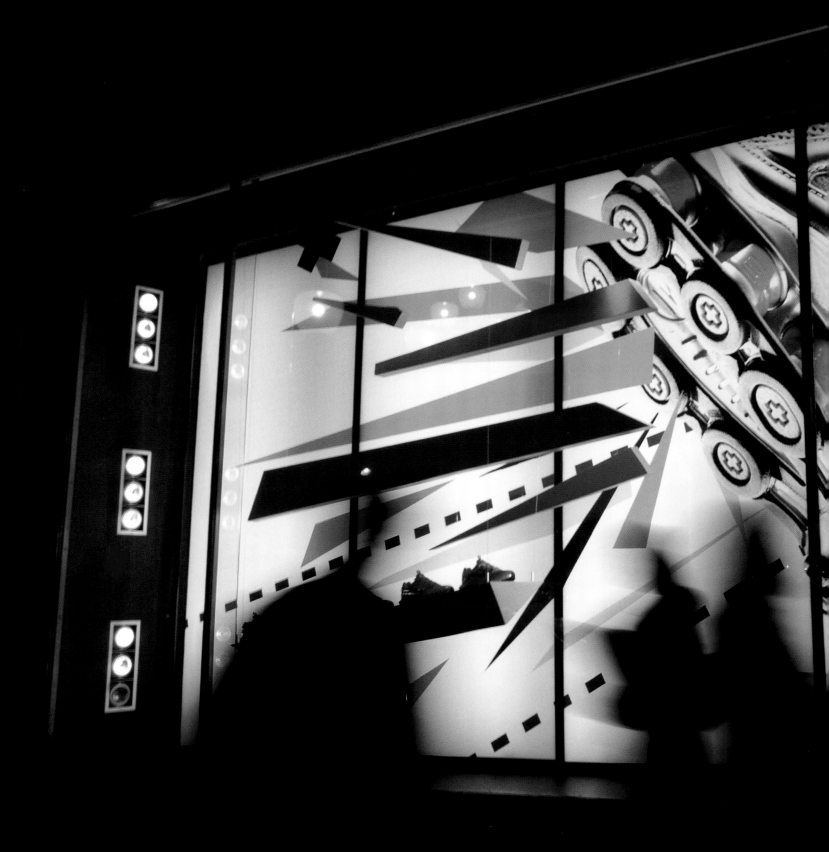

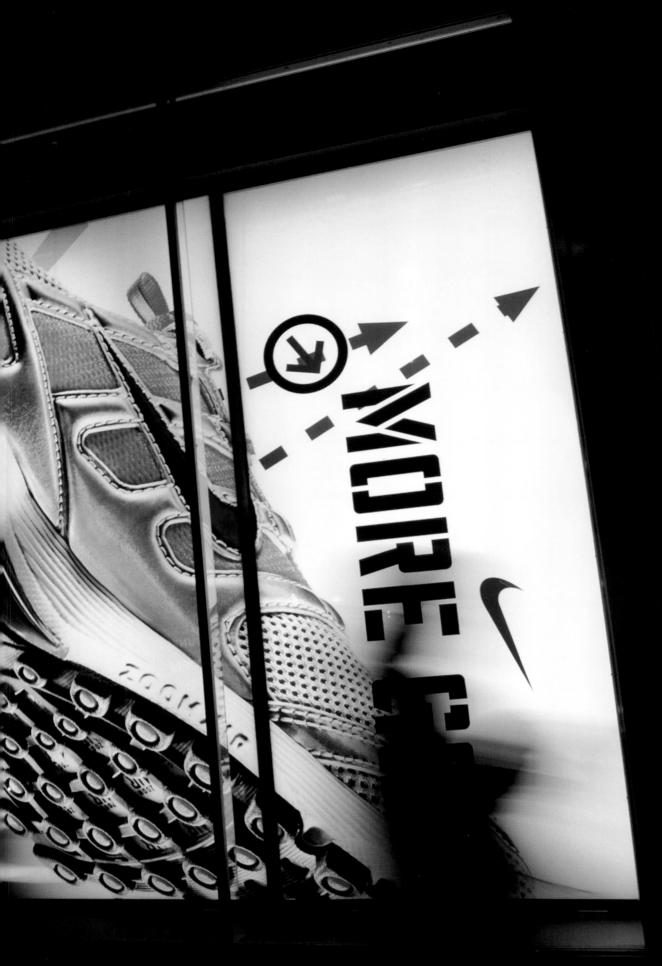

WAFFLE SOLE
WET TRACTION

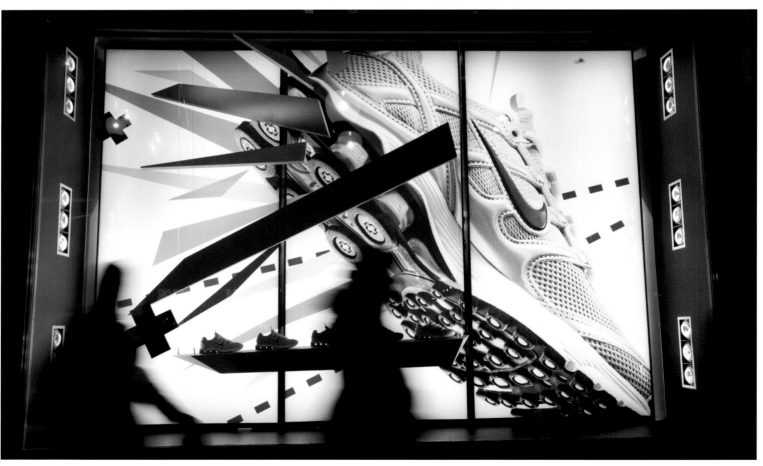

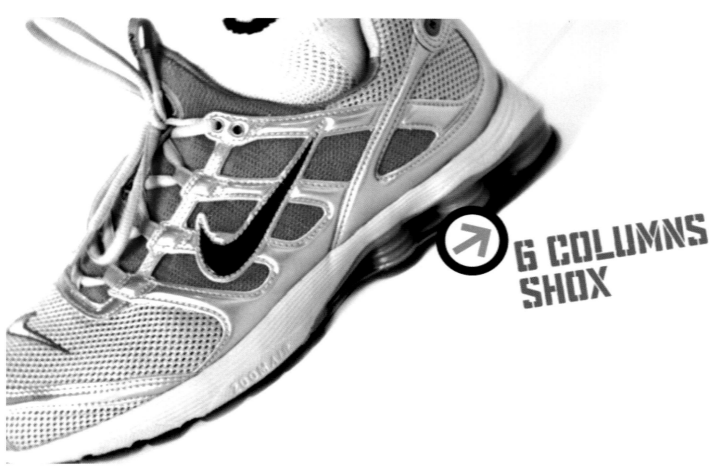

6 COLUMNS
SHOX

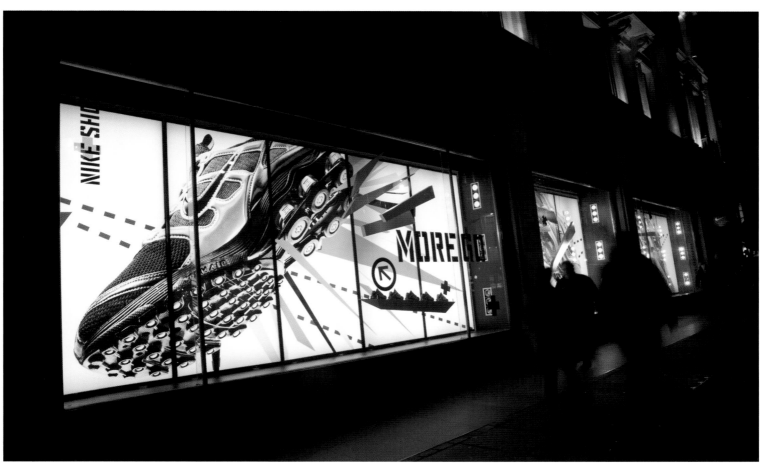

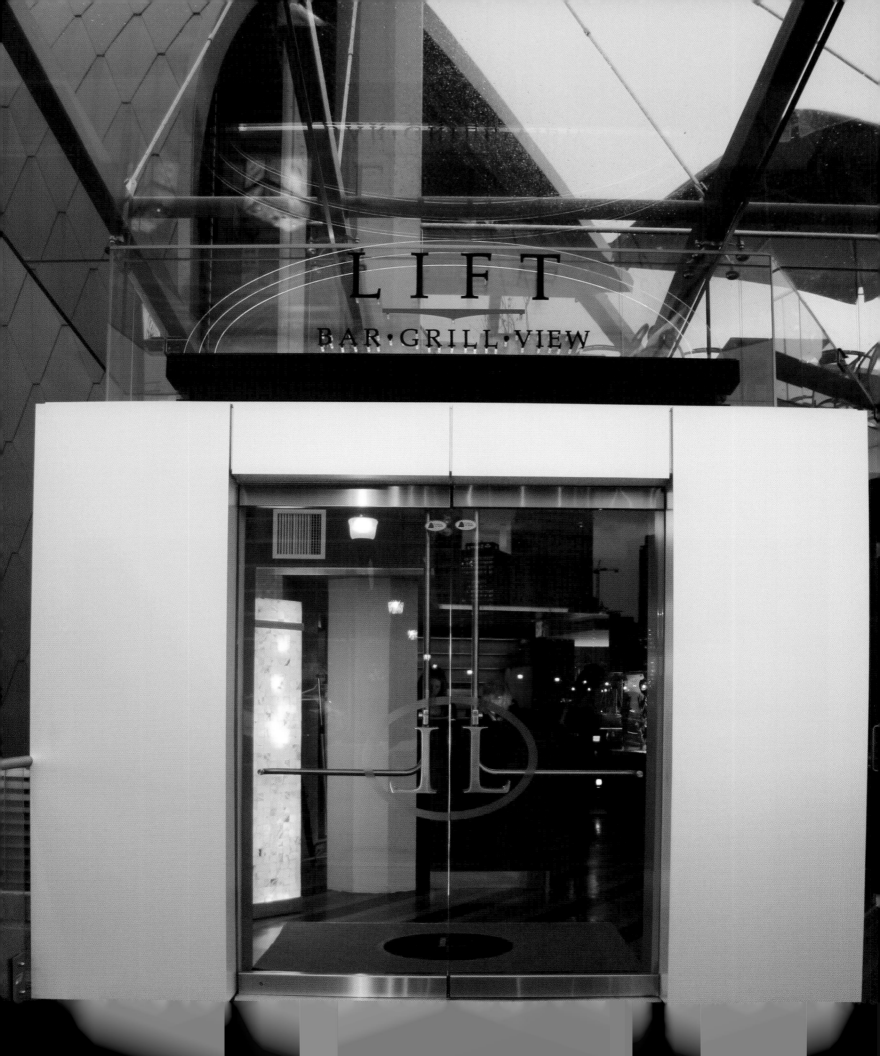

Design: **Wow! Branding** Photography: **© Angelo Cikes** Location: **Vancouver, Canada**

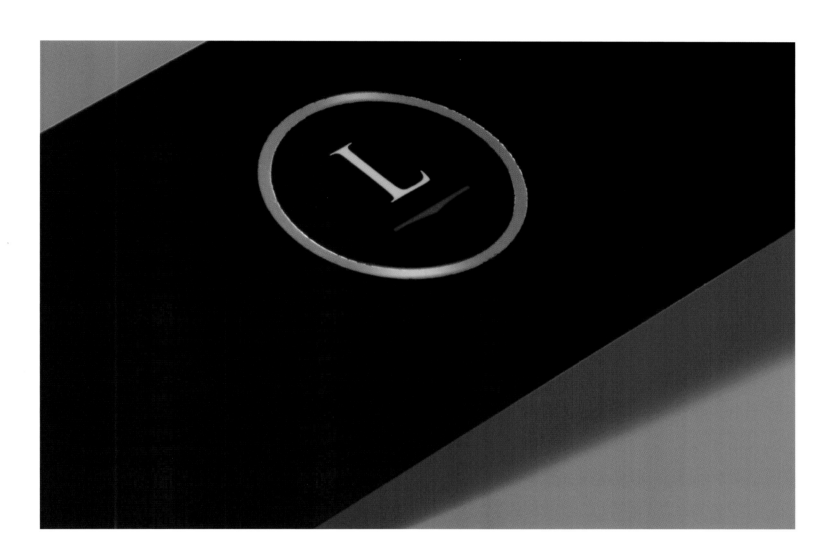

Wow! Branding is in charge of the corporate image of this restaurant, applied in vinyls, banners, and other graphic elements such as the menu. The initial concept was to create an elegant and subtle brand identity that had the same architectural beauty as the building. The logo plays with the limpid image of the typography, of soft lines on a black circle. On the exterior banners, the logo stands out on a red background.

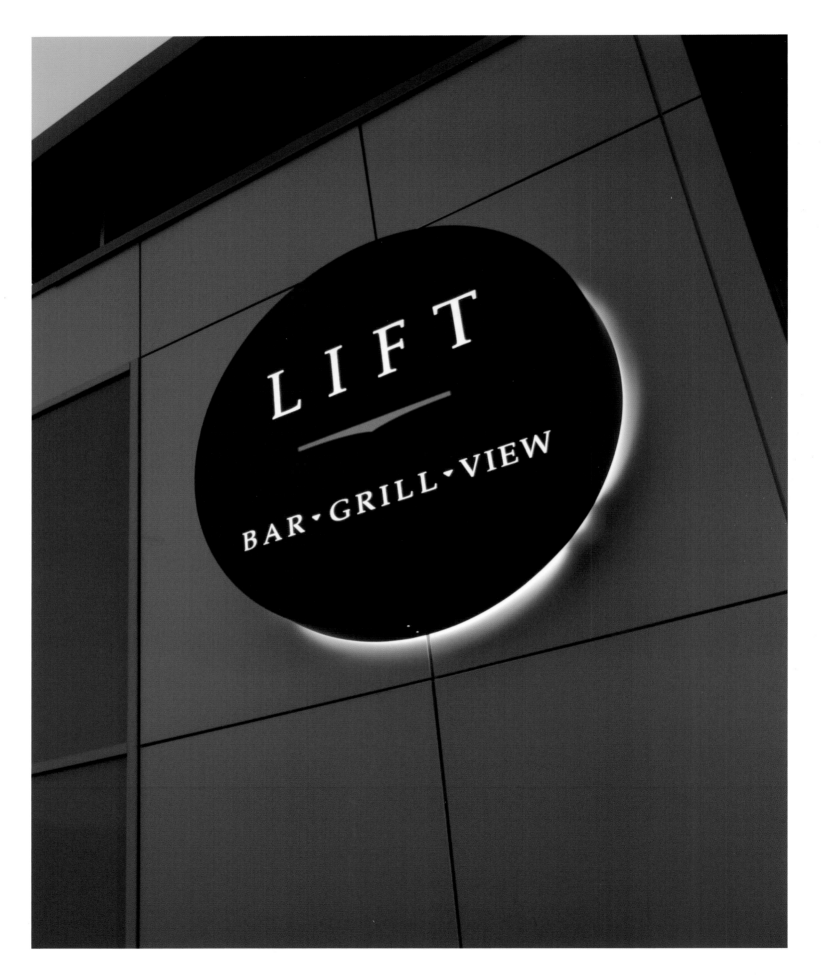

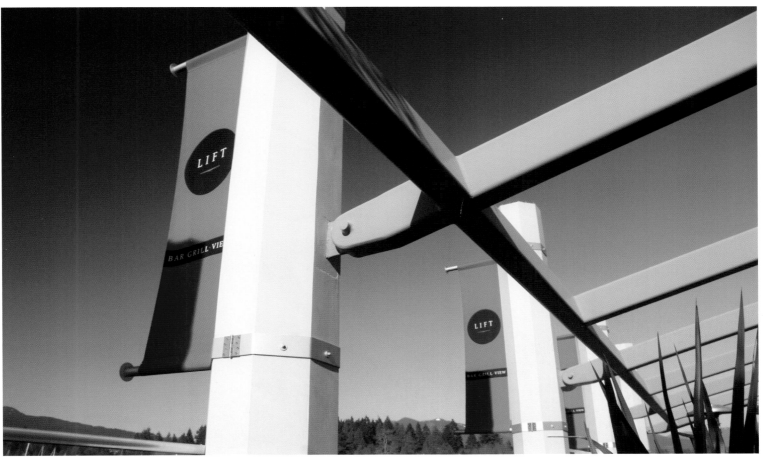

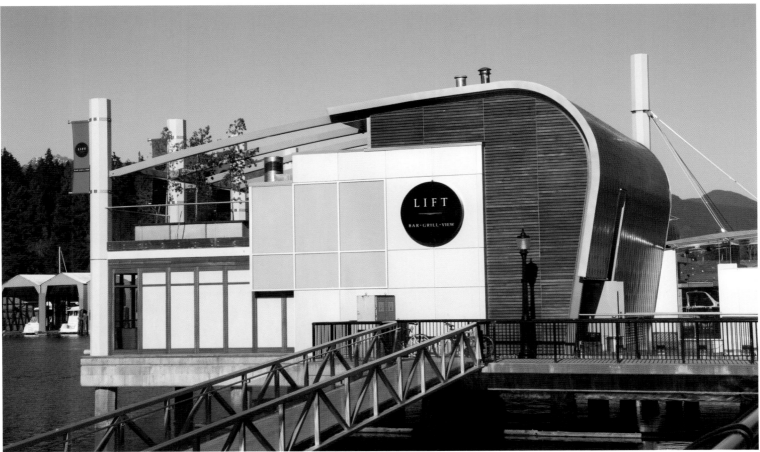

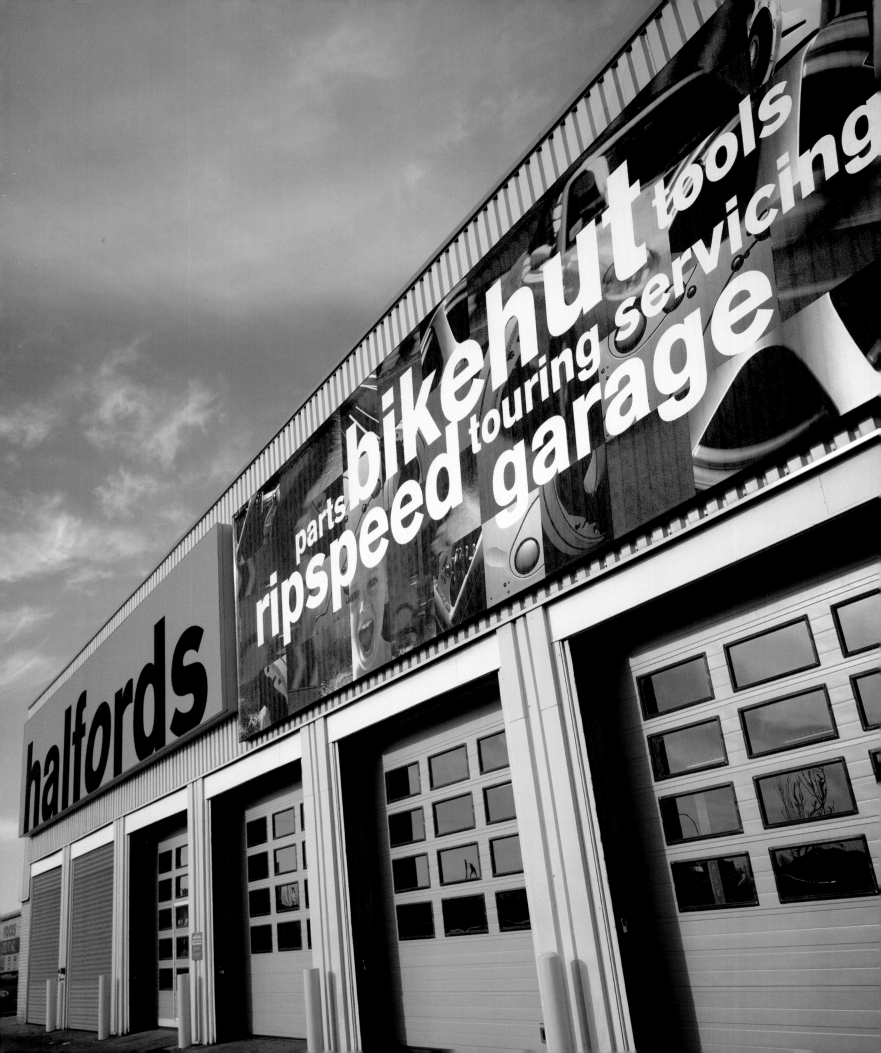

Halfords

Design: **Lippa Pearce Design** Photography: © **Richard Foster** Location: **London, UK**

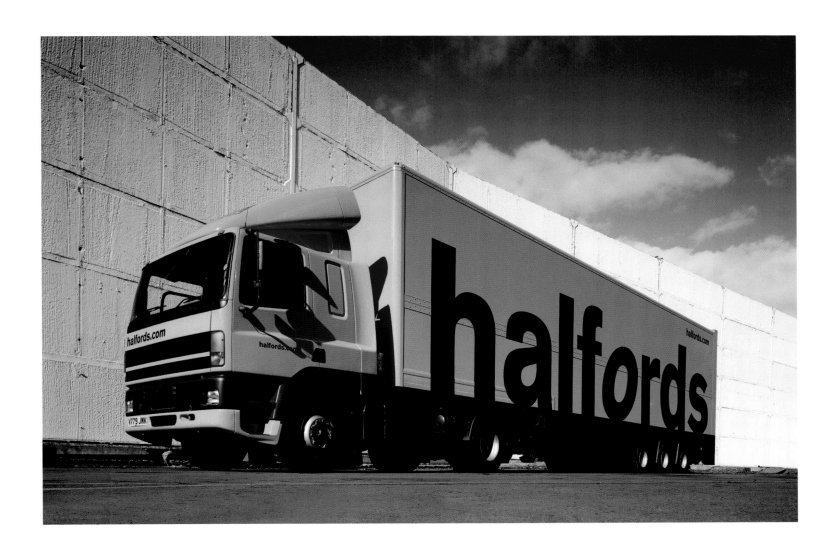

halfords

Lippa Pearce brilliantly designed all the corporate identity aspects of Halfords, the UK's leading retailer in automotive solutions, from the visual identity of its garages to the brand's signing and leaflets. After eight years of working for Halfords, Lippa Pearce has redesigned its logo, colors, image, and communication strategy, changes that have been incorporated into the buildings, clothes, packaging, and web page.

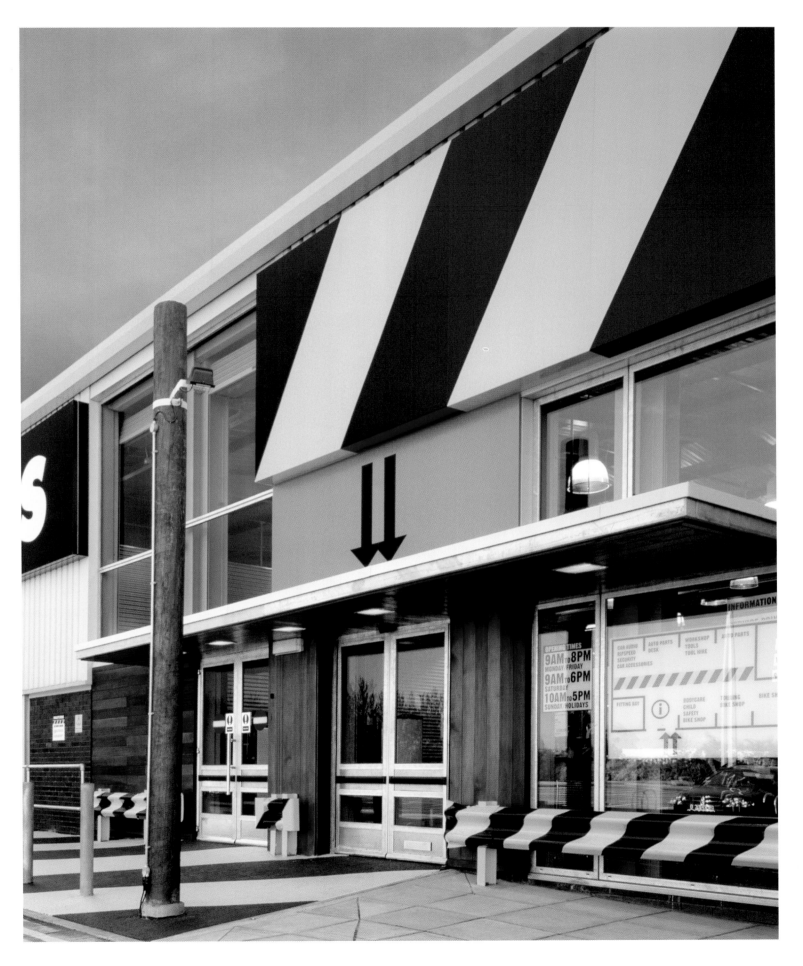

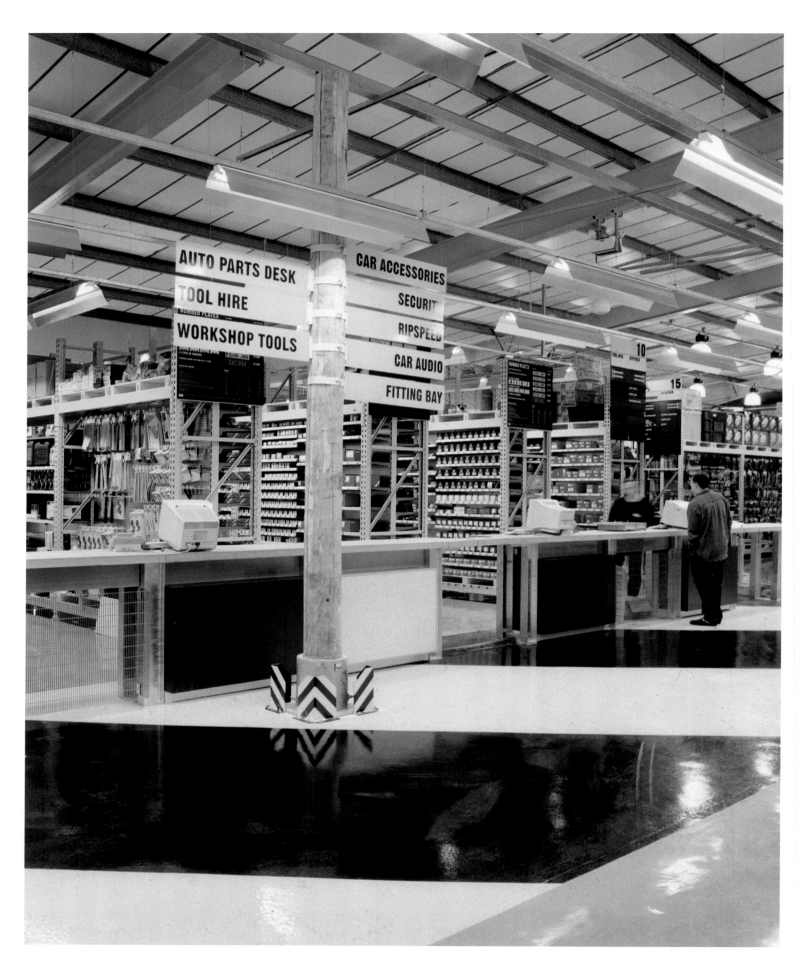

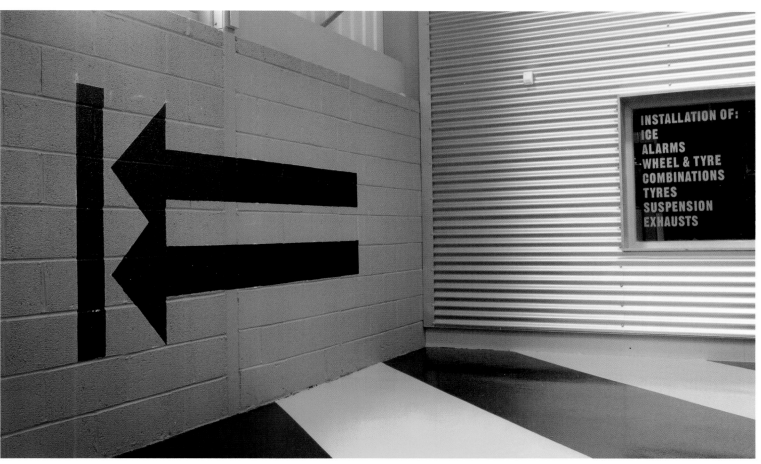

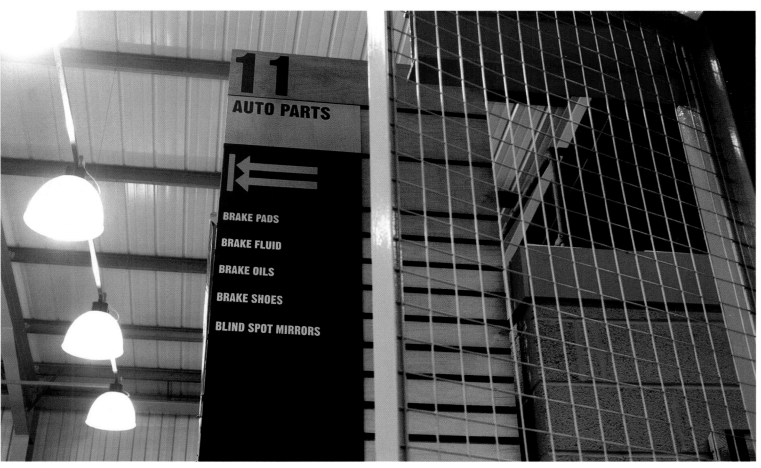

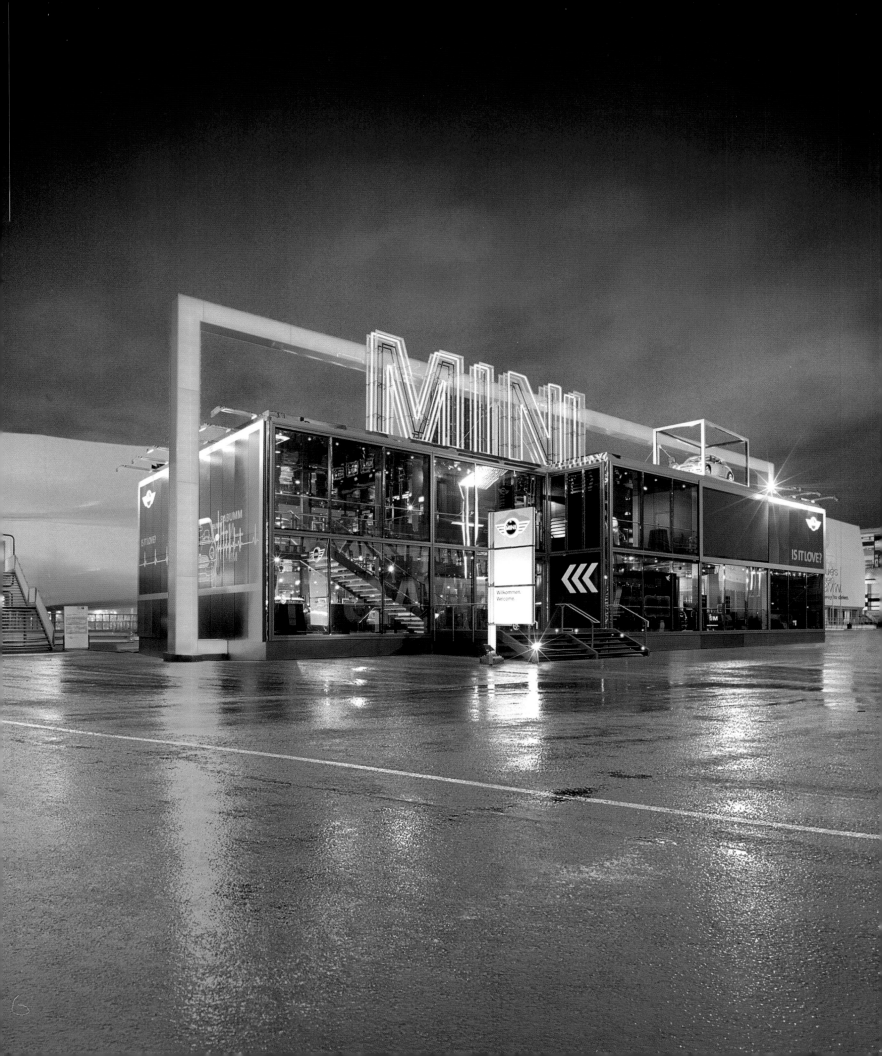

Mini

Design: **Interbrand, BMW Group** Photography: © **Interbrand** Location: **Global**

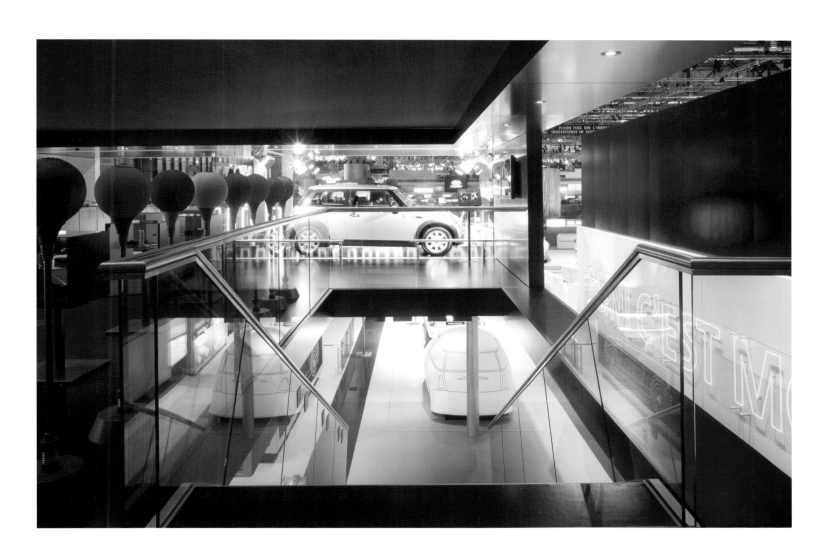

This proposal for the Mini label is perhaps one of the most stimulating, visible, and successful efforts of branding of new products in recent times. Interbrand was responsible for the complete corporate identity program for this label, and manages the implementation of strategic media such as the design of the sales floor, shown here, where the typography stands out with neon lights that clearly define the strong and independent concept of the label.

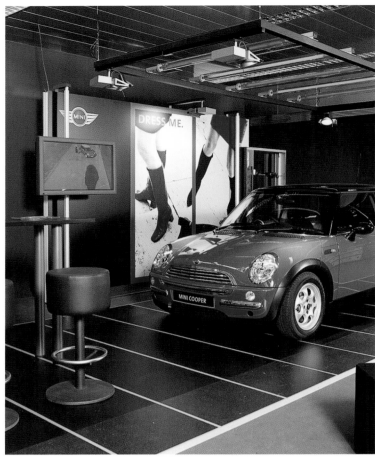

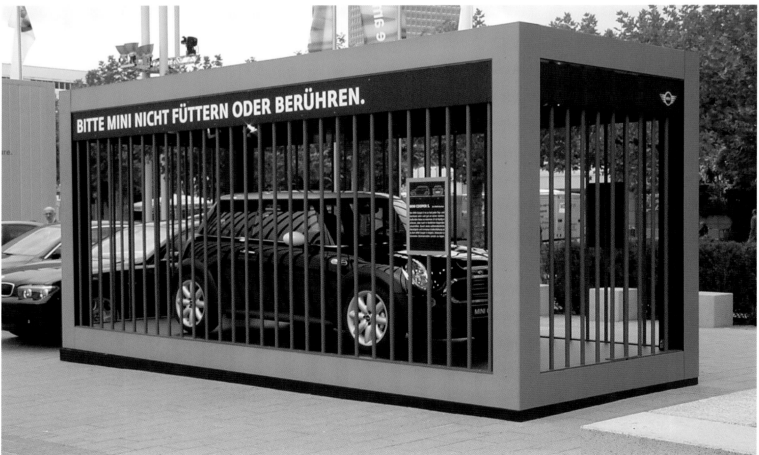

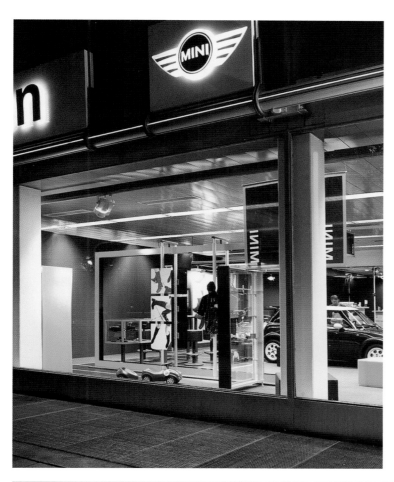
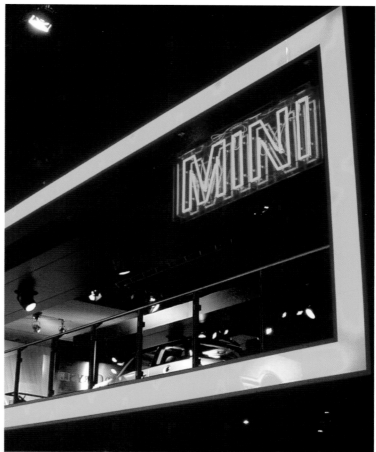
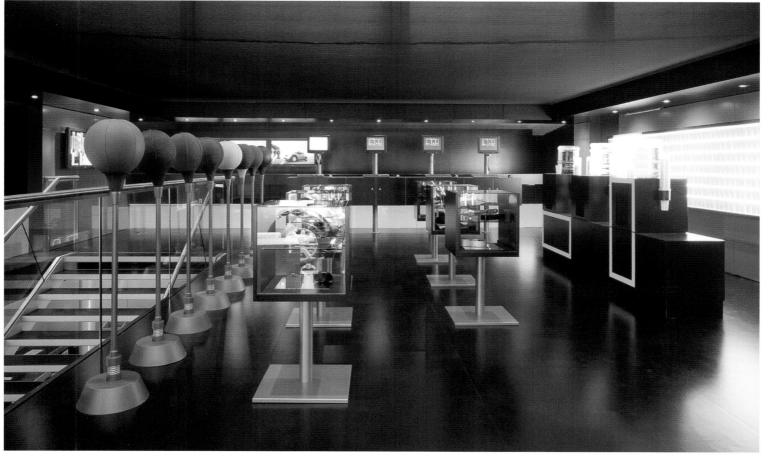

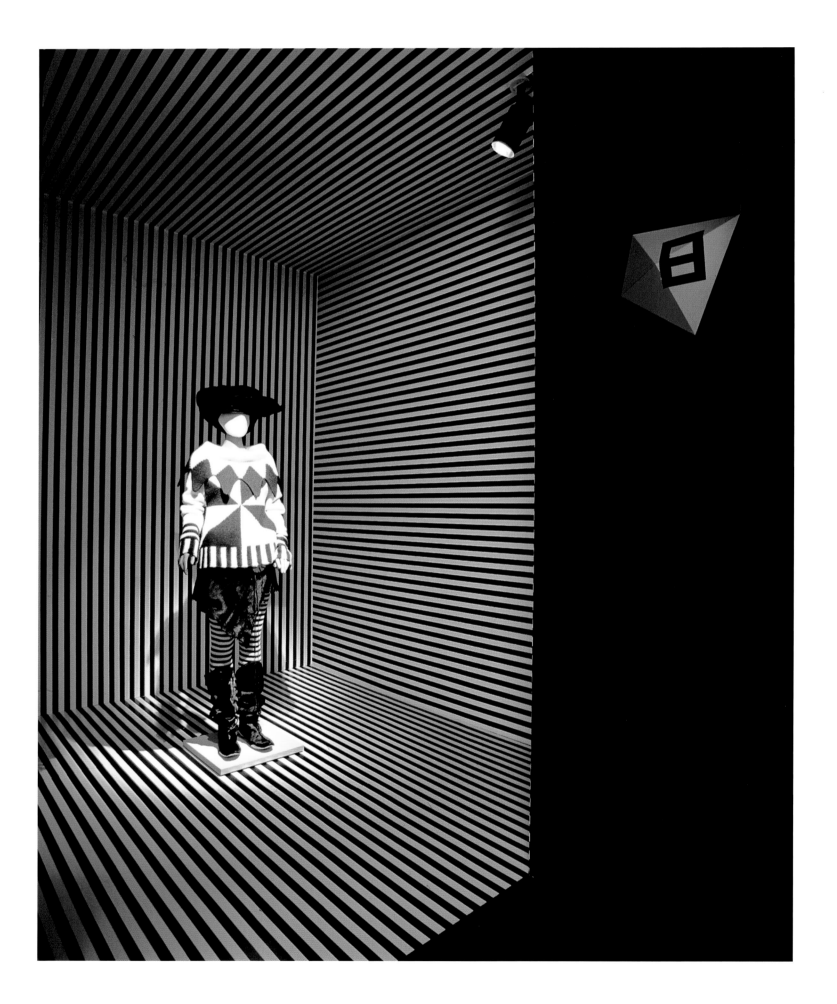

KOSHINO HIROKO EXHIBITION 2004

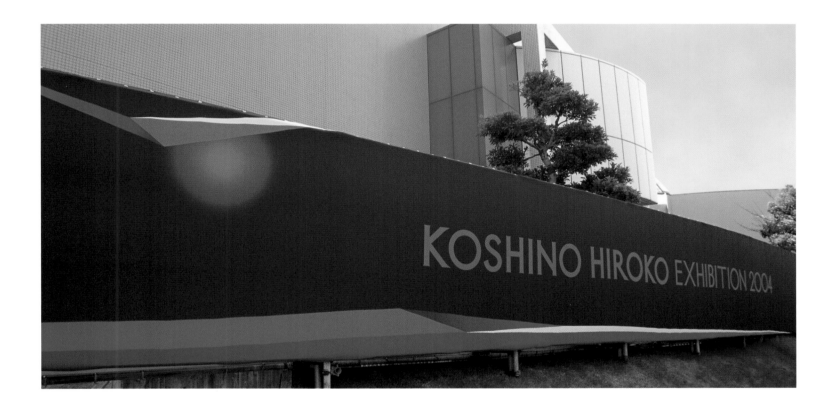

Hundred Design created the exterior banner present during the exhibition of the fashion designer Koshino Hiroko in the Ashiya City Museum of Art & History. The 236-foot long exterior poster spreads around the red tunnel that leads up to the entrance of the exhibition. Standing out inside of the museum is the pyramidal structure of numbers, imperceptible unless you are standing in front of it, that shows the order of the different pieces.

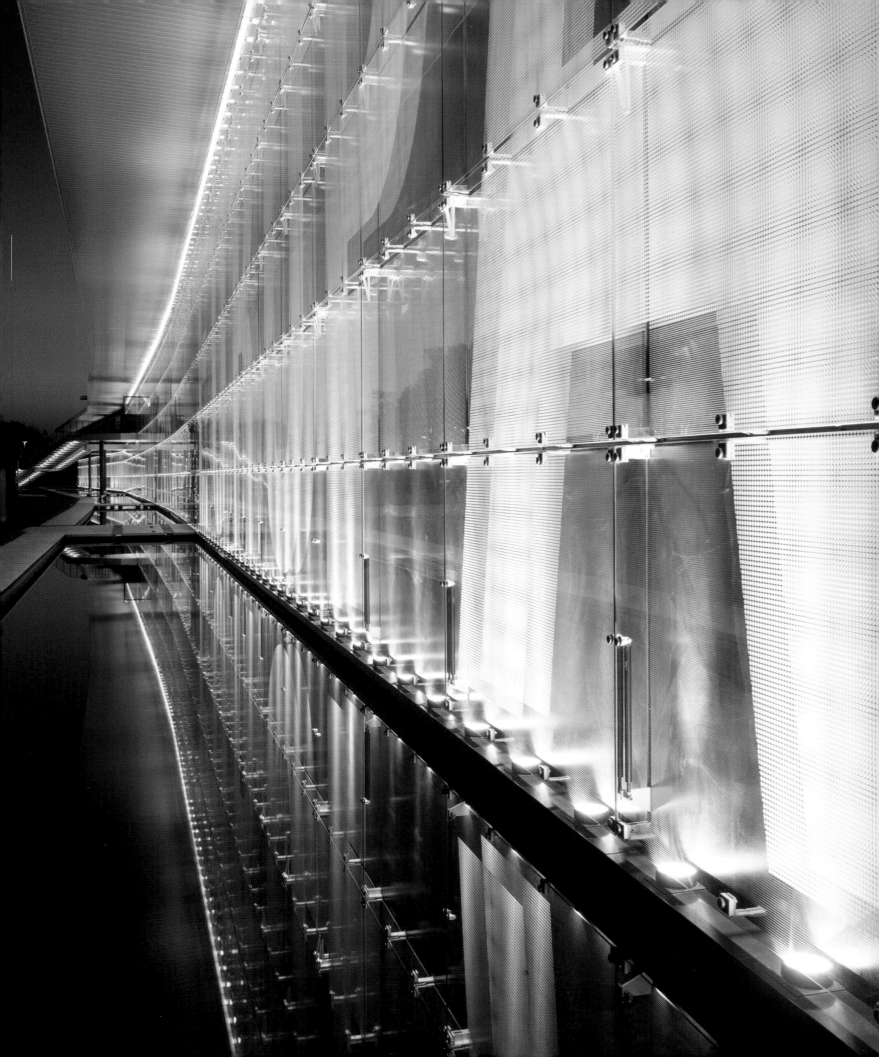

Design: **Massimiliano Fuksas** Photography: © **Philippe Ruault** Location: **Salzburg, Austria**

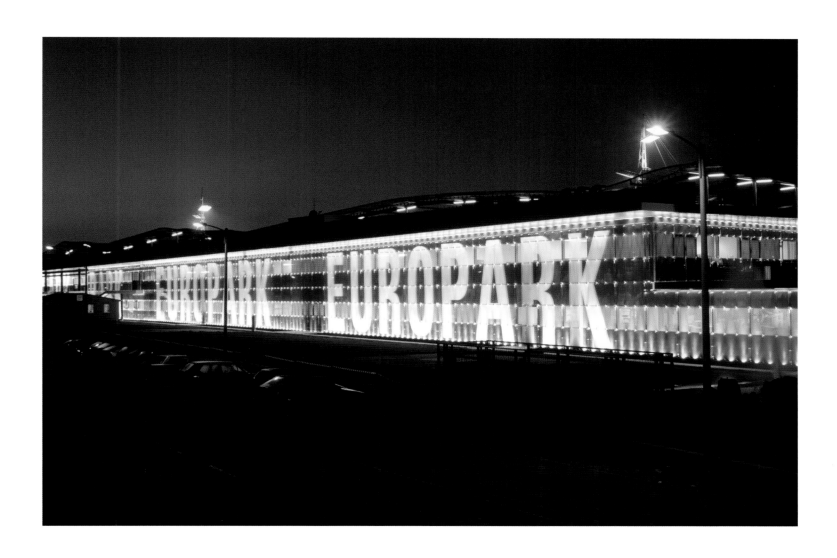

Europark transforms into a visual lure, thanks simply to the exploitation of the metallic grille structure of the building. This material becomes an eye-catching allusion to the sea, as well as acting as an identity sign for the building. At night, the façade lights up to show the name Europark, a counterpoint of dynamism in the tension of the architectural volume that shows Fuksas's constructive sensitivity, based on light and transparency.

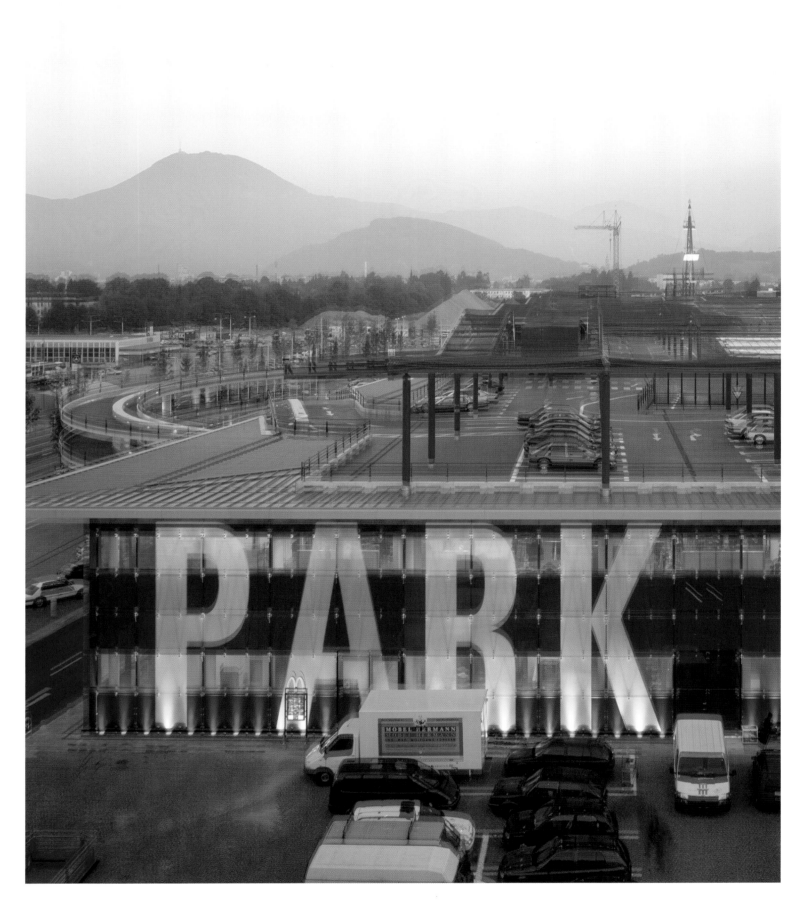

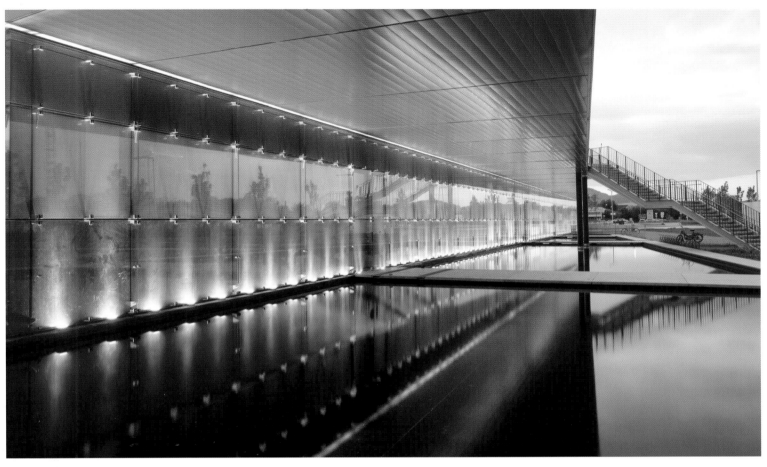

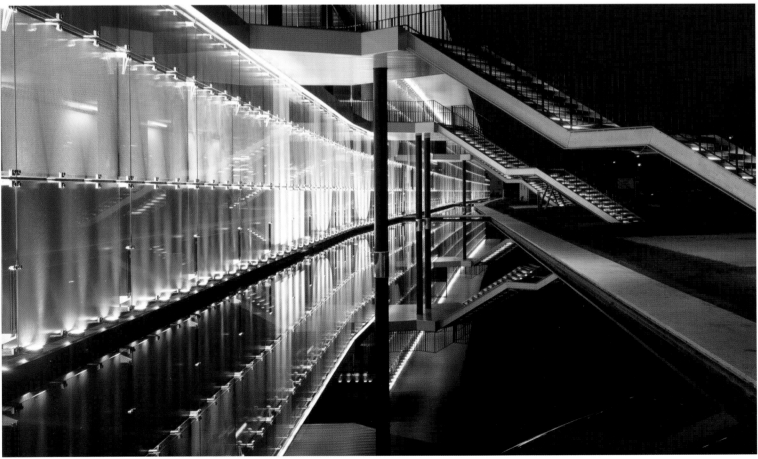

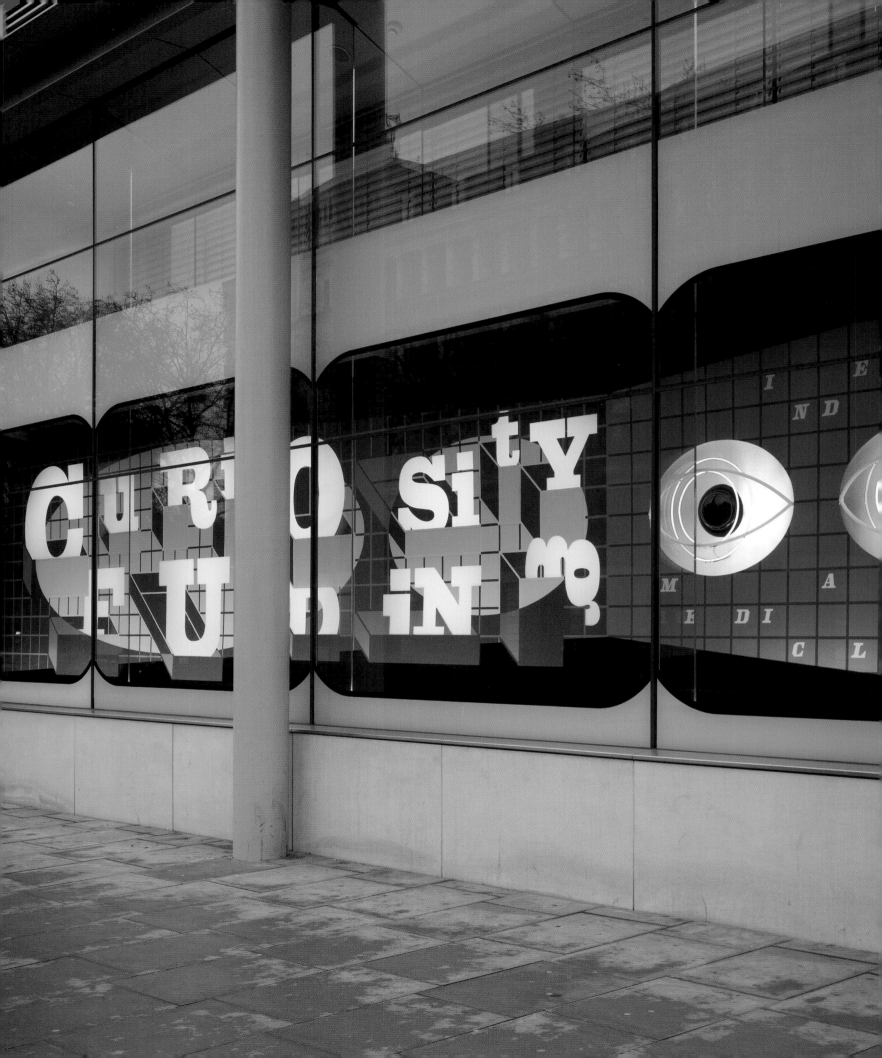

Café Wellcome, Wellcome Trust Installation

Design: **Doshi Levien** Photography: © **John Ross** Location: **London, UK**

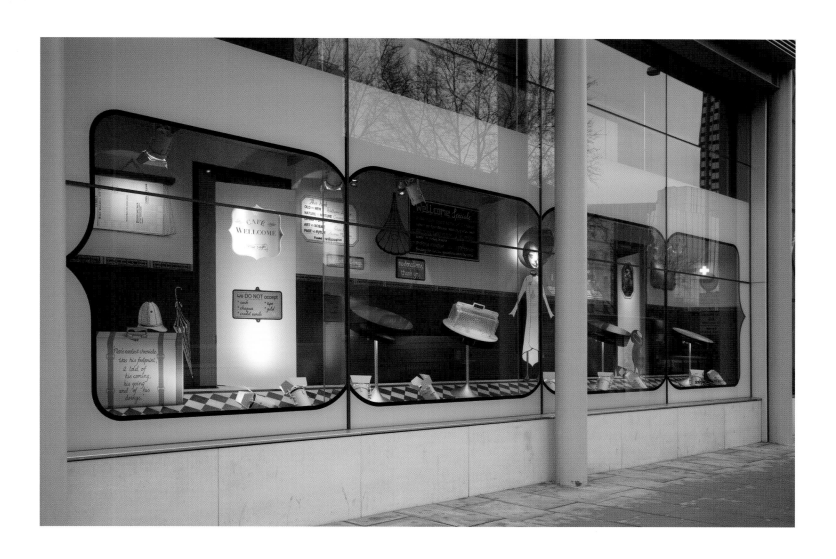

Café Wellcome is the second installation that Doshi Levien did for the medical research center Wellcome Trust. Different graphic elements, which awake the curiosity of passers-by, include luminous letters in one of the windows, which read "Curiosity Funding," publicizing one of the main goals of Wellcome Trust: financing exceptional research.

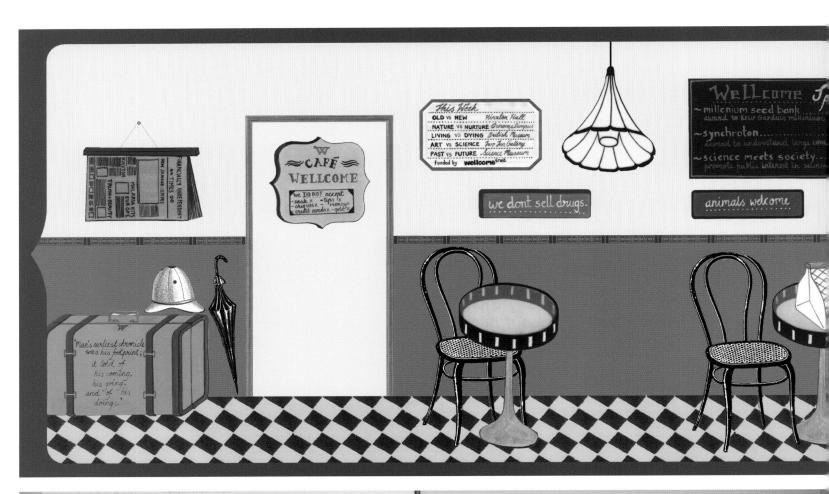

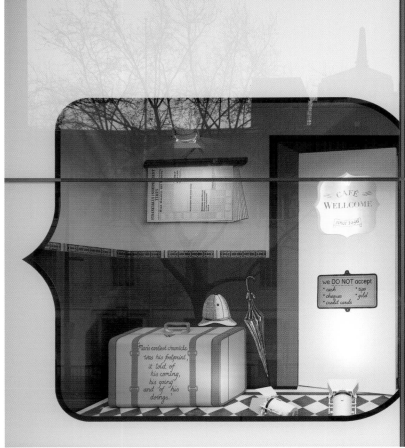

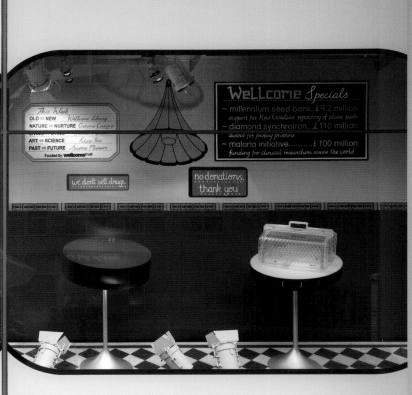

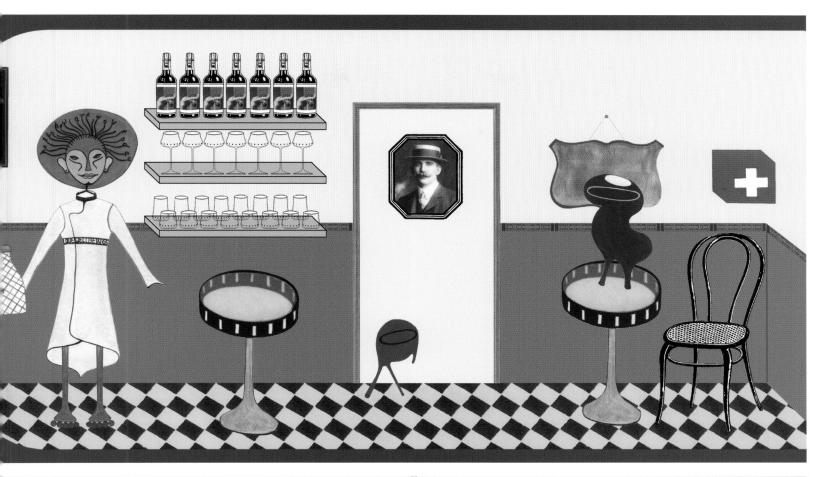

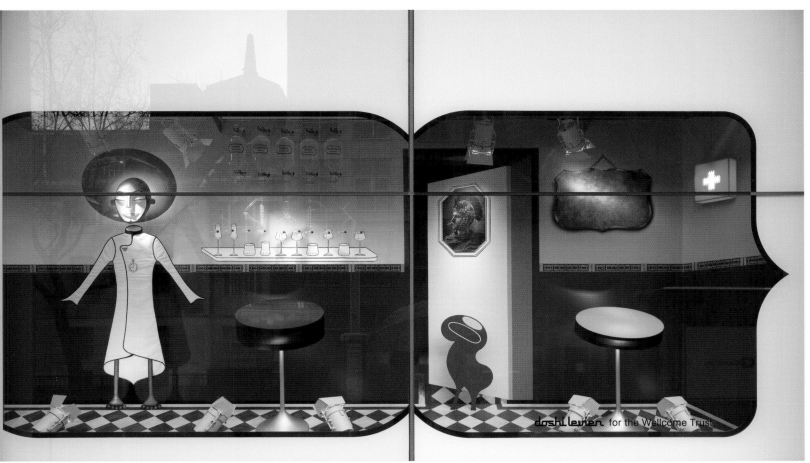

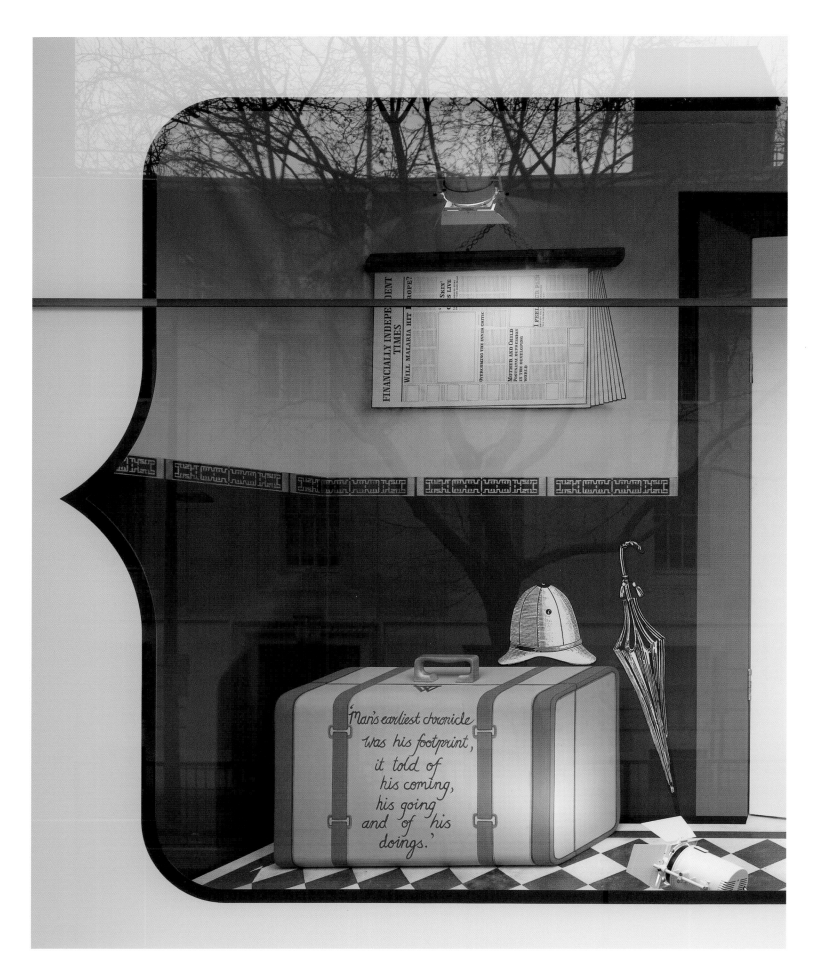

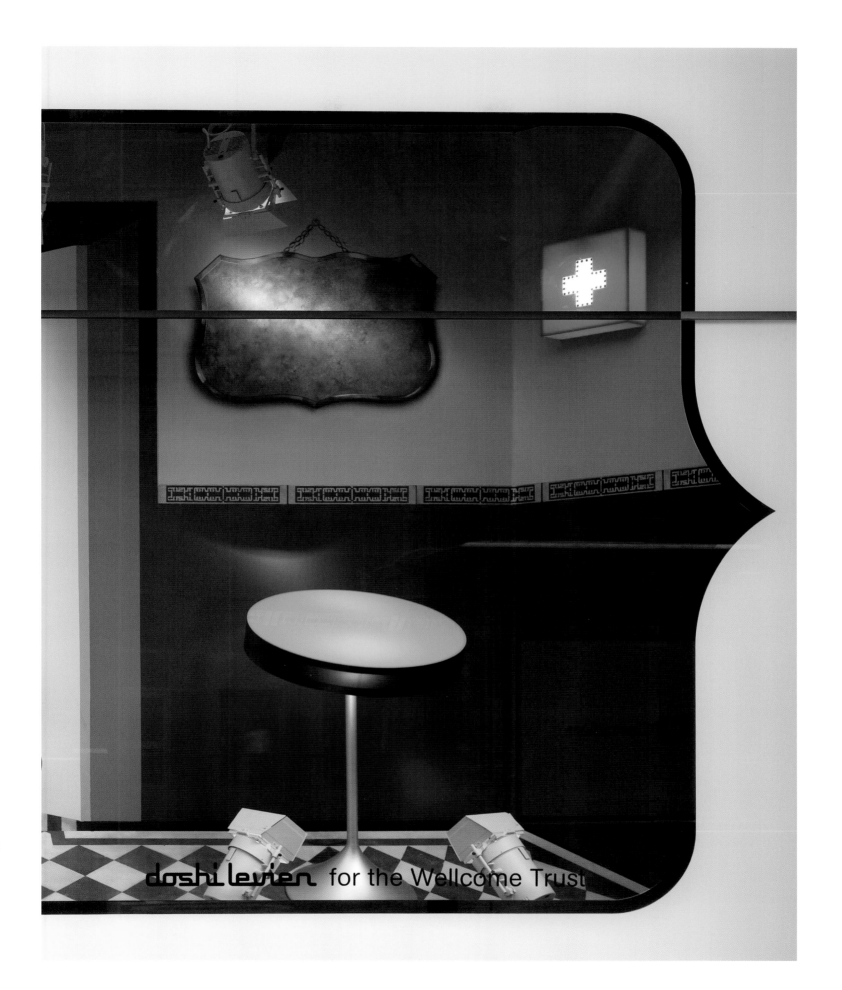

doshi levien for the Wellcome Trust

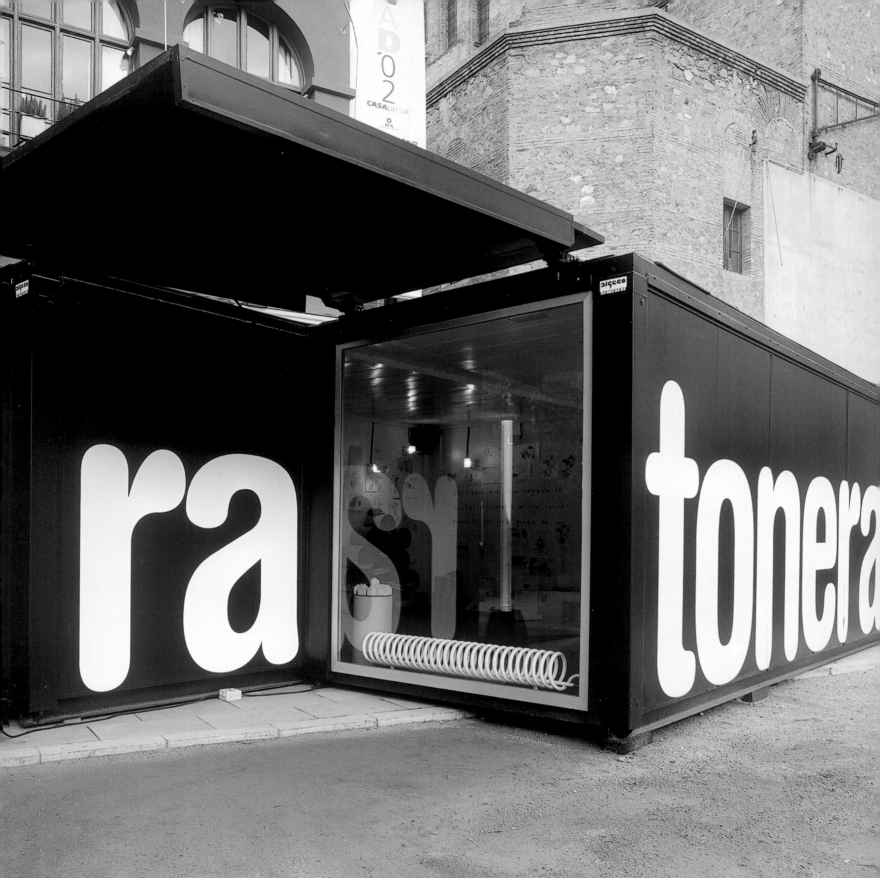

La Ratonera

Design: **Maite Torrent & Natàlia Tubella** Photography: © **Joan Mundó** Location: **Barcelona, Spain**

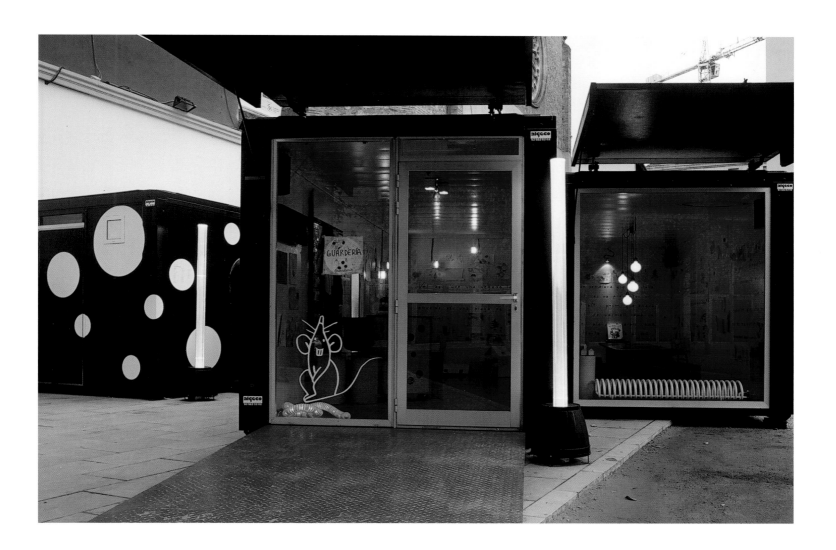

la ratonera

La Ratonera is the name of a nursery that was designed as a temporary space during the days of Casa Decor. The space consists of three prefabricated containers painted black, two of them with the name of the nursery and the third with white circles that look like cheese. The white interior walls have been decorated with an application of vinyls showing the tale of the "Pied Piper of Hamelin", which draws in the children, who can then enjoy its interior.

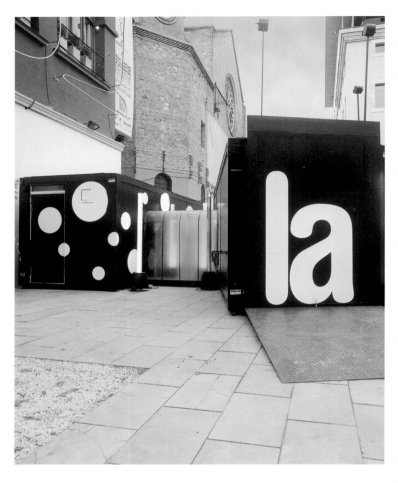

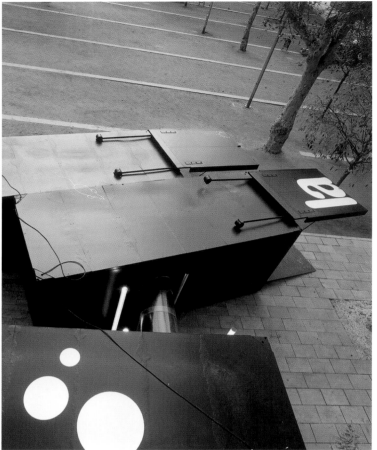

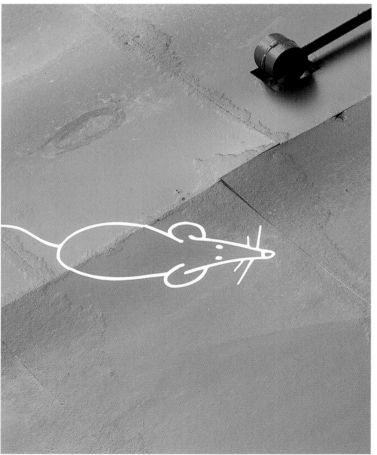

e quella

ntanyes

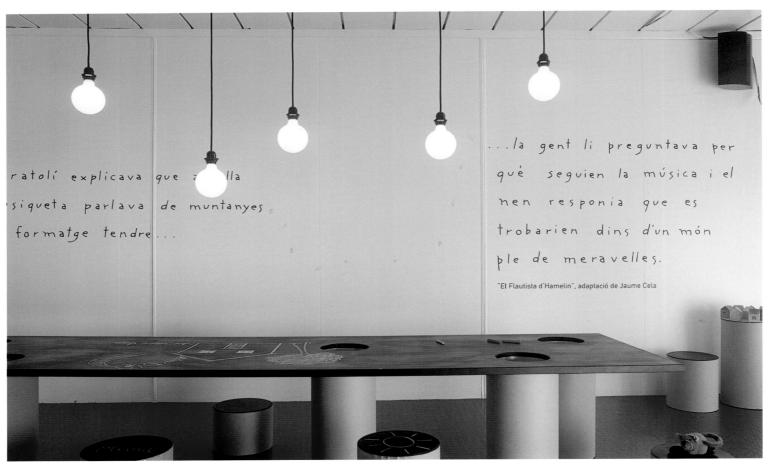

ratolí explicava que a ...lla
...siqueta parlava de muntanyes
...formatge tendre...

...la gent li preguntava per
què seguien la música i el
nen responia que es
trobarien dins d'un món
ple de meravelles.

"El Flautista d'Hamelin", adaptació de Jaume Cela

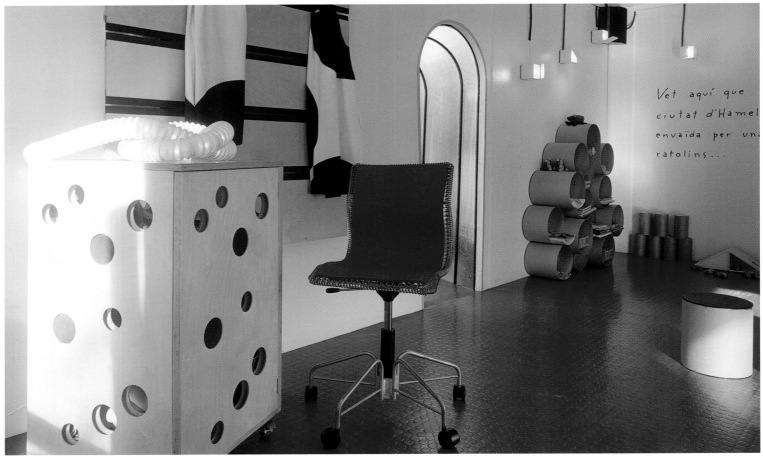

Vet aquí que
ciutat d'Hamel...
envaïda per un...
ratolins...

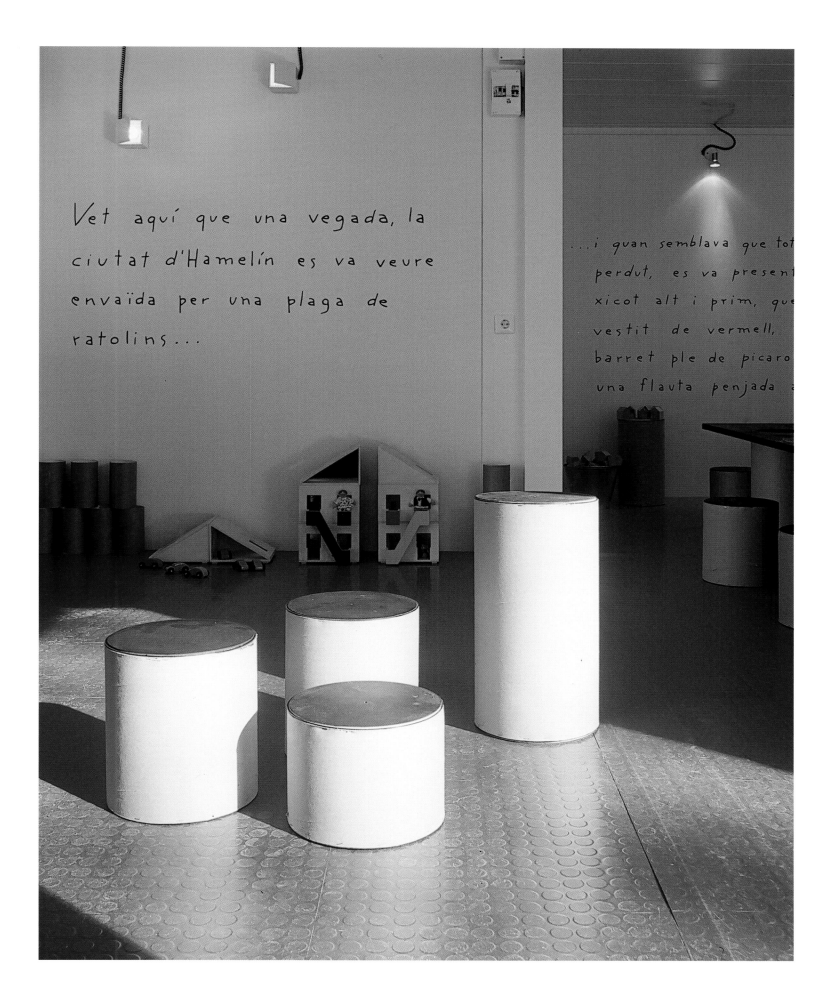

Vet aquí que una vegada, la ciutat d'Hamelín es va veure envaïda per una plaga de ratolins...

...i quan semblava que tot perdut, es va present xicot alt i prim, que vestit de vermell, barret ple de picaro una flauta penjada

bus stop

Design: **Lippa Pearce Design** Photography: **© Gareth Sambidge** Location: **London, UK**

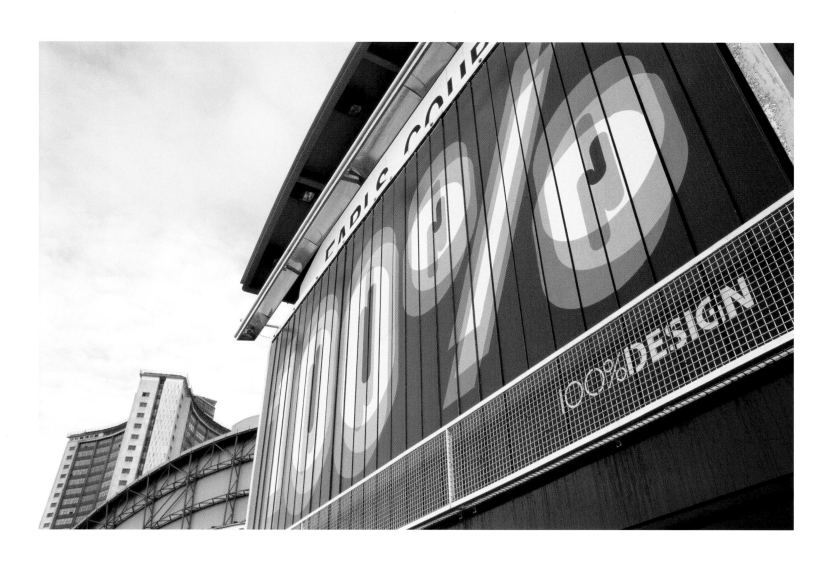

IOO%**DESIGN**

Lippa Pearce is the team responsible for the graphic program of the 100% Design fair, recognized internationally as being one of the best exhibitions of contemporary interior design. For three consecutive years, Lippa Pearce, with the collaboration of interior designer Ben Kelly, designed the interior and exterior graphics, the signing systems, the visitors' map, the interior advertising, and the press area, as well as other points of interest.

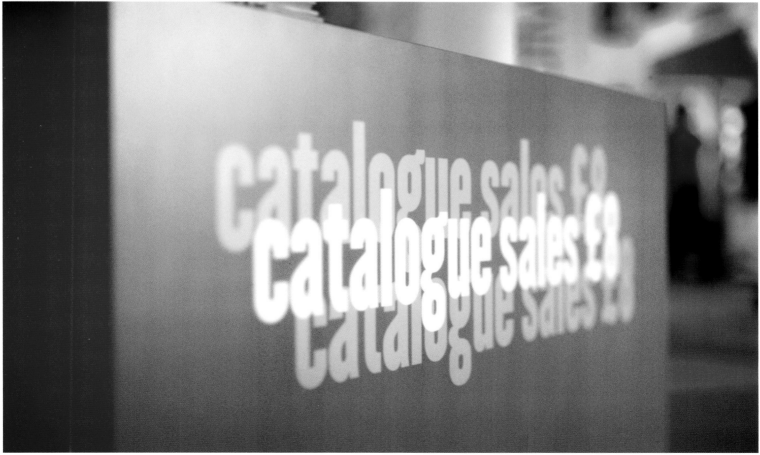

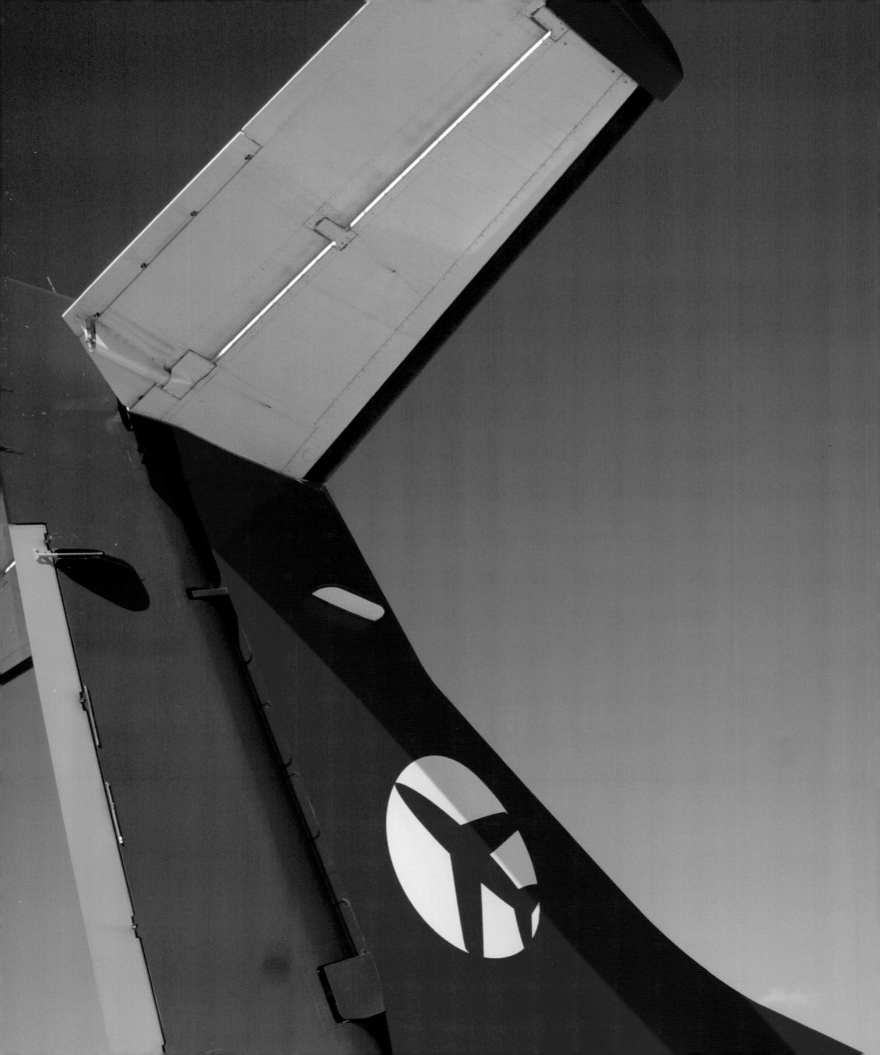

DAT - Danish Air Transport

Design: **Finn Nygaard Design** Photography: © **Finn Nygaard Design** Location: **Denmark**

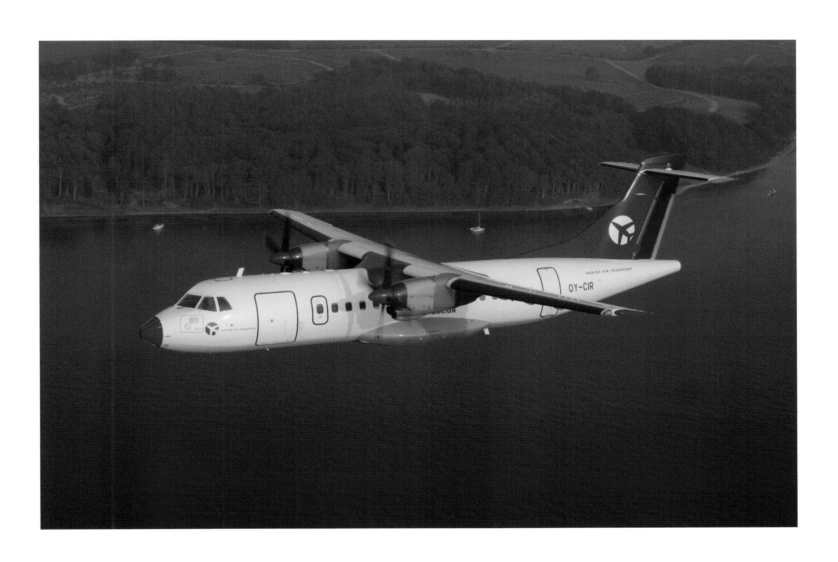

The Danish airline (DAT) commissioned Finn Nygaard Design to create the company's corporate identity, as well as the chromatic composition applied to the planes. The logo reproduces the form of a plane, thanks to the composition of complementary colors (orange, blue, yellow, and green). The same colors were applied on the plane to make the company's identity stand out among its competitors.

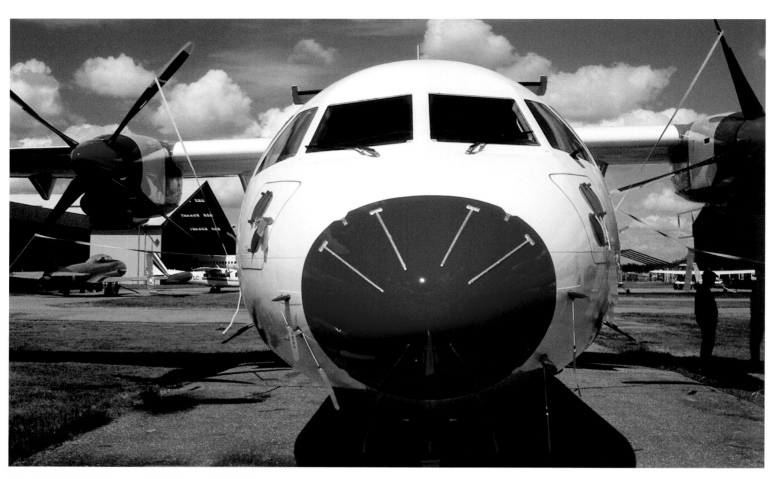

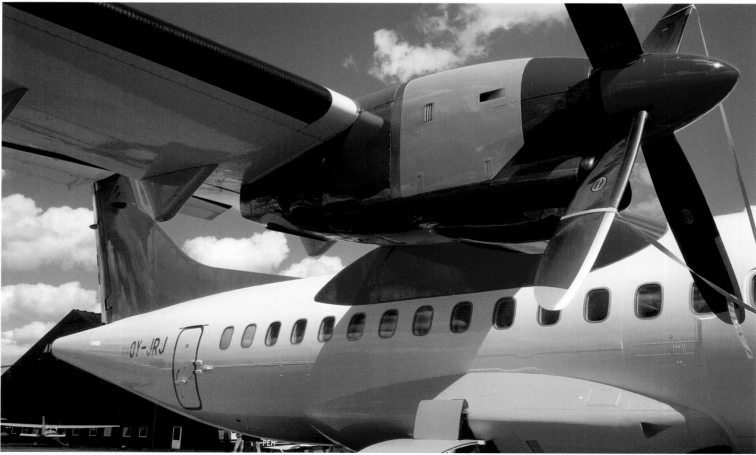

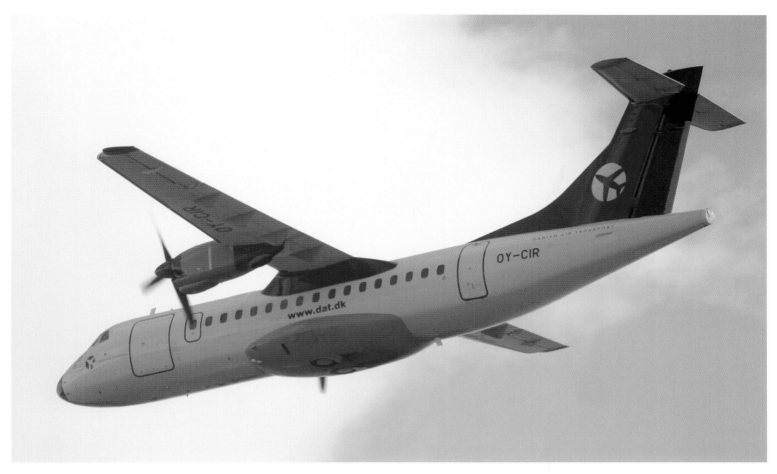

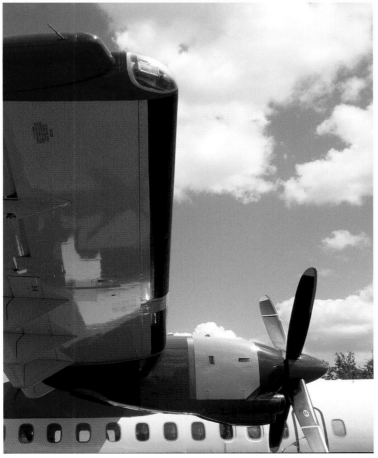

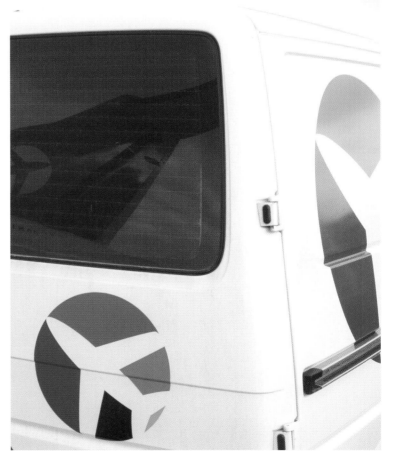

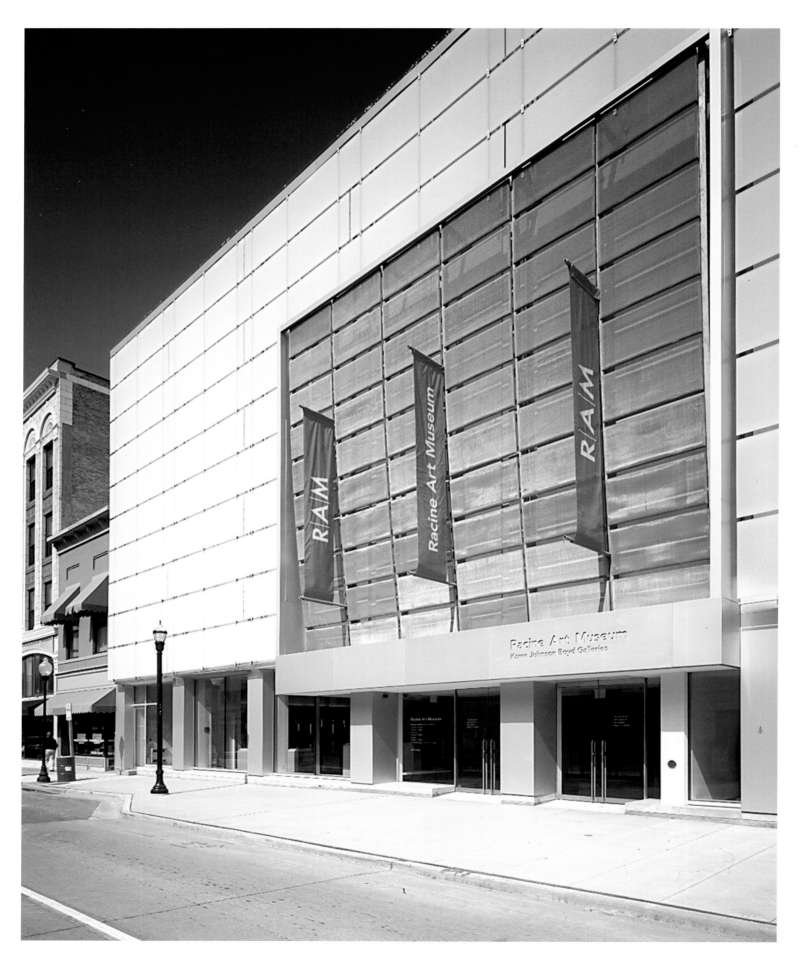

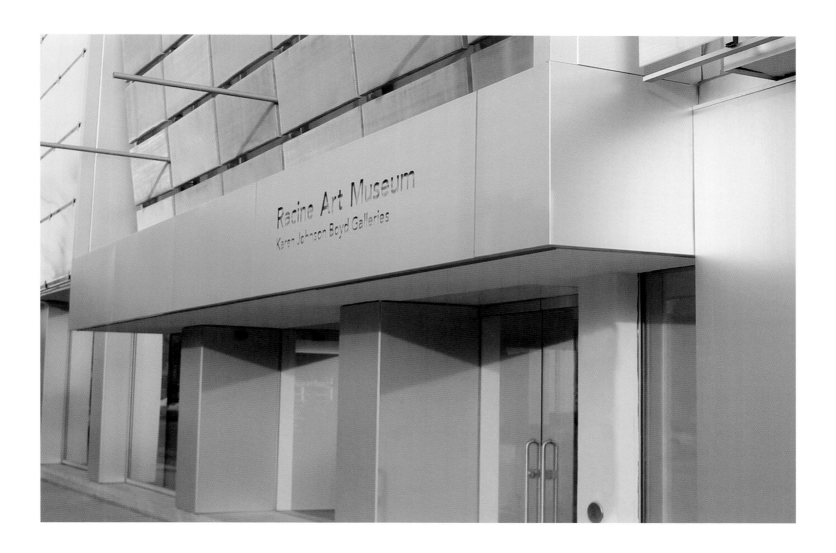

The Racine Art Museum (RAM) houses one of the most important collections of contemporary art in Wisconsin. Liska, together with the architect and commissioners of the museum, developed a corporate image that interrelates with the building's architecture. Banners, catalogs, advertisements, commercial objects, and interior and exterior signing—all the elements are based on the simplicity of the acronym RAM.

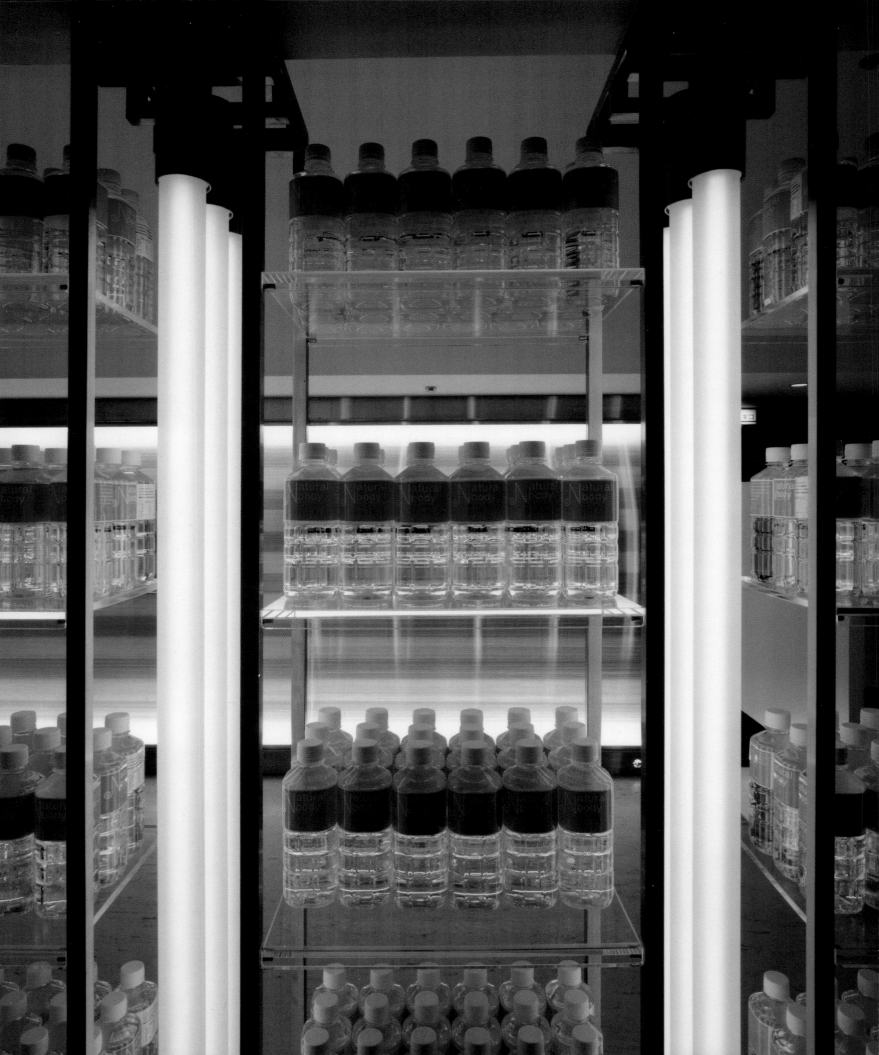

Design: **Fumita Design Office** Photography: **© Nacása & Partners** Location: **Tokyo, Japan**

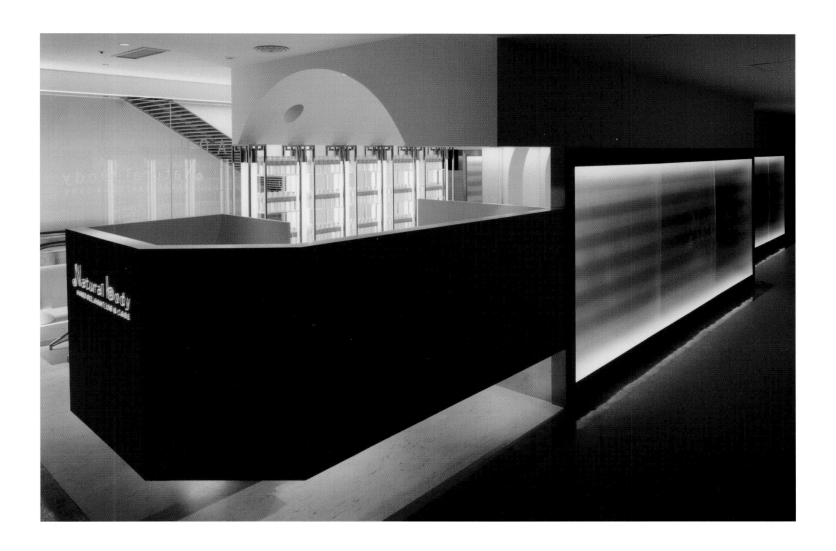

HAND RELAXATION & CARE

Natural Body plays with the special quality of its logo, designed by the Japanese studio Names&Design Complex. Its energetic typography lends it a dynamic and attractive image. The graphic identity of this space, dedicated to relaxing and caring for the body, has been applied in vinyls on the shop window, the display case at the cash register, and illuminated shelving. Names&Design Complex also created the packaging of a new range of cosmetic products from Natural Body.

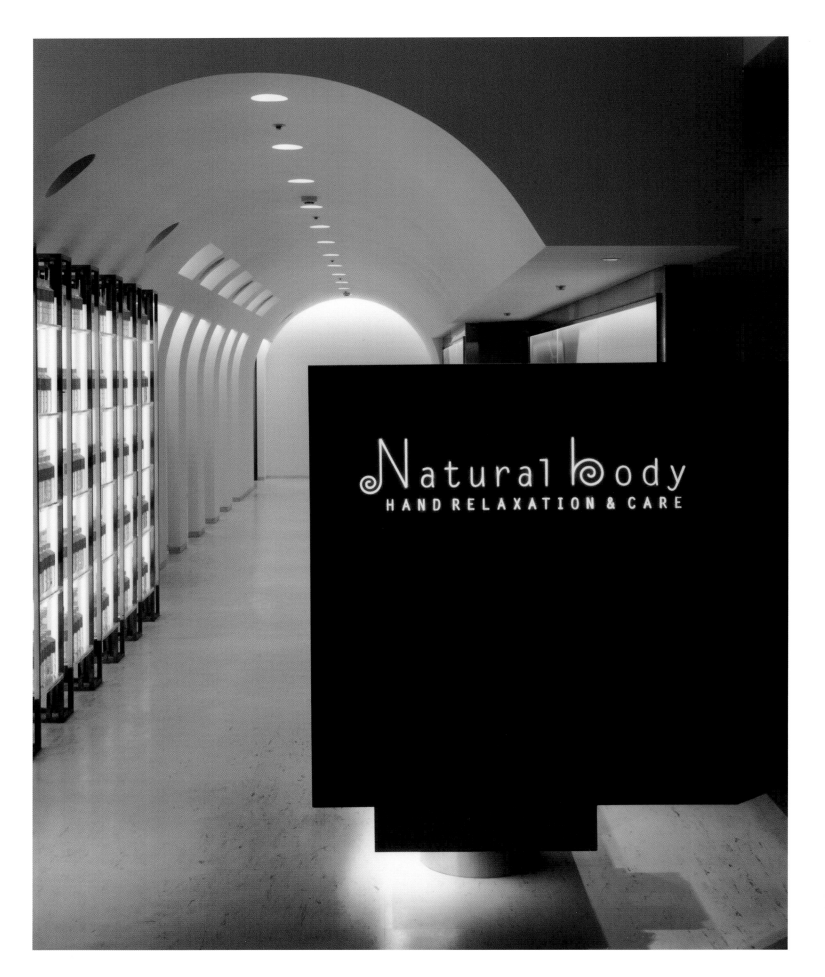

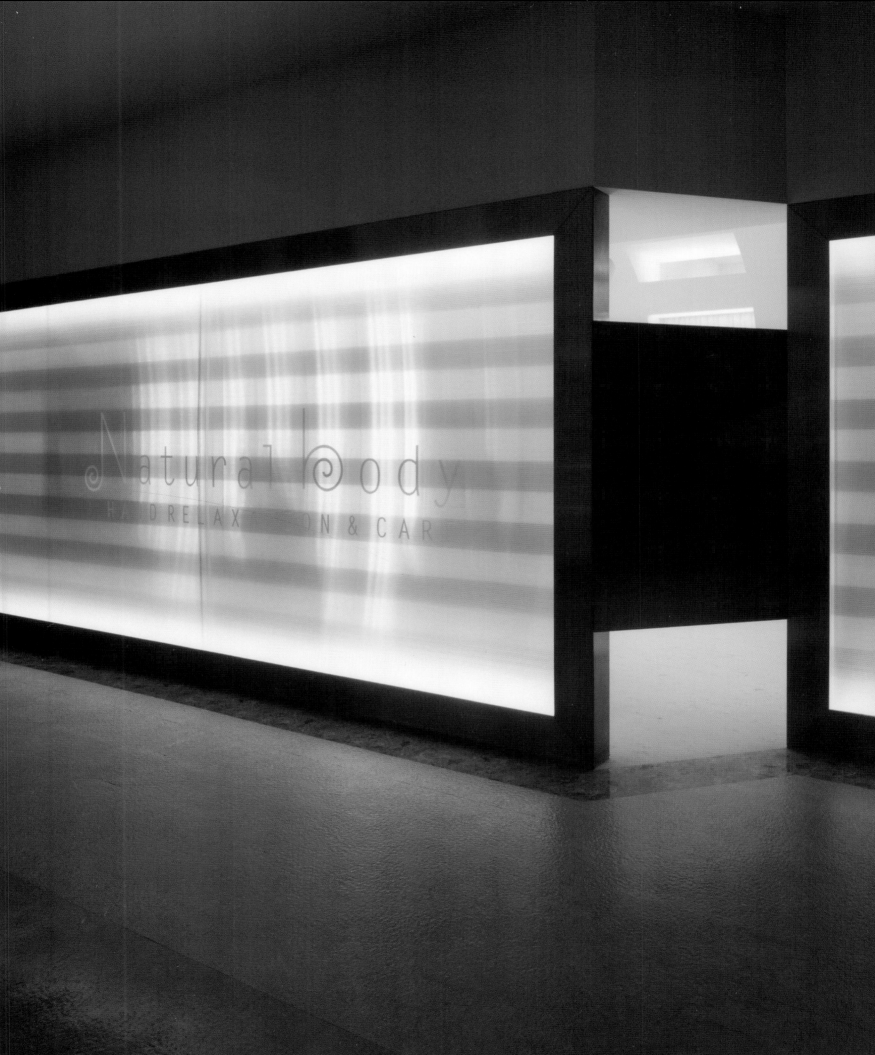

Queen Mary University of London

Design: **Bruce McLean, Alsop Design** Photography: **© Morley von Sternberg** Location: **London, UK**

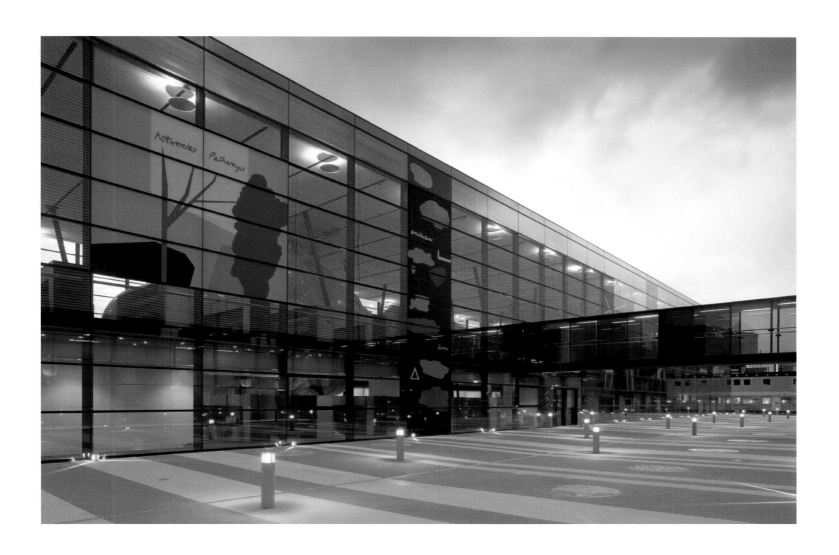

Queen Mary University, situated on the Whitechapel campus, has been converted into one of the first medical facilities with an eye-catching graphic and architectural identity, which marks a new understanding of the field of research. Dominating the façade are two murals inspired by molecular science, characterized by their striking chromatics, work of the artist Bruce McLean.

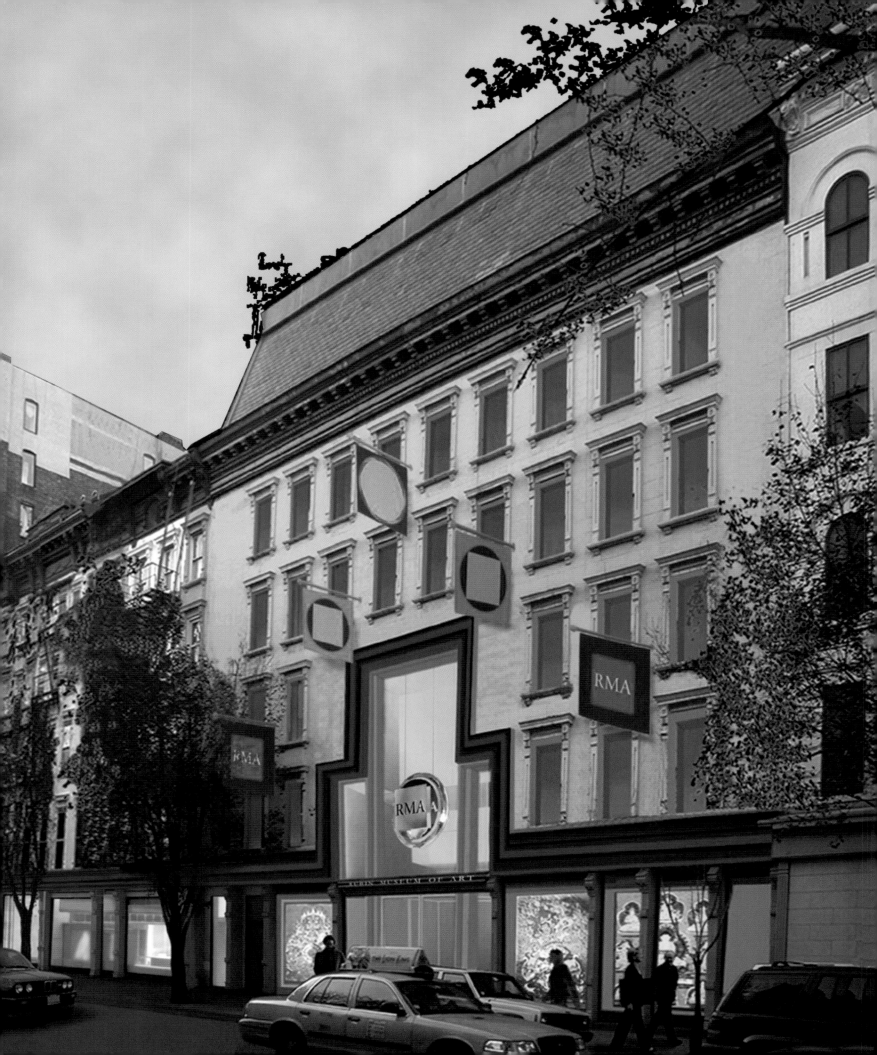

Design: **Milton Glaser** Photography: © **Matthew Klein** Location: **New York, USA**

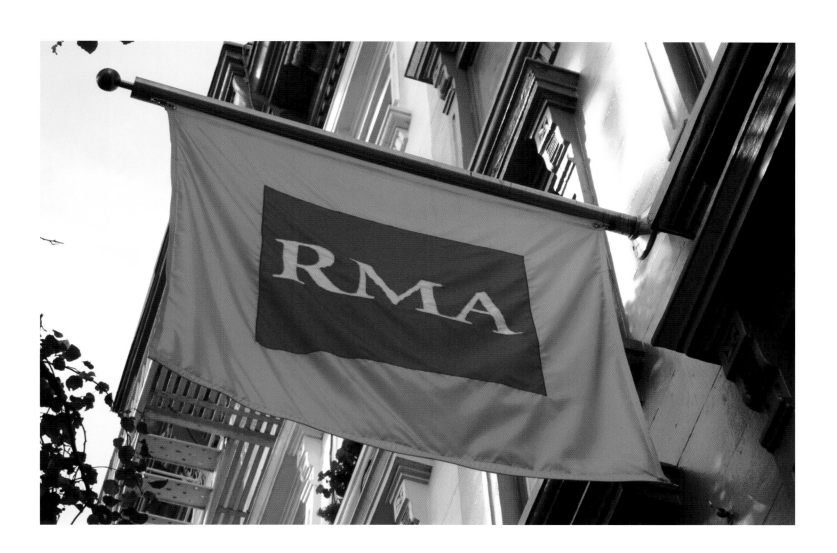

Milton Glaser was responsible for the concept of visual communication for the Rubin Museum of Art. The work began with the exhibition "Mandala," from whence arose the idea of the square inside the circle as a visual resource. Afterward, the logo was deconstructed and applied to the exterior banners. One of the greatest challenges was the creation of the mural on the wall of the entrance, representing the clouds as they are conceived in Tibetan art.

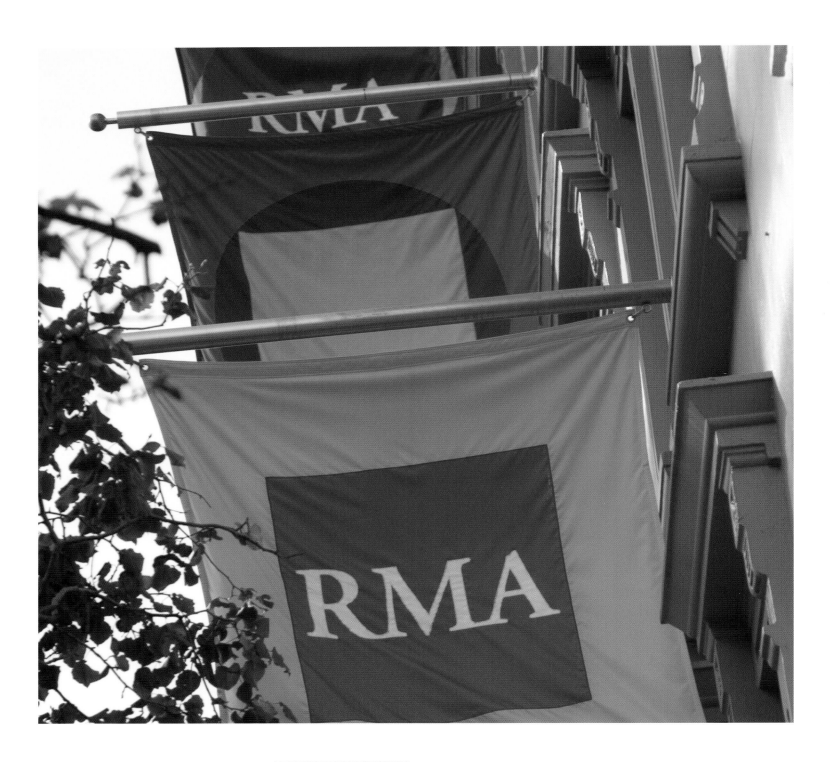

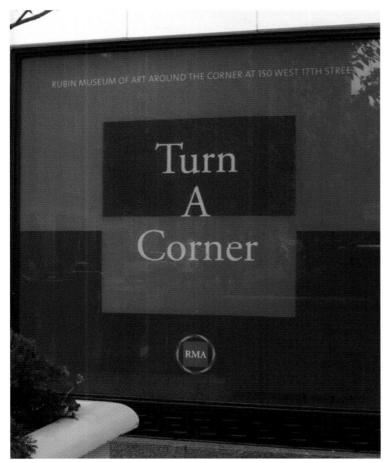

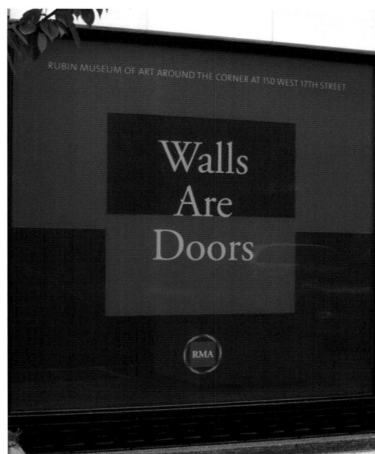

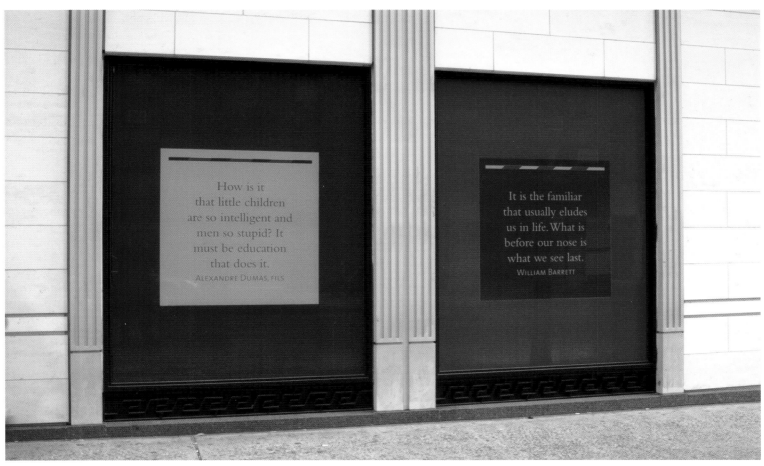

POWER FLOWER
MASAMICHI UDAGAWA AND SIGI MOESLINGER
ANTENNA DESIGN NEW YORK

PRESENTED BY

THE ART OF PURE PLEASURE

Only @ Bloomingdale's

Power Flower

Design: **Antenna Design** Photography: © Ryuzo Masunaga, Antenna Design Location: New York, USA

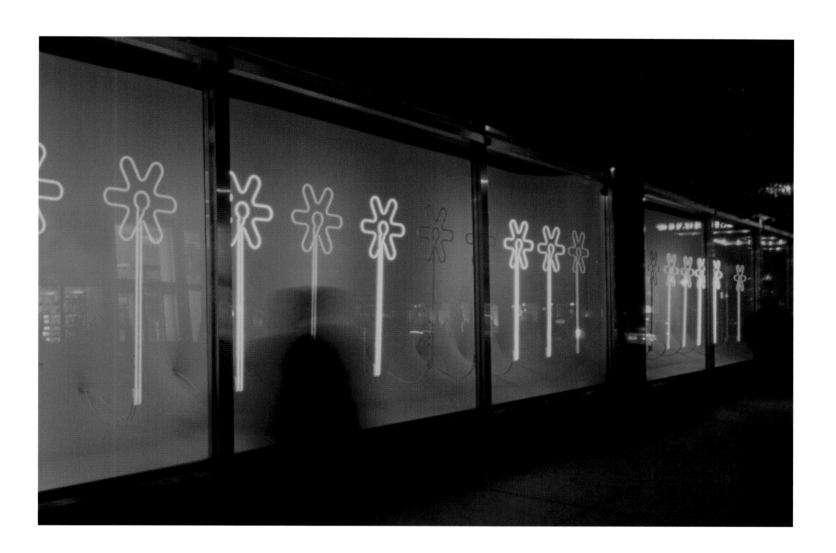

This interactive installation from Masamichi Udagawa and Sigi Moeslinger in the window of Bloomingdale's of New York forms part of an initiative promoted by Häagen-Dazs after the terrorist attacks of 9/11. For three weeks, the windows of Lexington Avenue exhibited these sculptures of neon flowers, which, thanks to movement sensors, lit up when in close proximity to passersby, adding to the atmosphere with background music.

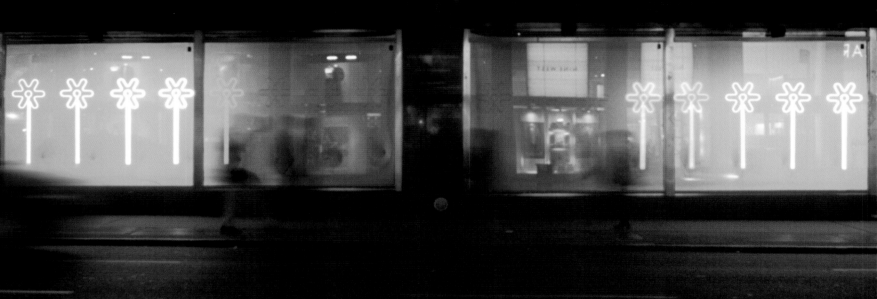

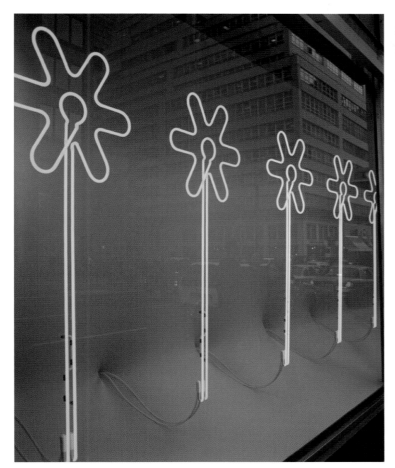

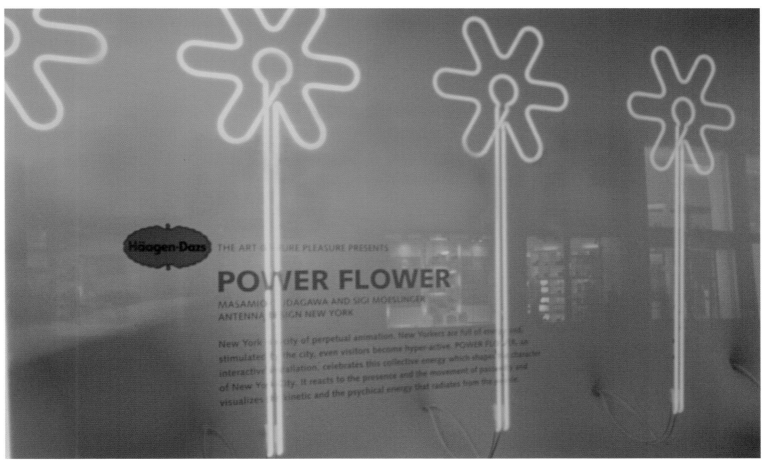

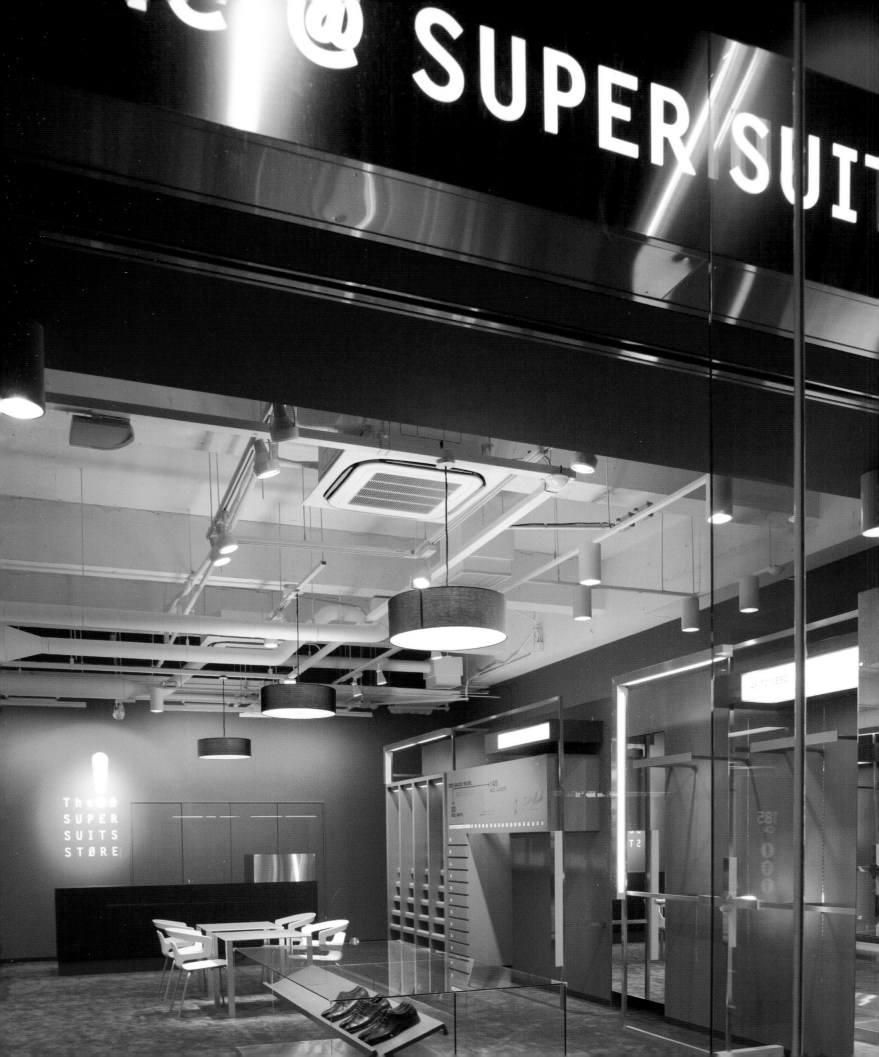

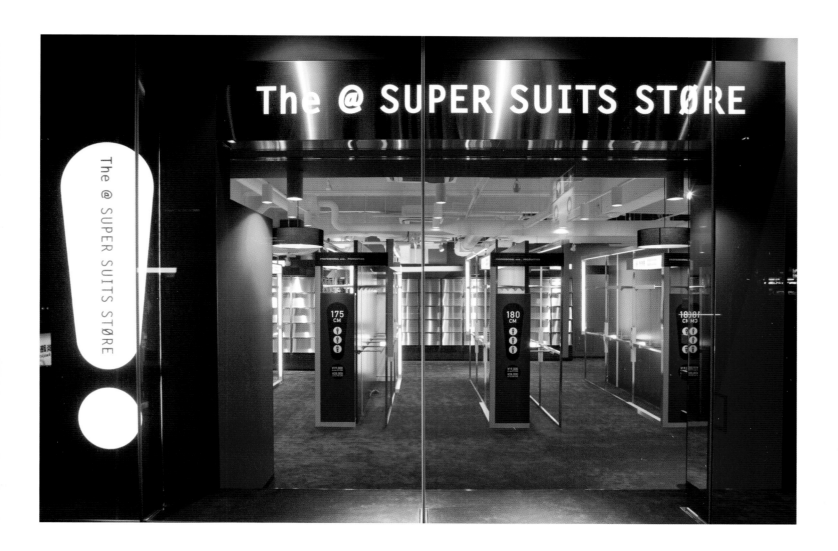

The @ SUPER SUITS STØRE

The graphics of The Super Suits Store revolutionized the Japanese market from the moment it appeared. The label changed its traditional corporate color, based on whites moderated by spaces, for red as the predominant tone. One of the techniques of this label to attract attention is the use of graphic resources, like the exclamation point that always carries with it a message of interest for the consumer.

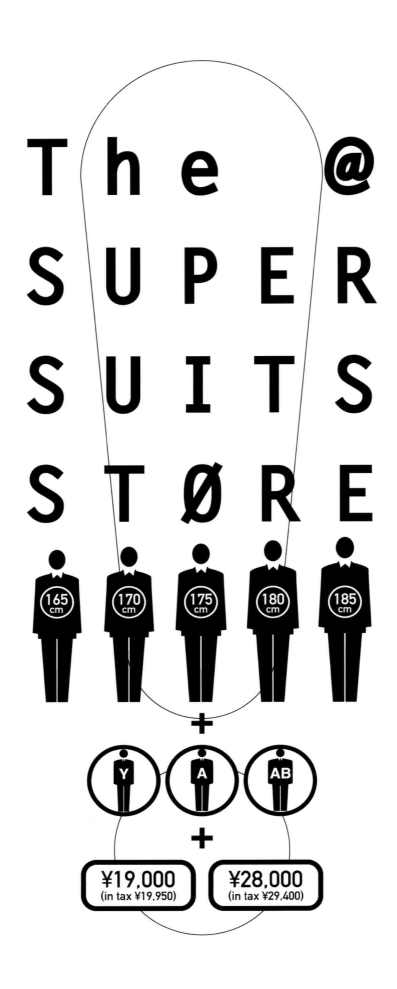

165 CM
Y
A
AB

¥19,000 (in tax ¥19,950)
¥28,000 (in tax ¥29,400)

170 CM
Y
A
AB

¥19,000 (in tax ¥19,950)
¥28,000 (in tax ¥29,400)

175 CM
Y
A
AB

¥19,000 (in tax ¥19,950)
¥28,000 (in tax ¥29,400)

180 CM
Y
A
AB

¥19,000 (in tax ¥19,950)
¥28,000 (in tax ¥29,400)

185 CM
Y
A
AB

¥19,000 (in tax ¥19,950)
¥28,000 (in tax ¥29,400)

(165CM) Y A AB — ¥19,000 (in tax ¥19,950)
¥28,000 (in tax ¥29,400)

(170CM) Y A AB — ¥19,000 (in tax ¥19,950)
¥28,000 (in tax ¥29,400)

(175CM) Y A AB — ¥19,000 (in tax ¥19,950)
¥28,000 (in tax ¥29,400)

(180CM) Y A AB — ¥19,000 (in tax ¥19,950)
¥28,000 (in tax ¥29,400)

(185CM) Y A AB — ¥19,000 (in tax ¥19,950)
¥28,000 (in tax ¥29,400)

SHIRT (38)(39)(40)(41)(42)(43) REGULAR & LONG SLEEVE — ¥2,900 (in tax ¥3,045)
¥3,800 (in tax ¥3,990)

NECK-TIE — ¥2,800 (in tax ¥2,940)
¥3,800 (in tax ¥3,990)

The @ SUPER SUITS STØRE

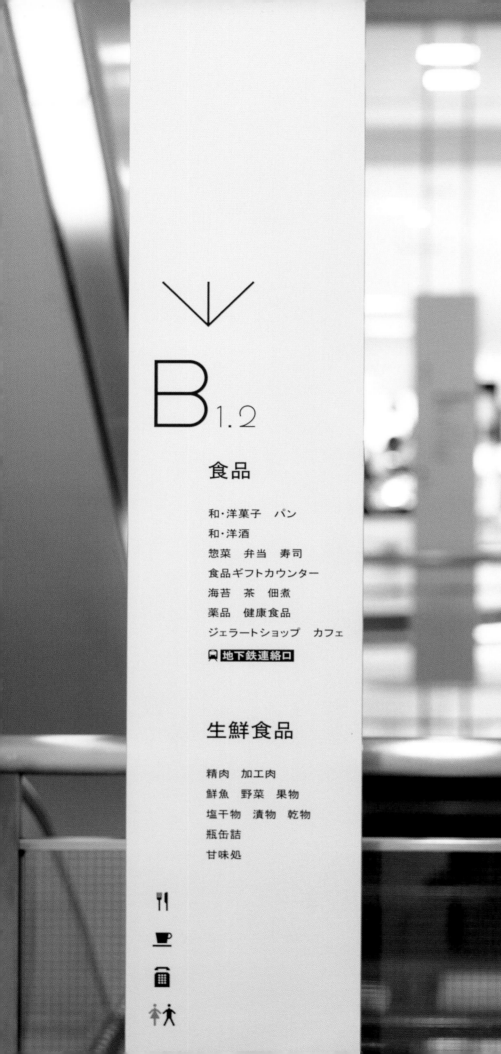

↓

B1.2

食品

和・洋菓子　パン
和・洋酒
惣菜　弁当　寿司
食品ギフトカウンター
海苔　茶　佃煮
薬品　健康食品
ジェラートショップ　カフェ

🚃 地下鉄連絡口

生鮮食品

精肉　加工肉
鮮魚　野菜　果物
塩干物　漬物　乾物
瓶缶詰
甘味処

↑

2

婦人服│ヤング

ヤングファッション
化粧雑貨
リタズダイアリー
フット＆ネイルケア
カフェ＆レストラン

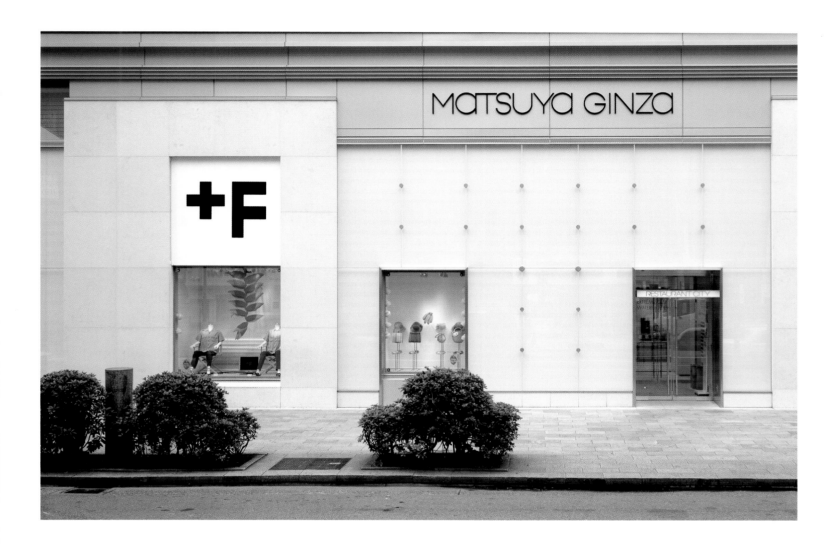

Matsuya Ginza

During the renovation of the Matsuya shop building in Ginza, Kenya Hara's team came up with an enormous canvas that would cover the entire front façade of the building. The proposal was based on enormous zips that opened as the remodeling of the interior evolved. The canvas became a conceptual model of the corporate image, as it represents Matsuya Ginza's idea of renovation.

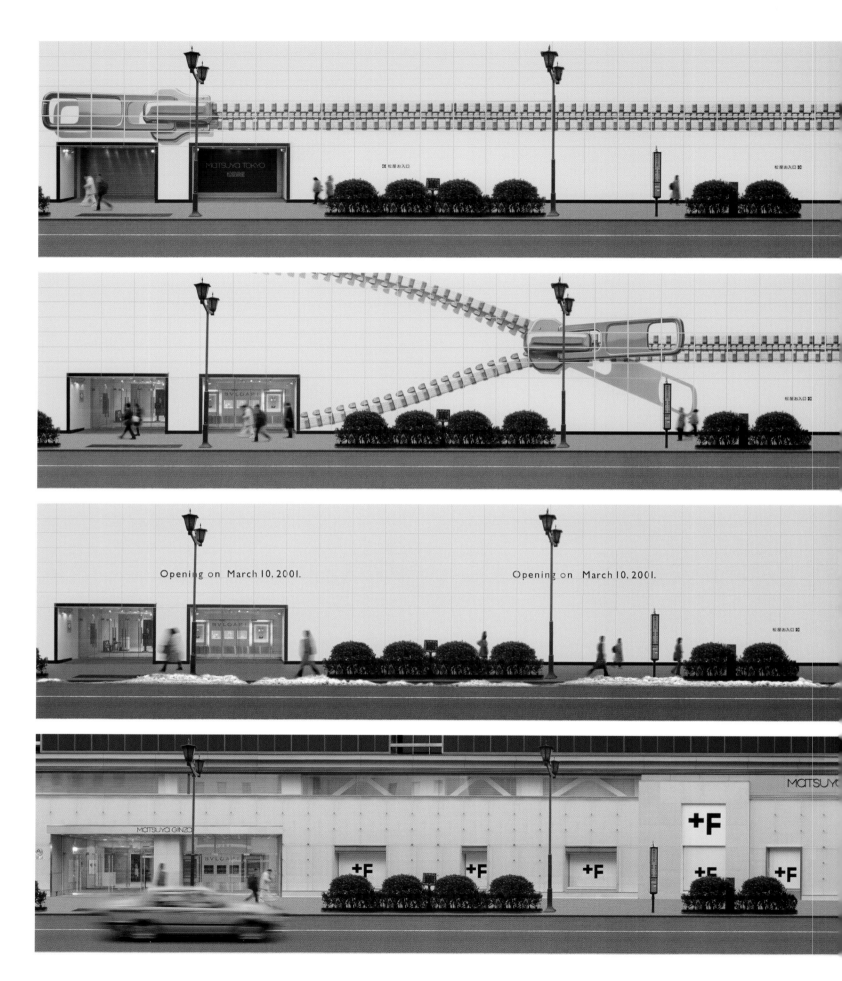

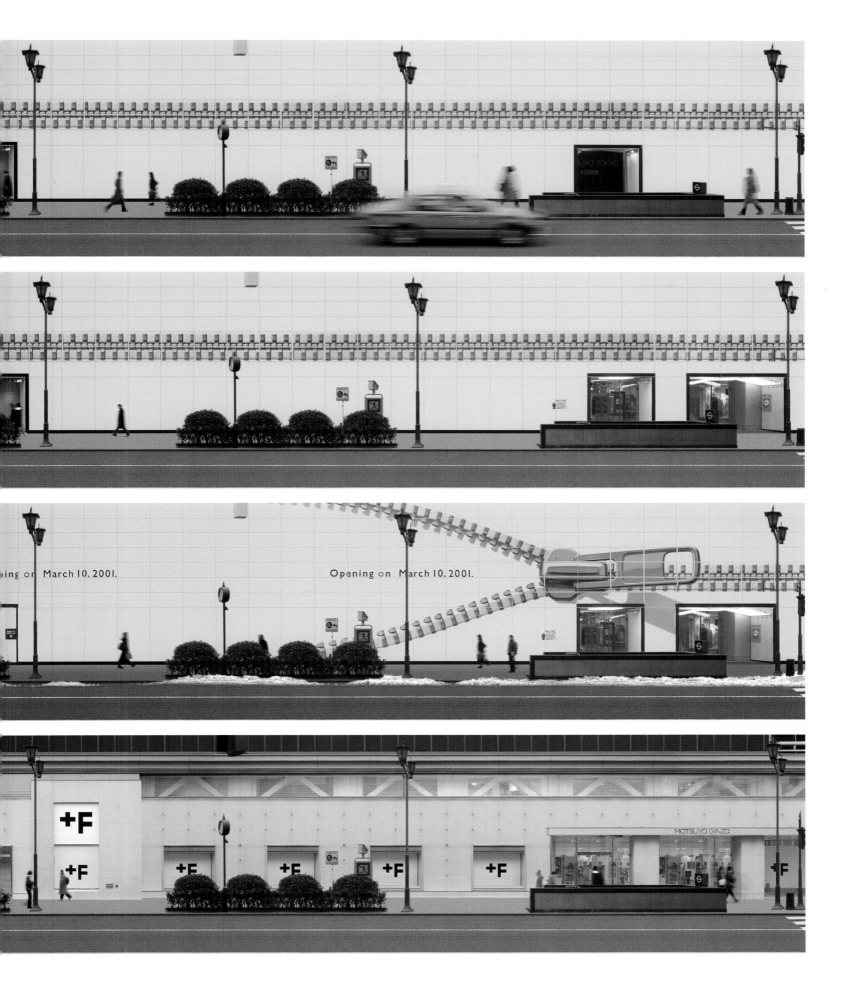

11|restaurant_bar_club

Situated on the eleventh floor of the former TPG Post building next to the Central Station in Amsterdam, 11 is not only a club, bar, and restaurant, but also a cultural platform. The initiators of 11 approached 178 Aardige Ontwerpers with an extensive commission to develop an innovative, creative, and pure identity reflecting 11's artisitic objectives. The identity is not determined by static and concrete rules, but the great diversity of media presentations in the corporate identity are interpreted in a loose and dynamic manner.

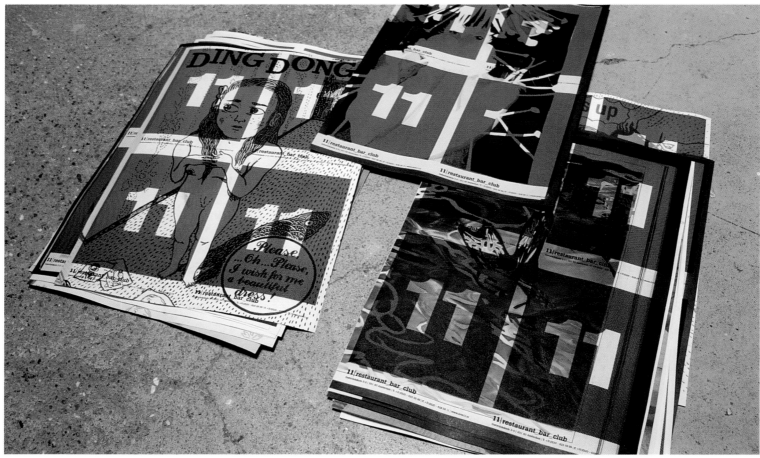

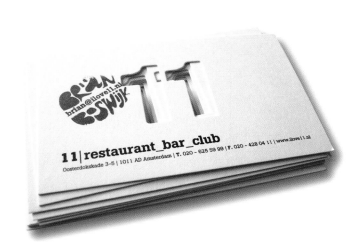

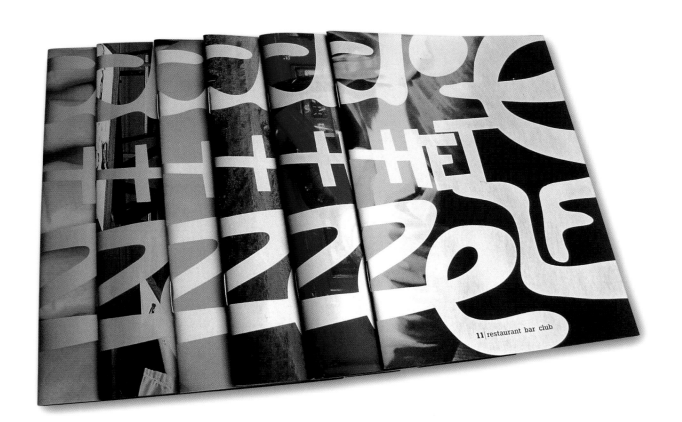

2

Interior Graphics

Although the logo is one of the pillars that sustain the graphic image of any corporation, other graphic elements predominate on the scenario as well, helping to increase the conceptual sense of the whole. Photographs, murals, posters, digital screens, and signs are all components associated with a company's image that help to consolidate its perception. There are many spaces that wisely invest their time developing these complementary graphic elements to give strength to the image. This stage forms part of the maturing process of the graphic concept and explores the possibilities to play with and adapt different media. Included in this chapter are some examples that work with the versatility of their graphics, such as museums, restaurants, sports centers, airports, offices, and ephemeral exhibitions, in which the key to communication resides in the image of the whole.

ENJOY IXXY'S BAGELS ANYWHERE, ANYTIME, ANYHOW

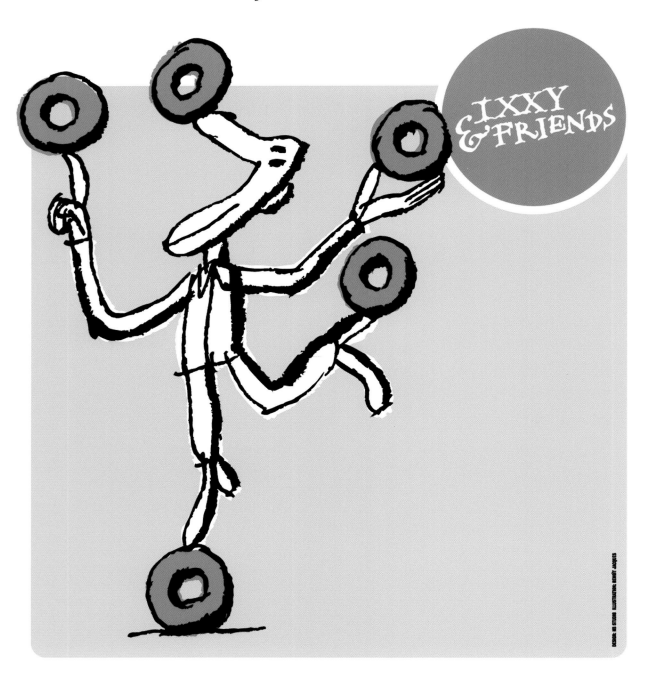

Ixxy's Restaurant

Design: **NB Studio, DAAM** Photography: **© Richard Glover** Location: **London, UK**

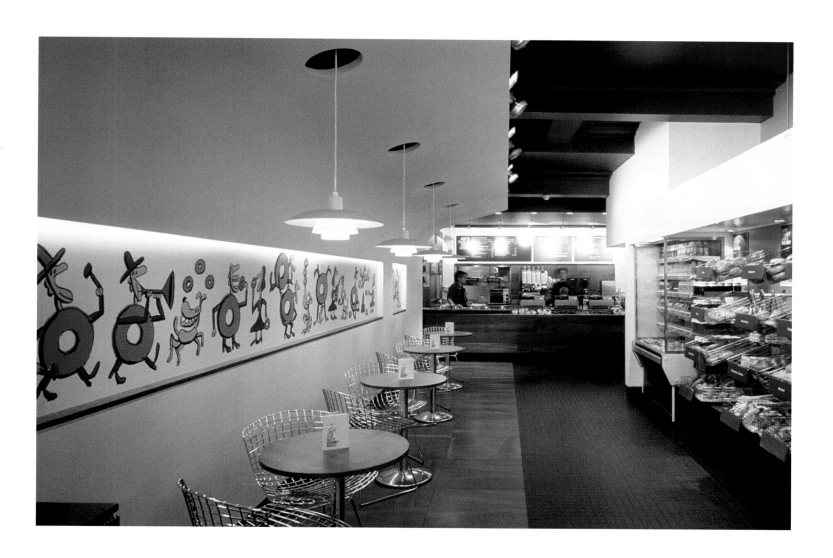

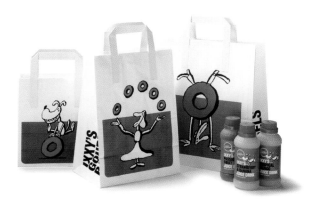

NB Studio designed the graphic identity of this informal restaurant for bagel lovers. The reoccurring composition of the elements and the striking chromatics reflect the spirit of Ixxy. NB Studio also designed the graphics of the exterior signboard, the menu, and the stationery, as well as the presentation posters, which reinforce the carefree and authentic character of the restaurant.

KUTLUG ATAMAN
MARGARET BARRON
DAVID BATCHELOR
GILLIAN CARNEGIE
NATHAN COLEY
DAVID CUNNINGHAM
DEXTER DALWOOD
IAN DAVENPORT
RICHARD DEACON
PETER DOIG

Tate Gallery, Days Like These

Design: **NB Studio** Photography: **© Nick Turner** Location: **London, UK**

KUTLUG ATAMAN
MARGARET BARRON
DAVID BATCHELOR
GILLIAN CARNEGIE
NATHAN COLEY
DAVID CUNNINGHAM
DEXTER DALWOOD
IAN DAVENPORT
RICHARD DEACON
PETER DOIG

The title "Days Like These" hides an exhibition of contemporary art, exhibited in the Tate Gallery in London, that displays the work of 23 young British artists. NB Studio designed the graphic image of the exhibition putting their creative stamp on the signage. The result was a striking graphic of colors that can be applied in different formats.

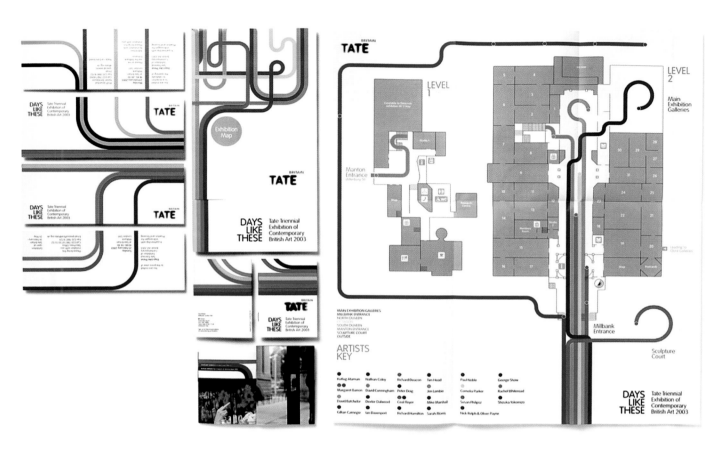

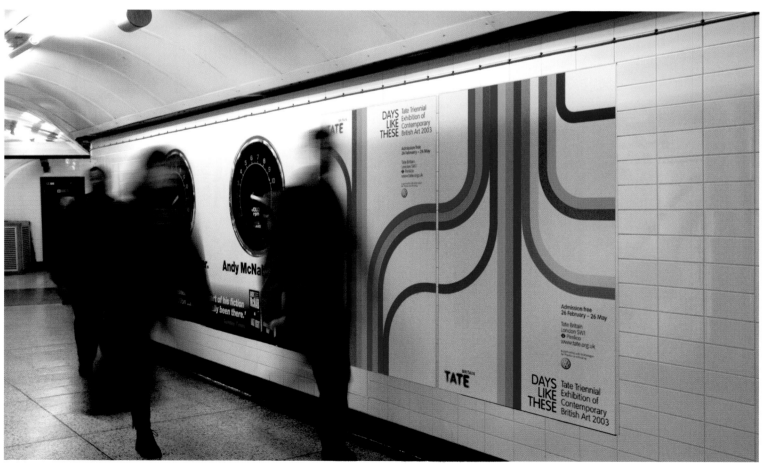

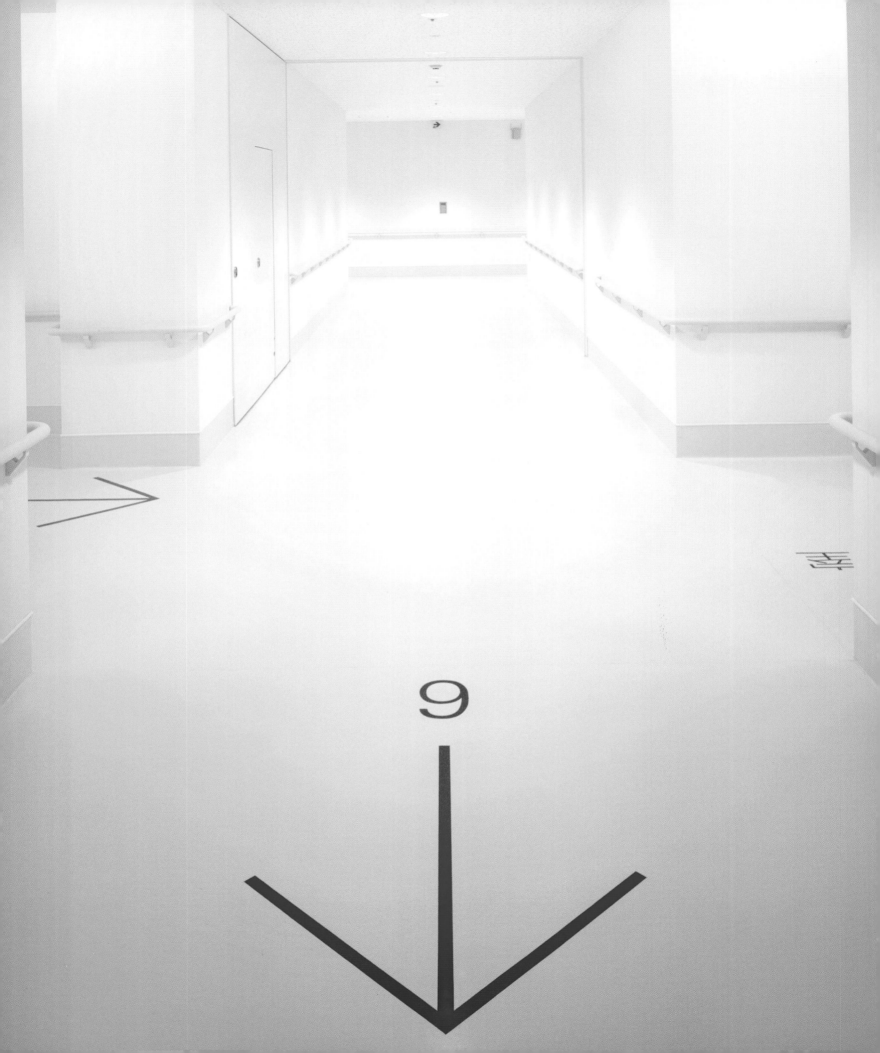

Katta Civic Polyclinic Signage System

Design: **Kenya Hara/Hara Design Institute** Photography: © **Kenichi Morisaki** Location: **Tokyo, Japan**

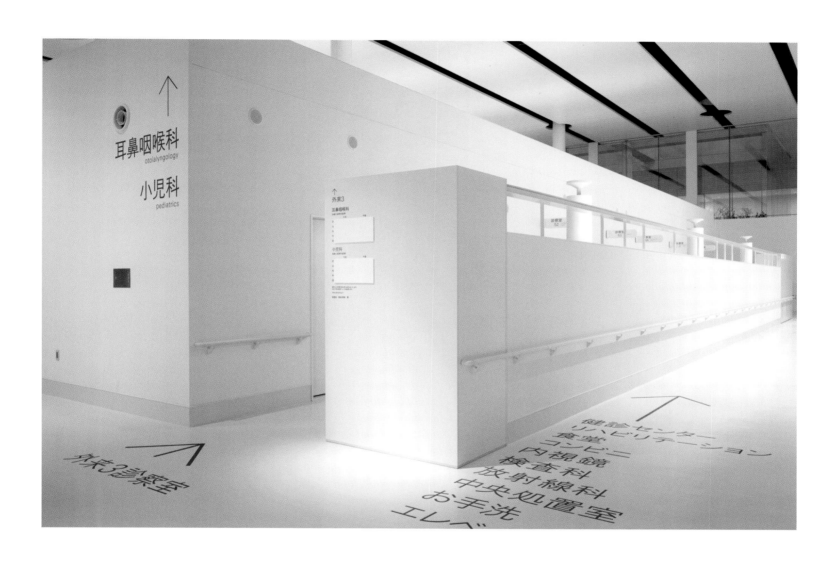

The signing system of this space is characterized by a clear visual interpretation of Chinese characters applied to the walls and floor. The space, totally white, allows the visual art to stand out from the neutral background. One of the main objectives was for the characters applied to the floor not to be erased by the friction of passing feet. The symbol of the red cross seen on one of the walls represents the building's main intersection.

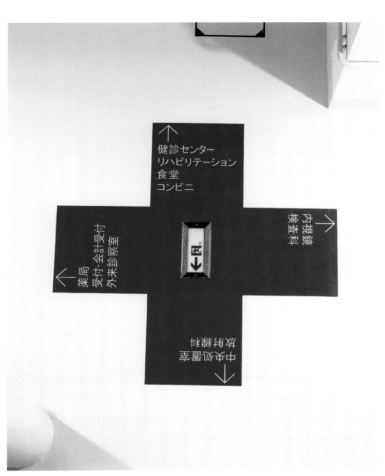

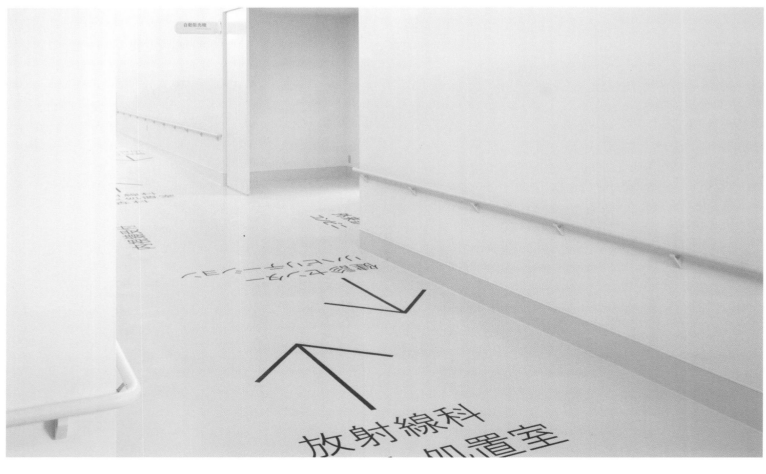

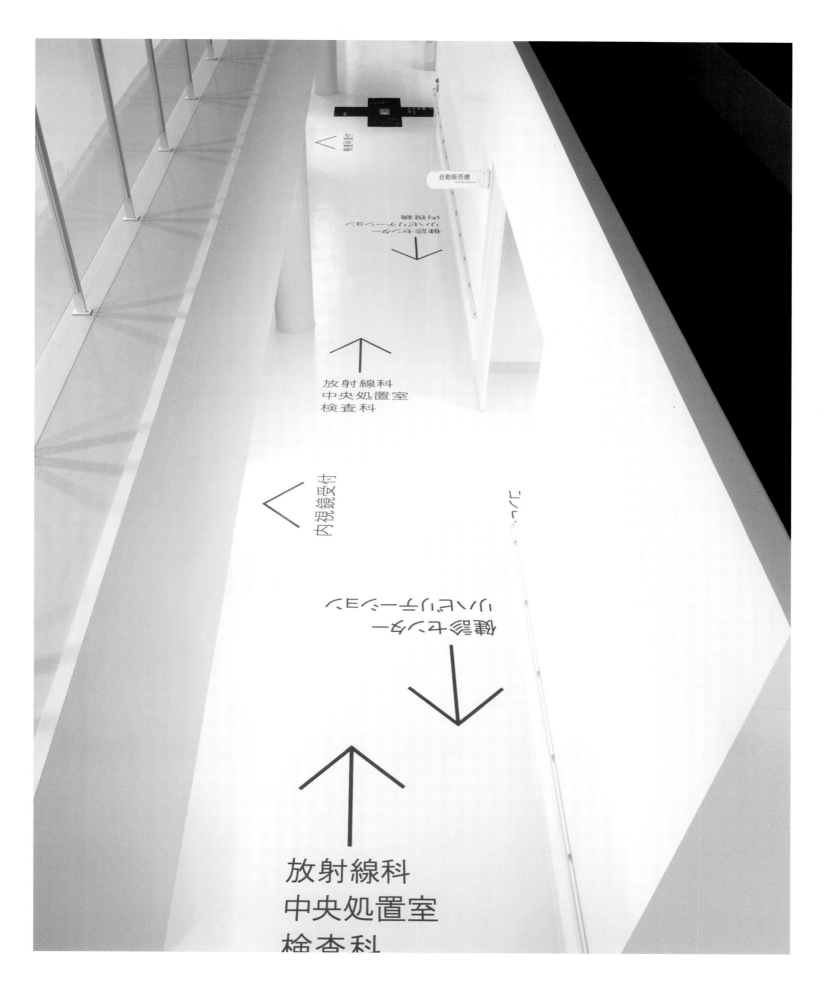

放射線科
中央処置室
検査科

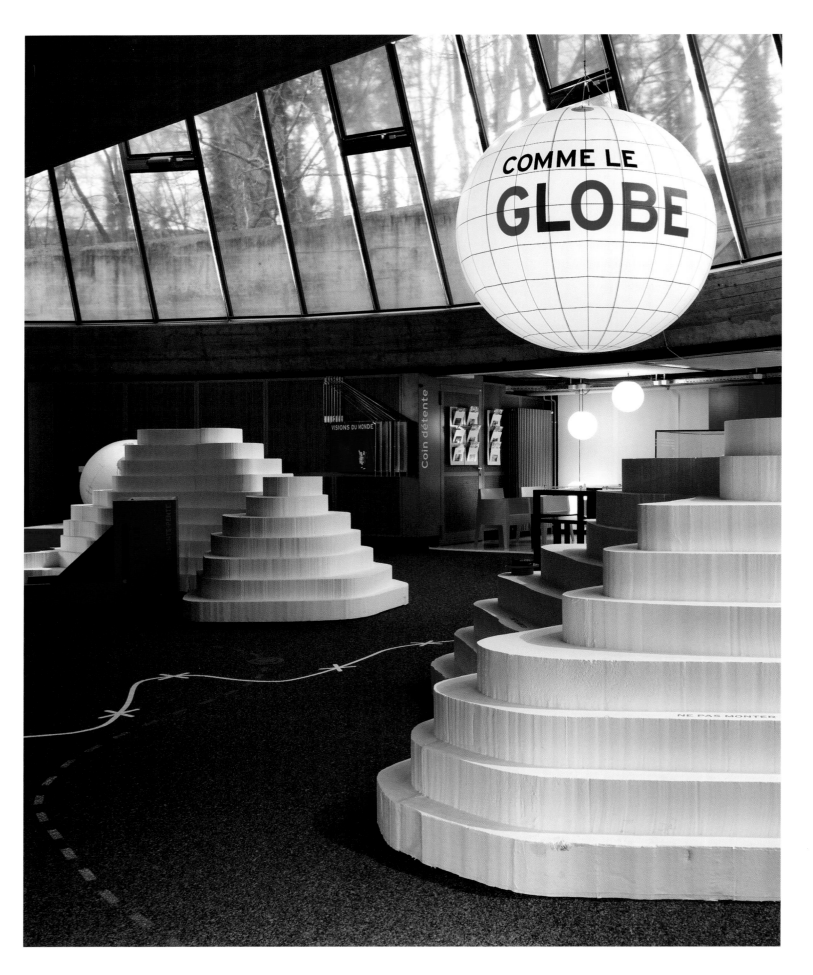

Espace des Inventions

Design: **Giorgio Pesce/Atelier Poisson** Photography: **© Thierry Zufferey** Location: **Lausanne, Switzerland**

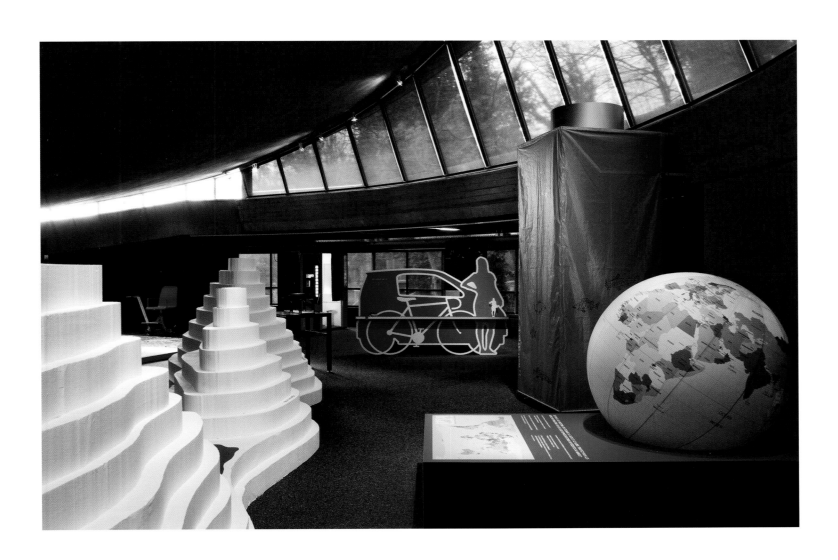

Atelier Poisson designed the logo, the graphic identity, and the signing for this children's space of scientific discovery. The logo is a robot traveling through space showing scientific problems. The interior signing is based on the planets, and the stationery uses recurring elements with vivid colors. The entry tickets take the surprising form of robot claws, a curious "gadget" that appeals to those who visit this interesting museum.

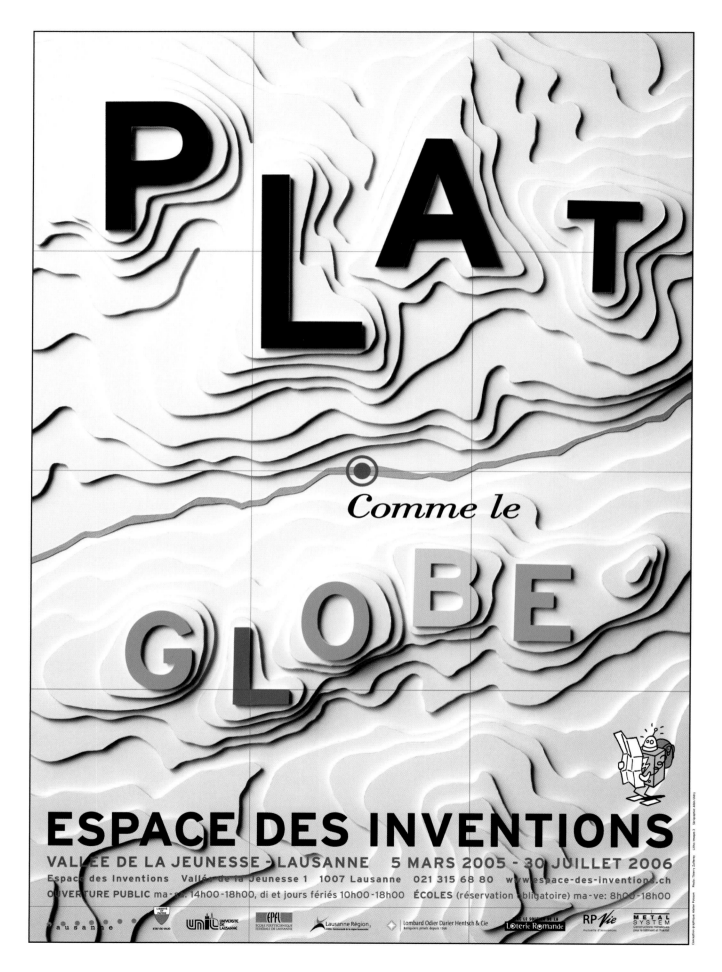

106

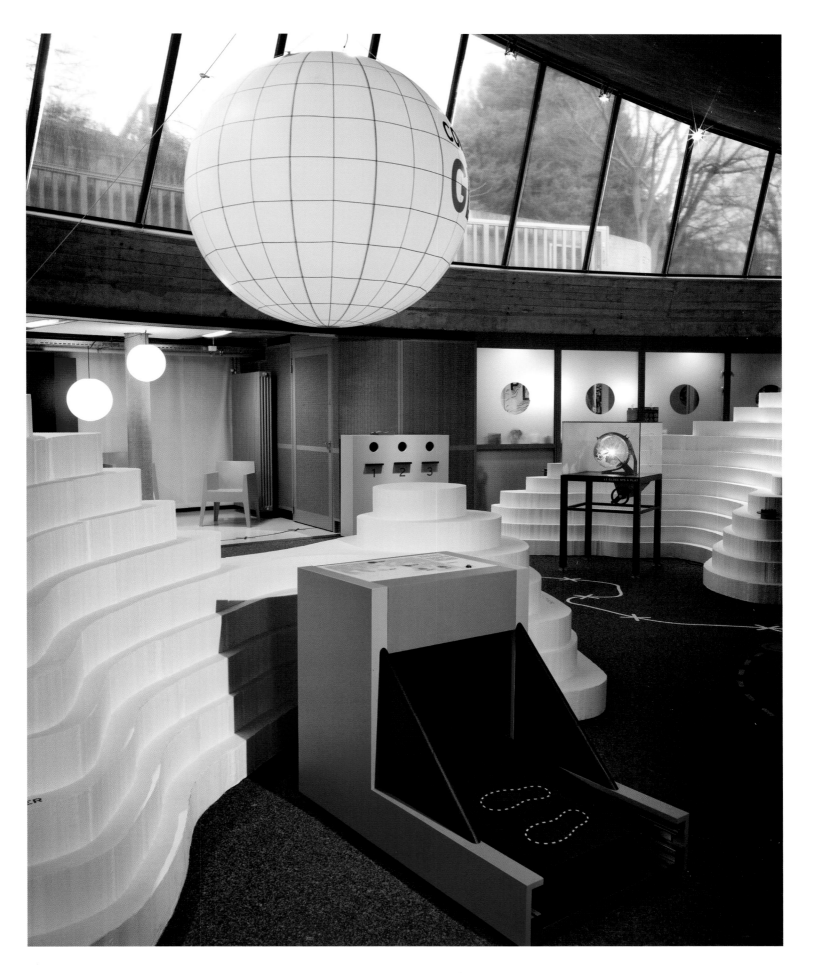

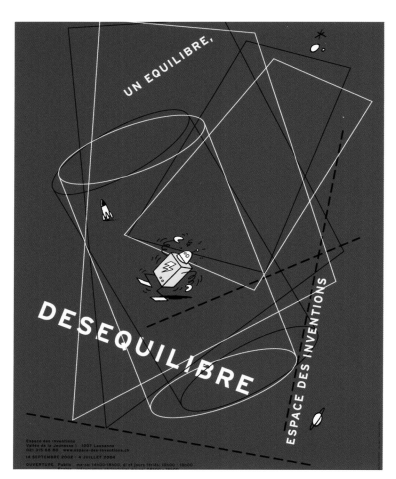

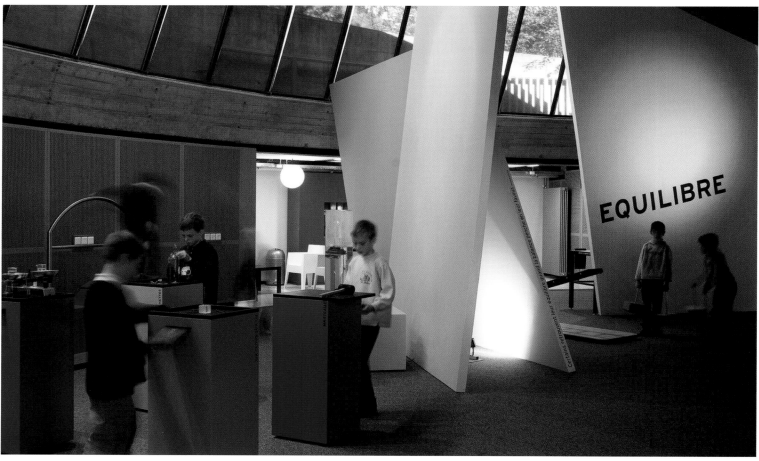

108

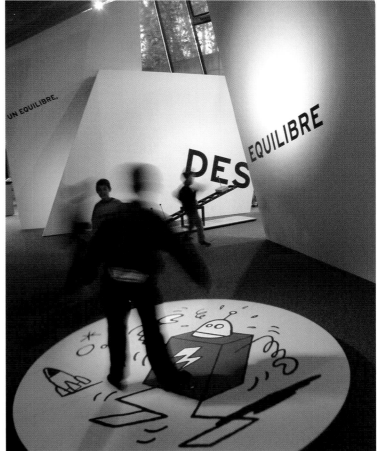

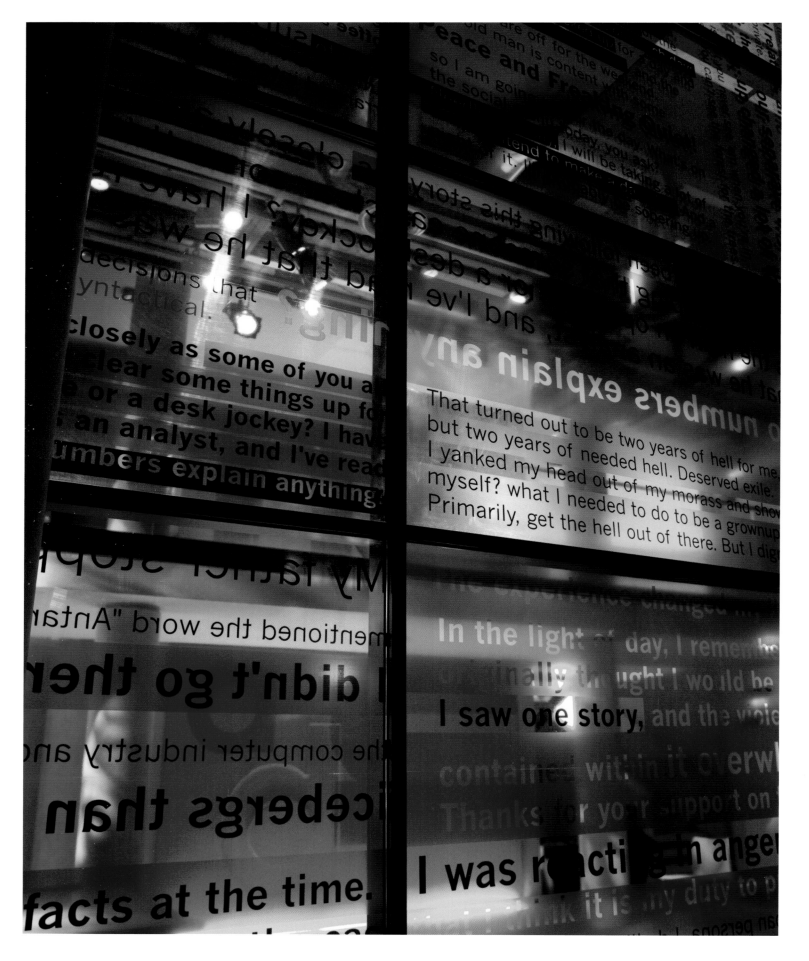

Dana Centre

Design: **Lippa Pearce Design** Photography: © **Richard Foster** Location: **London, UK**

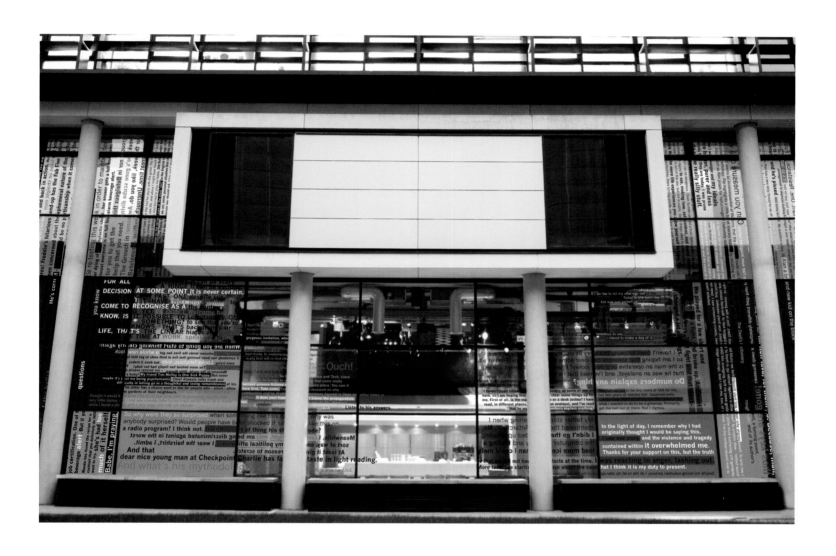

Lippa Pearce designed the identity (interior and exterior graphics and signing) of the Dana Centre, the latest addition to the London Science Museum. The proposal reflects a center where the public maintains a constant dialogue with the latest advances in contemporary science. The result is a building with an almost tactile identity based on the concept of language as signs.

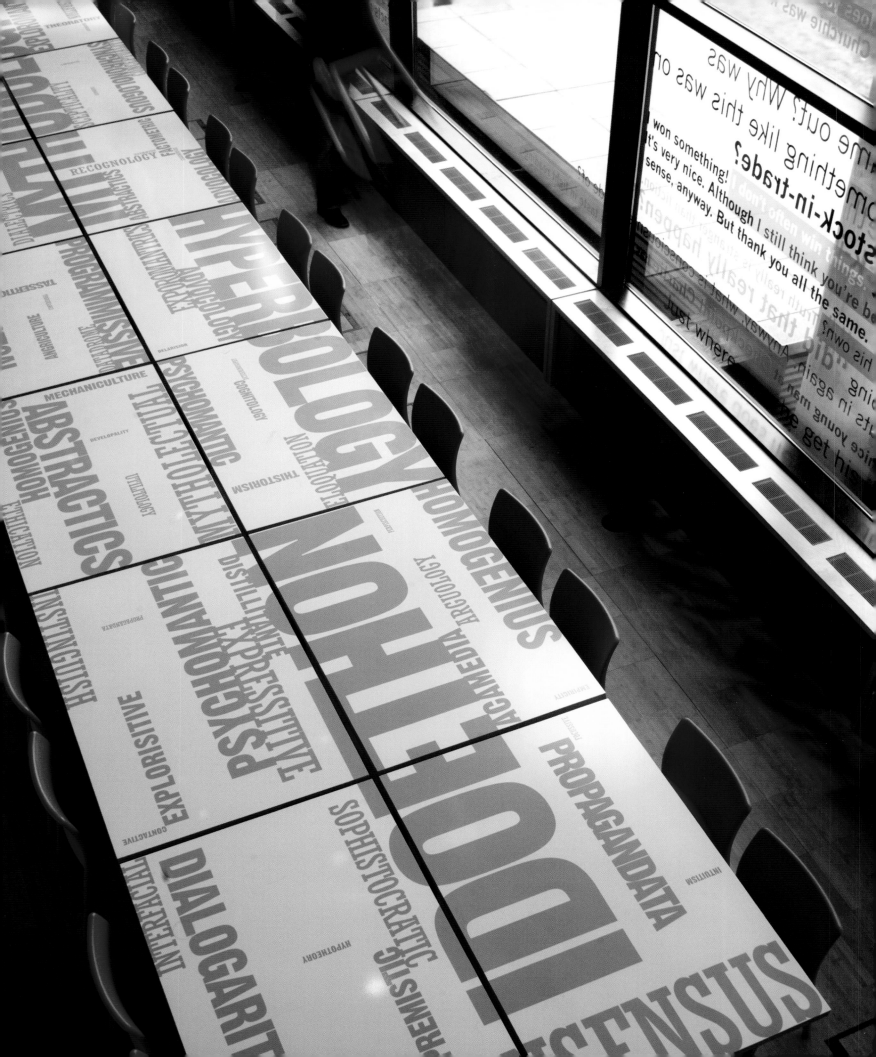

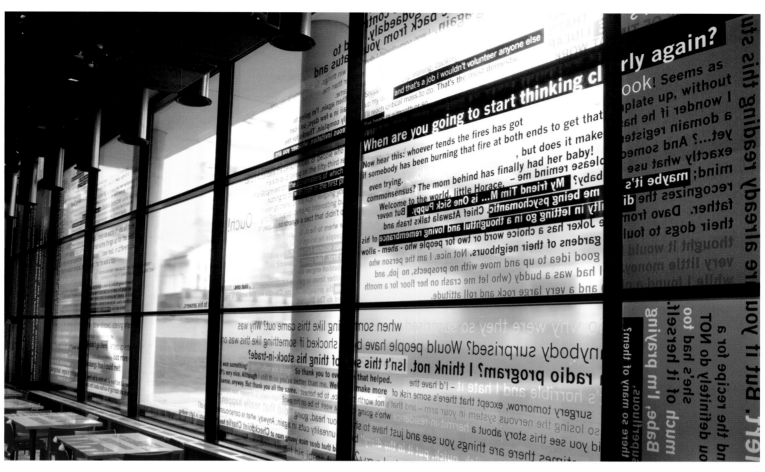

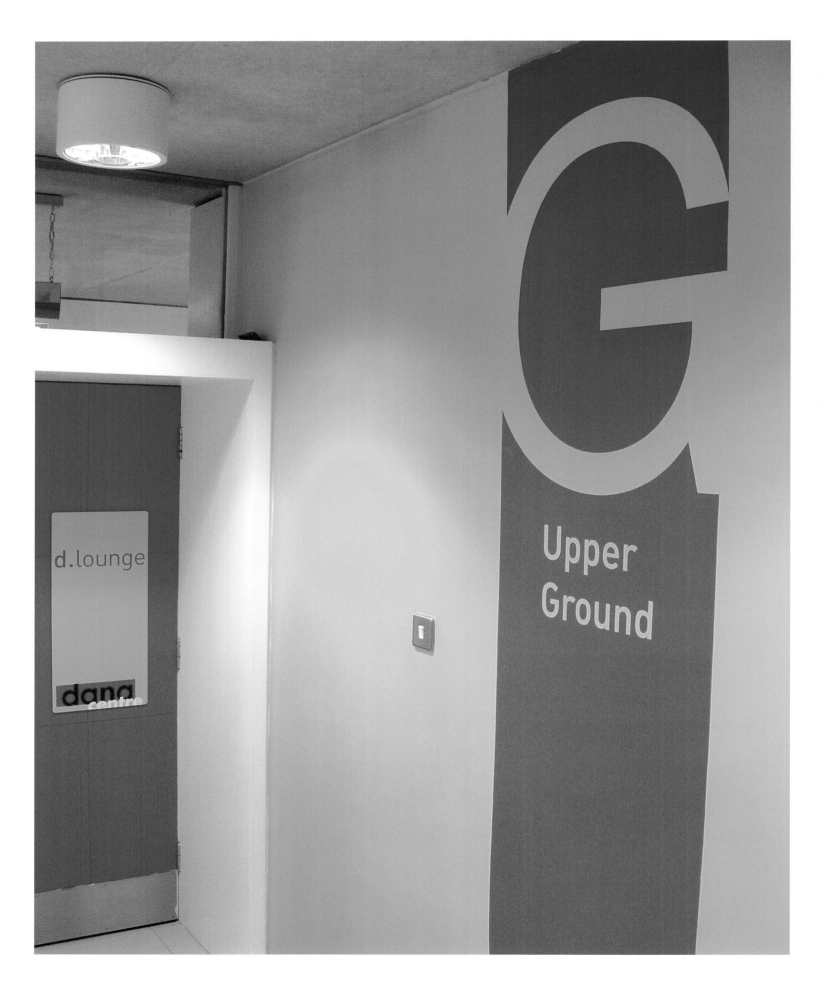

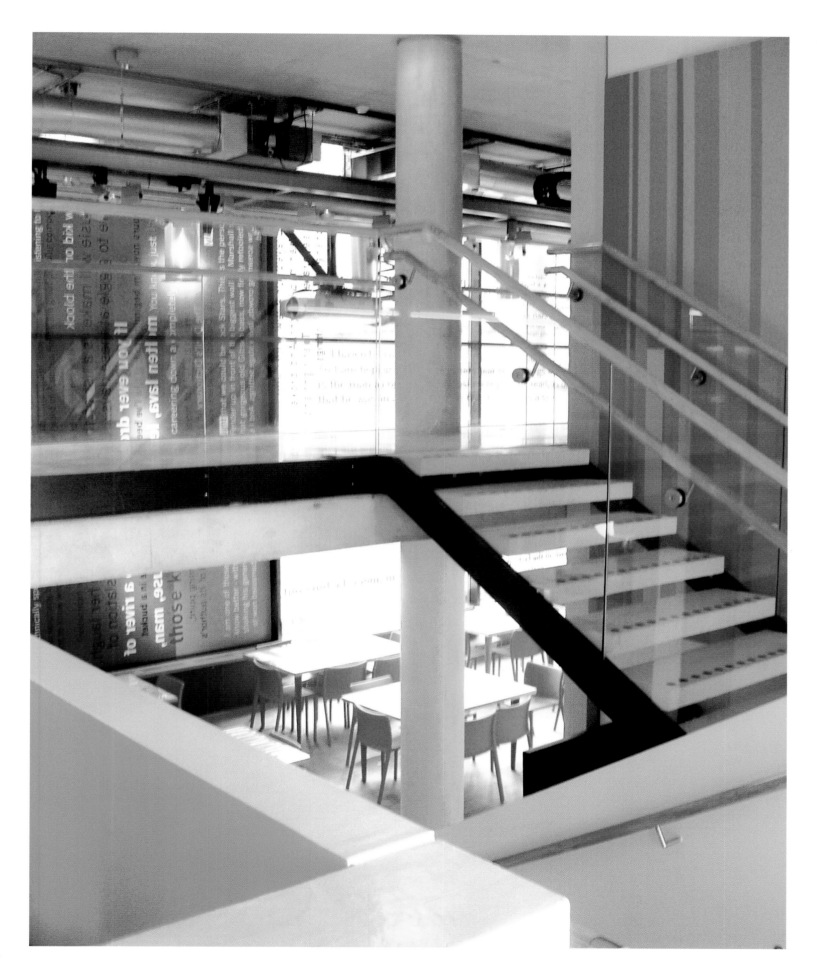

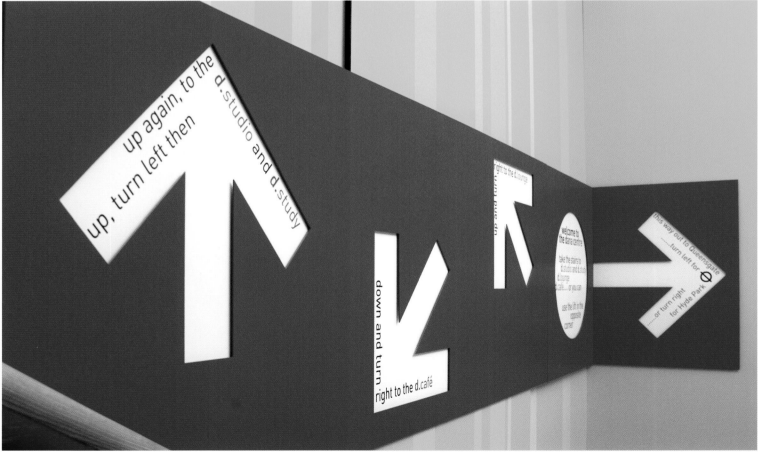

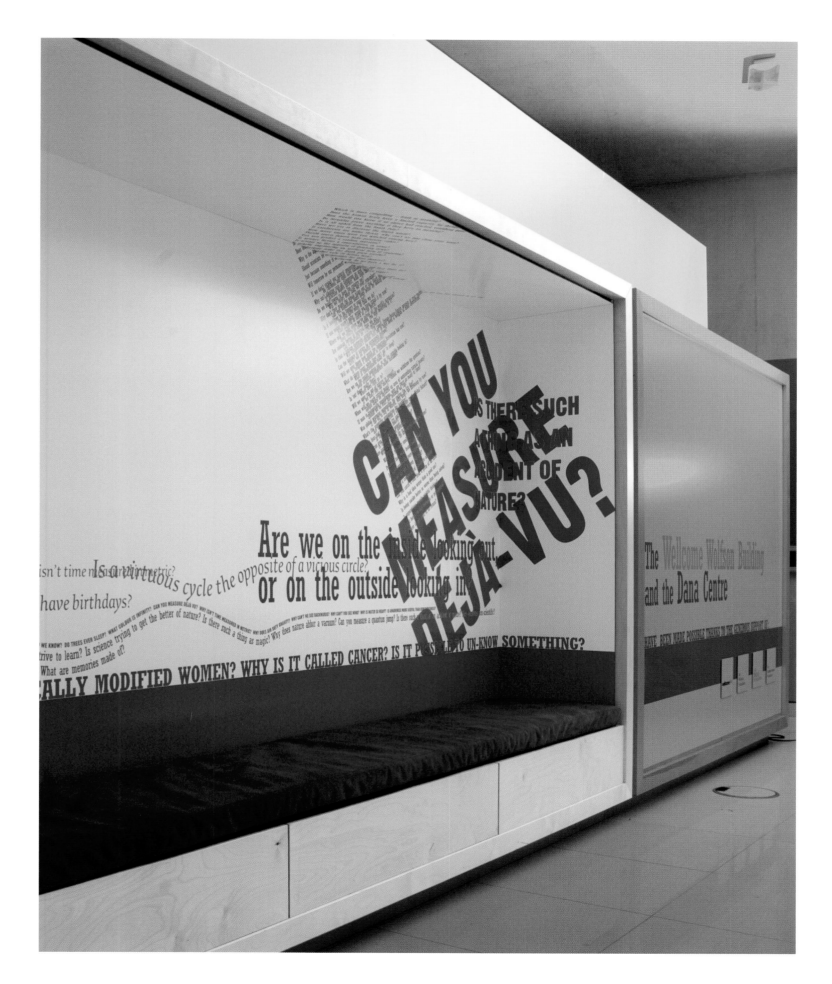

INVITATION

Chère Madame, cher Monsieur,

Avec l'ouverture de la Manufacture, Haute école de théâtre de Suisse romande (HETSR), un grand projet, réunissant les énergies de tous les cantons francophones et bilingues, vient de prendre chair. Implantée dans une ancienne usine de taille de pierres précieuses à Lausanne-Malley, la Manufacture accueille depuis fin septembre sa première volée. Ni théâtre prêt à fonctionner, ni école pour débutants, mais atelier d'expériences pour artistes en formation, ce laboratoire théâtral s'ouvre par ailleurs ponctuellement au public.

Afin de fêter le début de cette aventure tant attendue, nous vous convions à l'inauguration officielle de la Manufacture, Haute école de théâtre de Suisse romande,

LE VENDREDI 28 NOVEMBRE 2003 DÈS 17H00

Vous trouverez ci-contre le programme détaillé de cette soirée festive et conviviale par laquelle nous souhaitons vous faire partager notre joie liée à l'aboutissement de ce projet ambitieux et remercier celles et ceux qui l'ont soutenu.

Dans l'attente d'avoir le plaisir de vous rencontrer, chère Madame, cher Monsieur, recevez nos cordiales salutations.

Jean Guinand
Président du Conseil de la fondation HETSR

Yves Beaunesne
Directeur de la Manufacture

P.S.: POUR IMMORTALISER VOTRE VENUE ET MARQUER VOTRE IMPLICATION, NOUS VOUS SERIONS RECONNAISSANTS DE NOUS LÉGUER UN LIVRE CHOISI POUR LA CIRCONSTANCE ET DÉDICACÉ DE VOTRE PLUME, POUR ÉQUIPER NOTRE BIBLIOTHÈQUE.
UNE SORTE DE «CADEAU DE PREMIÈRE»...

« Jouer n'est pas un jeu. »

« L'école n'est pas l'antichambre du théâtre, mais le lieu de sa source. »

Haute école de théâtre de Suisse romande
sortie autoroute Lausanne-Malley / plan d'accès sur le site

Rue Grand-Pré 5 CP 160 T +41 021 620 08 80
CH-1000 Lausanne 16 F +41 021 620 08 89
I www.hetsr.ch E hetsr@hetsr.ch

« L'école est un théâtre, libéré des comparaisons et des opinions dominantes, ouvert sur le monde, un lieu d'apprentissage et de laboratoire pour une troupe de service public. »

« Qu'est-ce que le théâtre ? Des restes d'arbres avec des restes de feu et d'orage. Tout est vrai. Tout est faux. Rien ne doit être vanité. »

INAUGURATION

« Le théâtre est un conflit entre l'élégance et la mode. La mode est le chemin de la soumission, l'élégance, celui de l'impudence. »

PROGRAMME

17h00
Cérémonie d'inauguration officielle de la Manufacture, Haute école de théâtre de Suisse romande.
Allocutions de
Monsieur Jean Guinand, ancien conseiller d'état et président du conseil de fondation HETSR
Monsieur Yves Beaunesne, directeur de la Manufacture
Monsieur Thierry Béguin, conseiller d'état (NE) et président de la CIIP
Madame Anne-Catherine Lyon, conseillère d'état (VD), chargée du DIP et des affaires culturelles
et
chants choraux interprétés par les élèves de la Manufacture, sous la direction de Michèle Millner.

18h30
Apéritif

« Il n'y a pas de meilleur apprentissage que celui qui aide à la construction de son désir. »

18h30-21h00
A la découverte de la Manufacture (visites non-stop). Laissez-vous guider au cœur du laboratoire théâtral par de brèves interventions des élèves liées à une série de photos choisies par Mario Del Curto, mises en mots et en scène par Antoine Jaccoud et Denis Maillefer. Un parcours initiatique...

19h30
Buffet dînatoire

21h00
Spectacle : en utilisant la même forme que son dernier spectacle «Les tribus modernes», la Compagnie de l'Œillade vous invite à l'occasion de cette inauguration à partager des souvenirs sur le thème de la première fois dans un spectacle intitulé «L'Occupation», liant la musique, le théâtre et l'image. Avec Lee Maddeford, Daniel Perrin, Roland Vouilloz, Yves Jenny et Bruno Deville.

22h30
Bal : en deuxième partie de soirée, des membres de l'Orchestre Jaune - Daniel Perrin, Christian Gavillet, Matthias Desmoulin, Luigi Galati et Karine Barbey - s'appliqueront à faire danser les moins joyeux...

carte réponse

A retourner jusqu'au 14 NOVEMBRE 2003 à la Manufacture, Haute école de théâtre de Suisse romande, Case postale 180, CH-1000 Lausanne 16 ou par courriel à hetsr@hetsr.ch

☐ J'assisterai à la Cérémonie officielle d'inauguration de la Manufacture à 17h00

☐ Je me joindrai au buffet dînatoire

☐ J'assisterai au spectacle «L'Occupation» à 21h00

☐ Je serai accompagné de..........................

☐ Je ne pourrai pas me joindre à vous

Prénom et nom :..........................
Raison sociale :..........................
Adresse :..........................
e-mail :..........................
Date :.......................... Signature :..........................

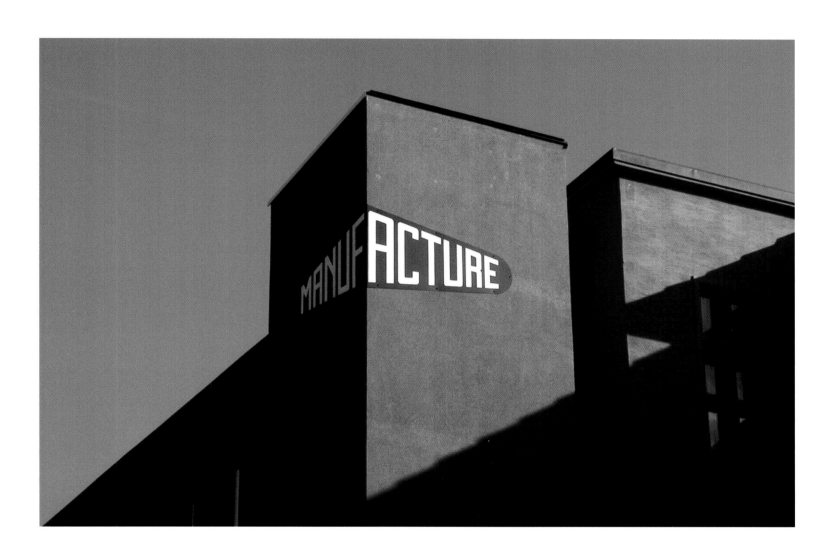

La Manufacture is the name of the Superior School of Theater of Lausanne, so named because it is situated in a former watch factory. The Giorgio Pesce team opted to renovate the graphic and corporate identity of the school; the new logo was based on an old catalog found in the warehouse of the old factory, which was also the inspiration for other communication media with the same industrial nature.

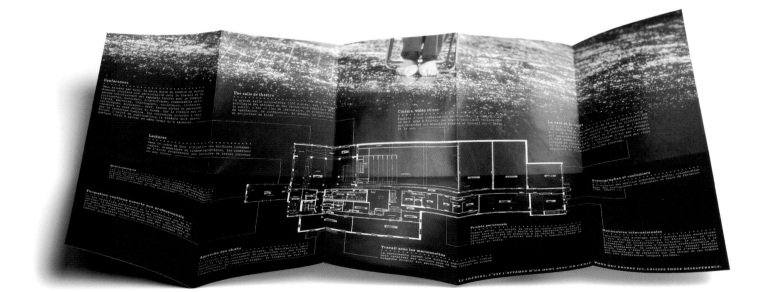

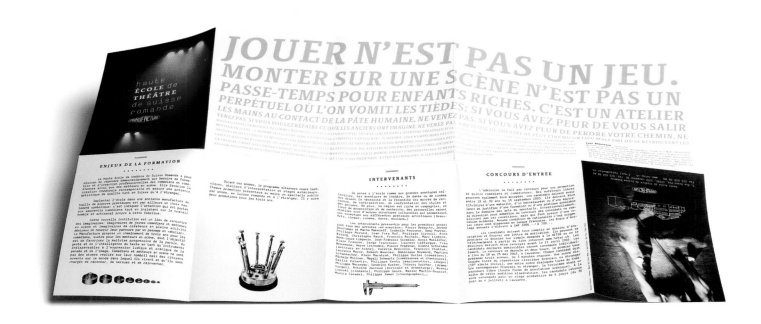

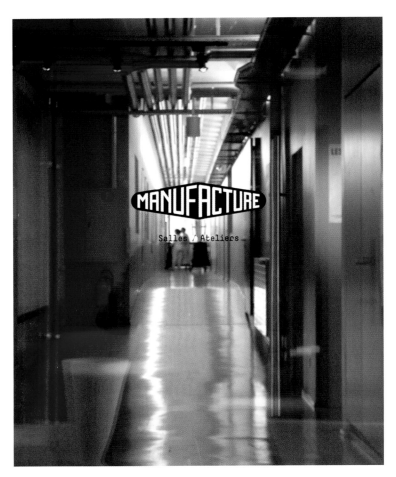

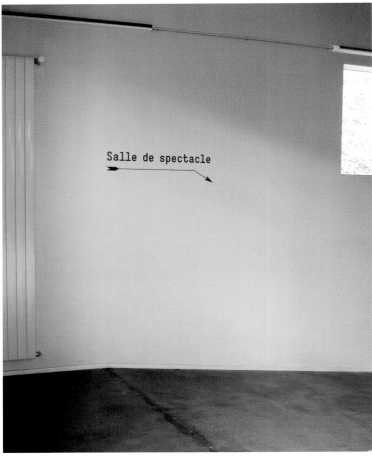

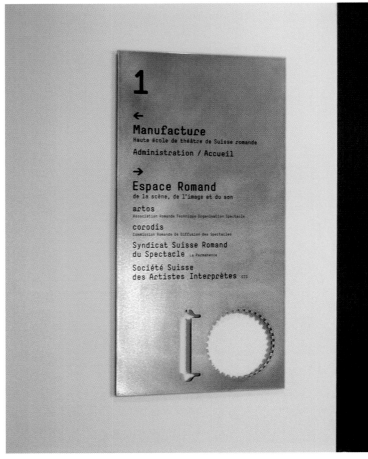

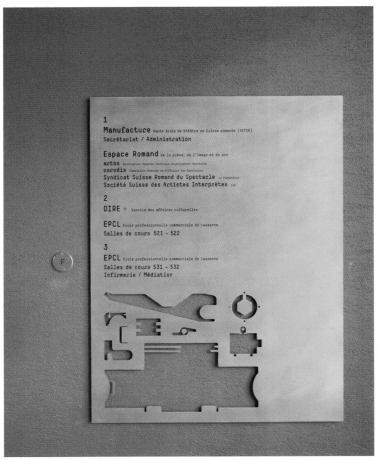

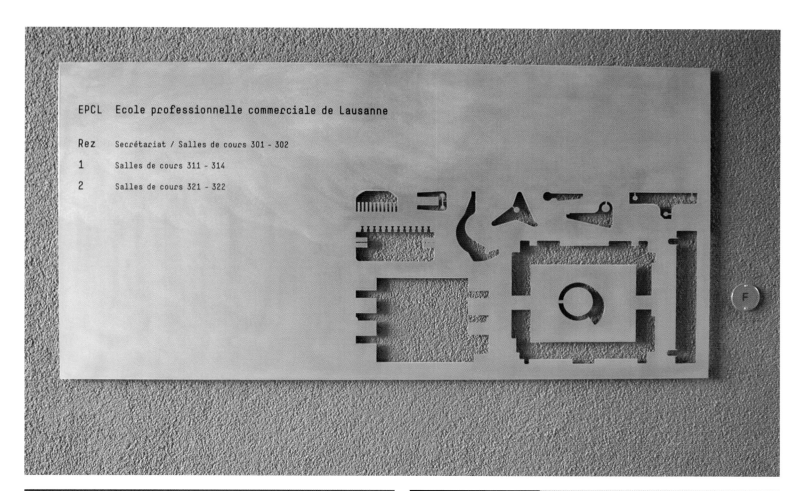

EPCL Ecole professionnelle commerciale de Lausanne

Rez Secrétariat / Salles de cours 301 - 302

1 Salles de cours 311 - 314

2 Salles de cours 321 - 322

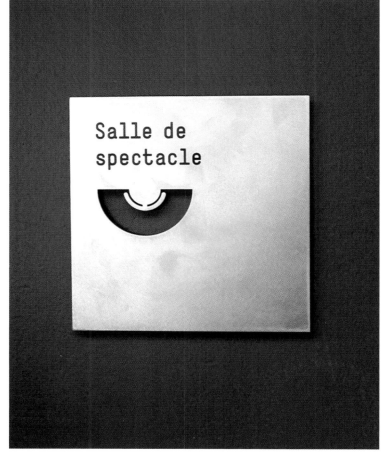

Salle de
spectacle

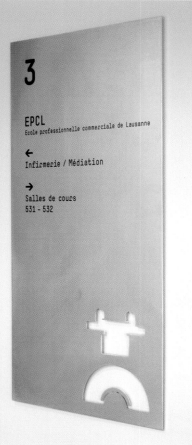

3

EPCL
Ecole professionnelle commerciale de Lausanne

←
Infirmerie / Médiation

→
Salles de cours
531 - 532

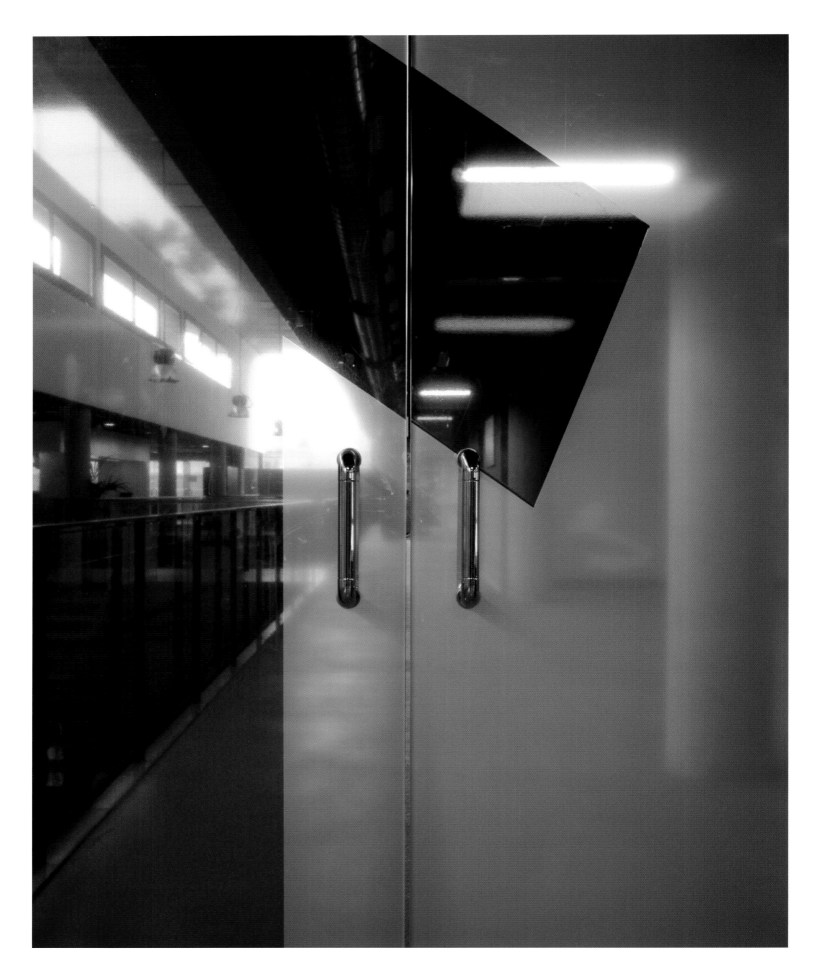

Duet Sports

Design: **Alonso Balaguer y Arquitectos Asociados** Photography: **© Pedro Pegenaute** Location: **Barcelona, Spain**

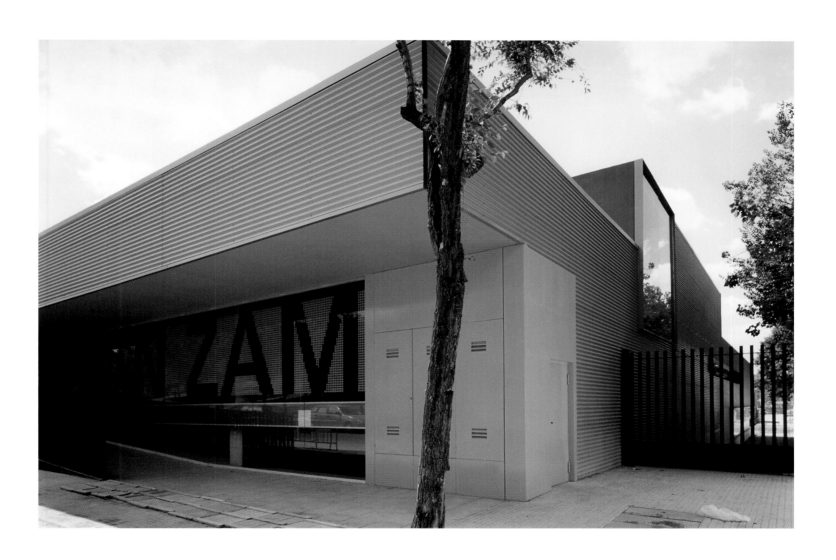

Duet Sports is a visual presentation that achieves a graphic and chromatic relationship between the different spaces of the sports club. The swimming pool, the changing rooms, the massage parlor, and the reception area contain applications in vinyl that indicate to the visitor the activity taking place inside. Standing out in the gym, for example, the application of different silhouettes on a bike is a quickly perceived graphic sign that orients the visitor.

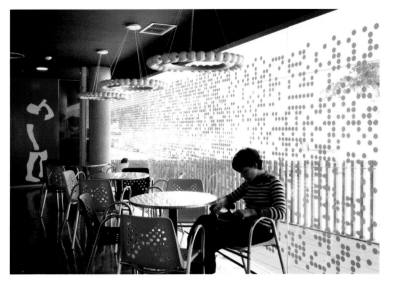

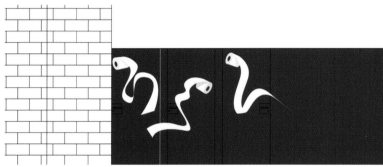
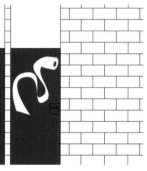
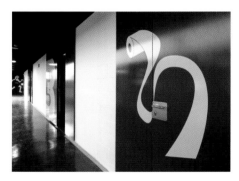
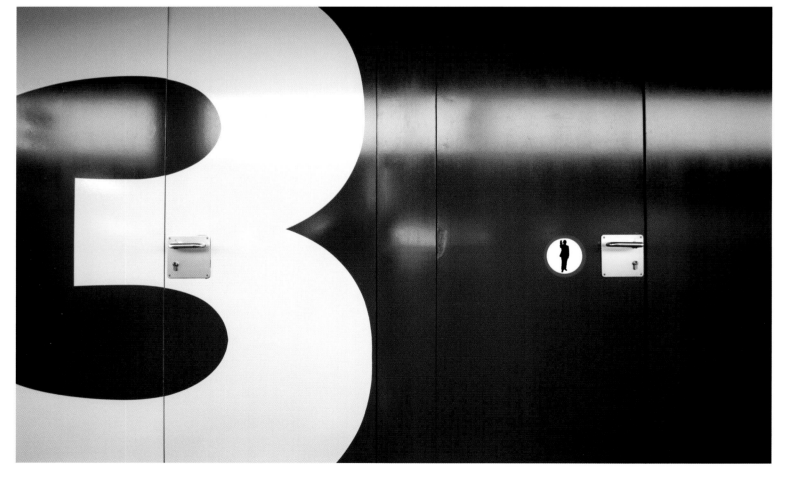

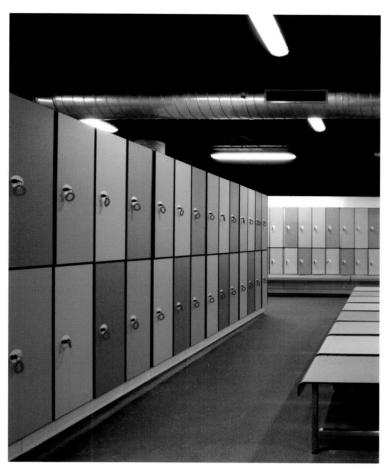
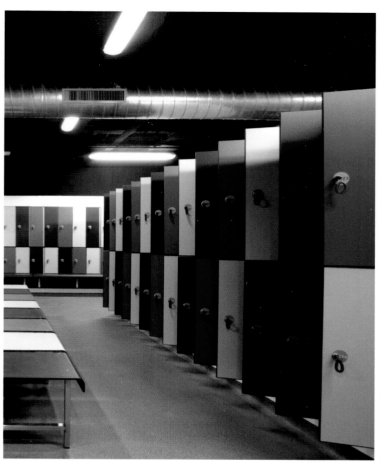
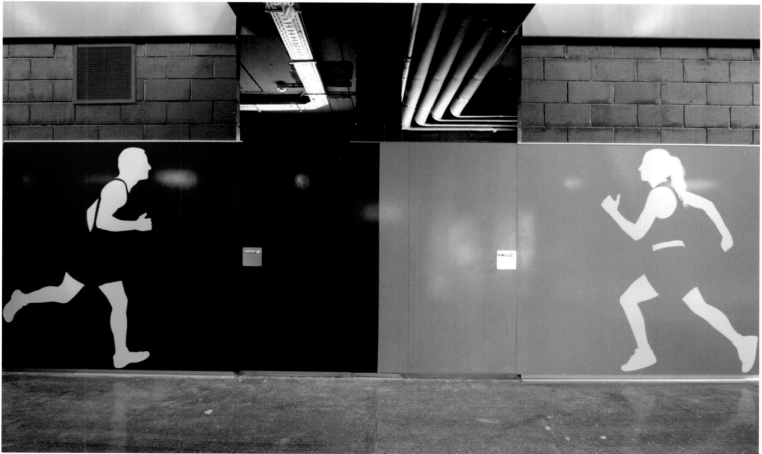

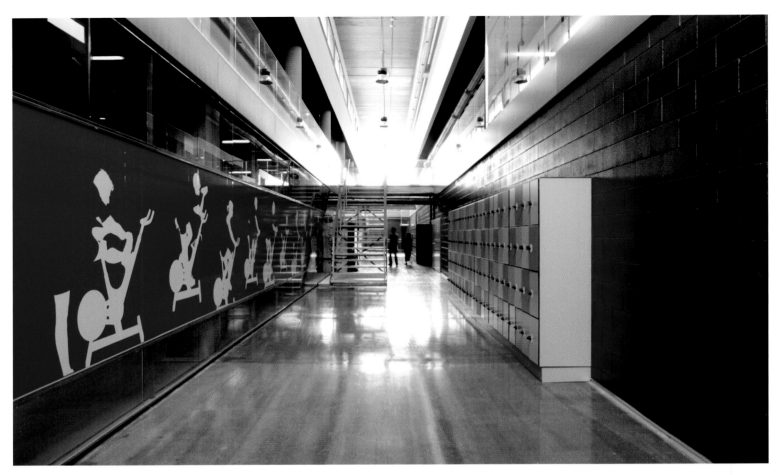

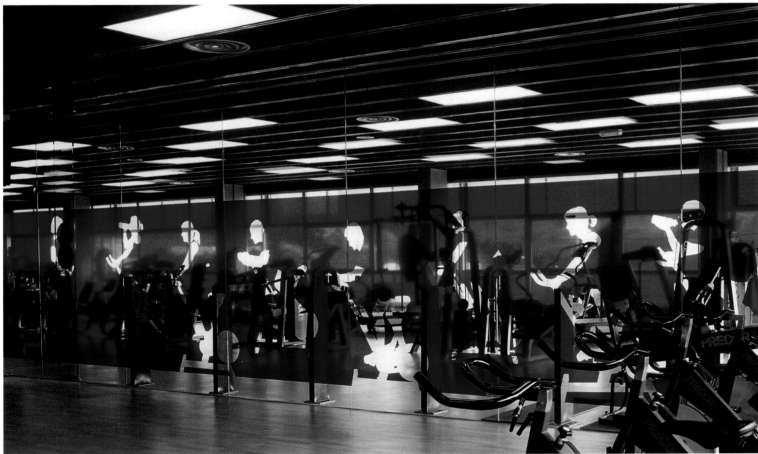

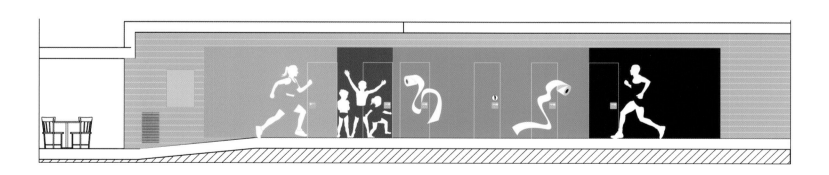

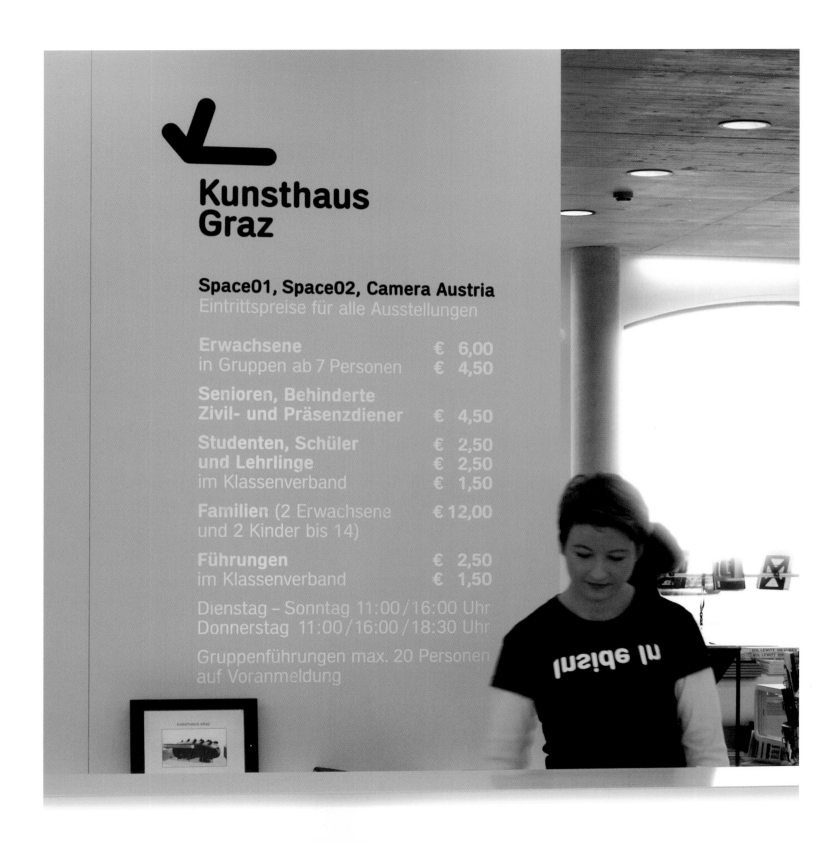

Kunsthaus Graz

Space01, Space02, Camera Austria
Eintrittspreise für alle Ausstellungen

Erwachsene € 6,00
in Gruppen ab 7 Personen € 4,50

Senioren, Behinderte
Zivil- und Präsenzdiener € 4,50

Studenten, Schüler
und Lehrlinge € 2,50
im Klassenverband € 1,50

Familien (2 Erwachsene € 12,00
und 2 Kinder bis 14)

Führungen € 2,50
im Klassenverband € 1,50

Dienstag – Sonntag 11:00 / 16:00 Uhr
Donnerstag 11:00 / 16:00 / 18:30 Uhr

Gruppenführungen max. 20 Personen
auf Voranmeldung

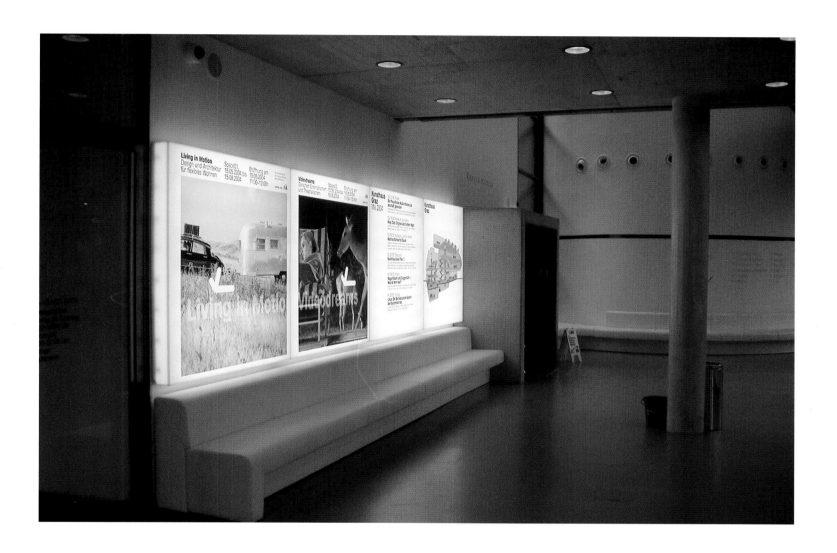

Lichtwitz Büro designed the logo, the graphic identity, and the signing of the new contemporary art space of the city of Graz. The abstract logo is the three-dimensional expression of the space, which at the same time serves to orient the visitor. The signing has been applied directly to the doors, walls, and floor with a special retroreflective vinyl, which changes color depending on the angle of vision. Lichtwitz also designed the merchandising elements of the museum.

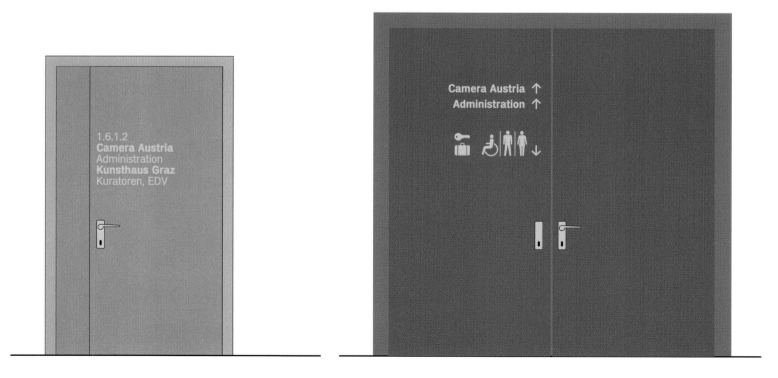

Bitte beachten Sie...
Please note...

Rauchverbot No smoking	Keine Haustiere No pets	Keine Skates oder Scooter No skates or scooters
Kunstwerke nicht berühren Don't touch any artwork	Kein Essen, keine Getränke No food or drinks	Kein Blitzlicht No flash photography
Keine großen Taschen No bulky bags	Keine Rucksäcke No backpacks	Keine spitzen Gegenstände No sharp objects

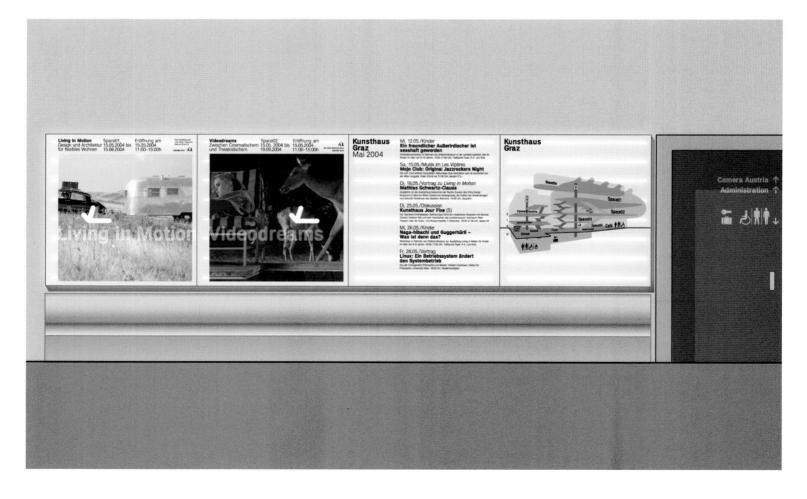

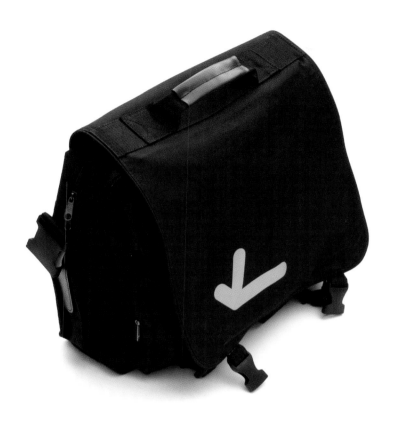

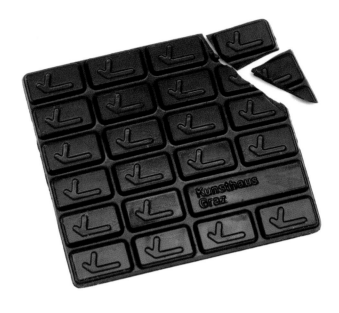

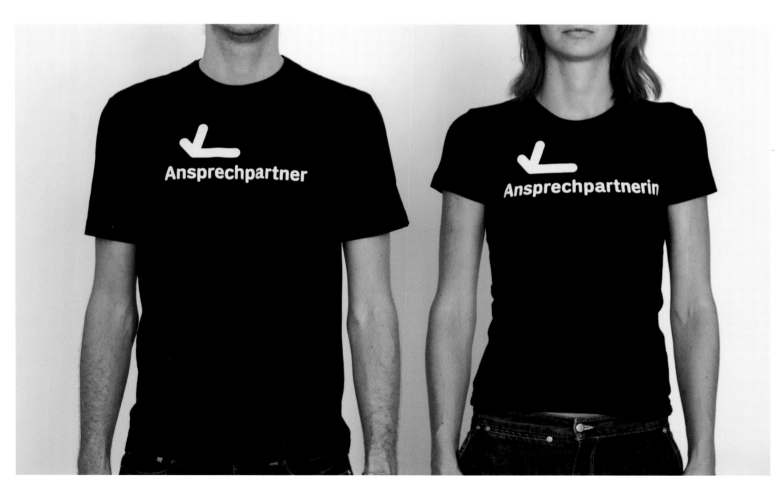

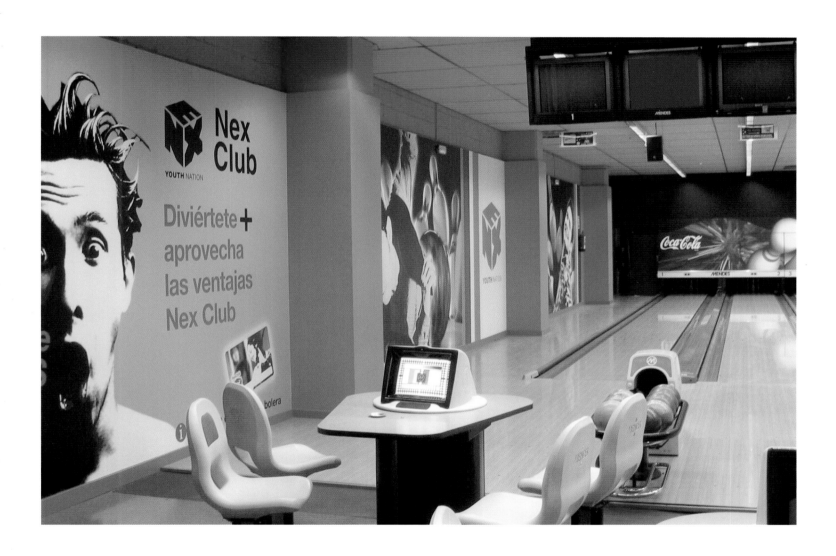

x2.0 designed the new corporate image of the Nex bowling alley. The logo, as much as the vinyls of the façade and interior, reflects an image of vitality and freshness. The logo consists of the three letters in the word Nex, formed into a die-like cube, a symbol of games and entertainment.

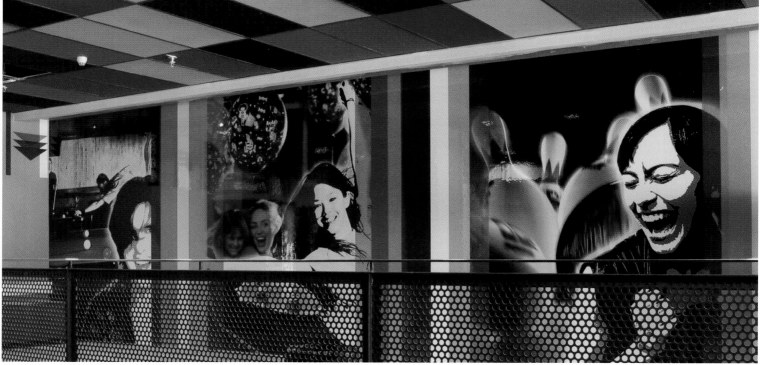

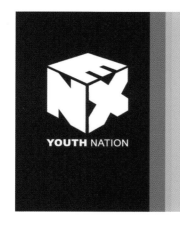

YOUTH NATION

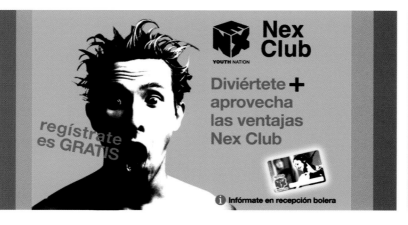

NEX Club
YOUTH NATION

Diviértete +
aprovecha
las ventajas
Nex Club

regístrate
es GRATIS

ℹ Infórmate en recepción bolera

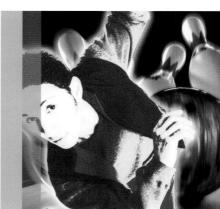

▼ Bolera
▼ Billares
▼ Futbolines
▼ Juegos con premio
▼ Internet
▼ Fiestas
▼ Salón Recreativo
▼ Bar
▼ Club Nex

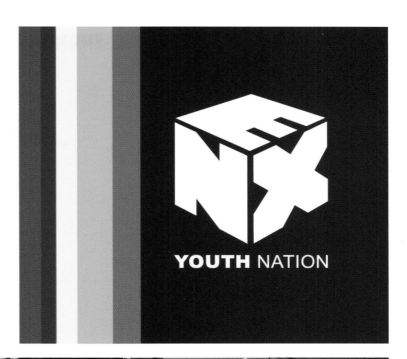

YOUTH NATION

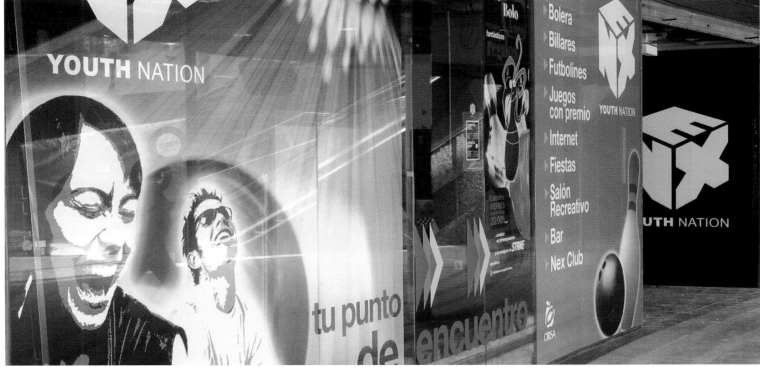

YOUTH NATION

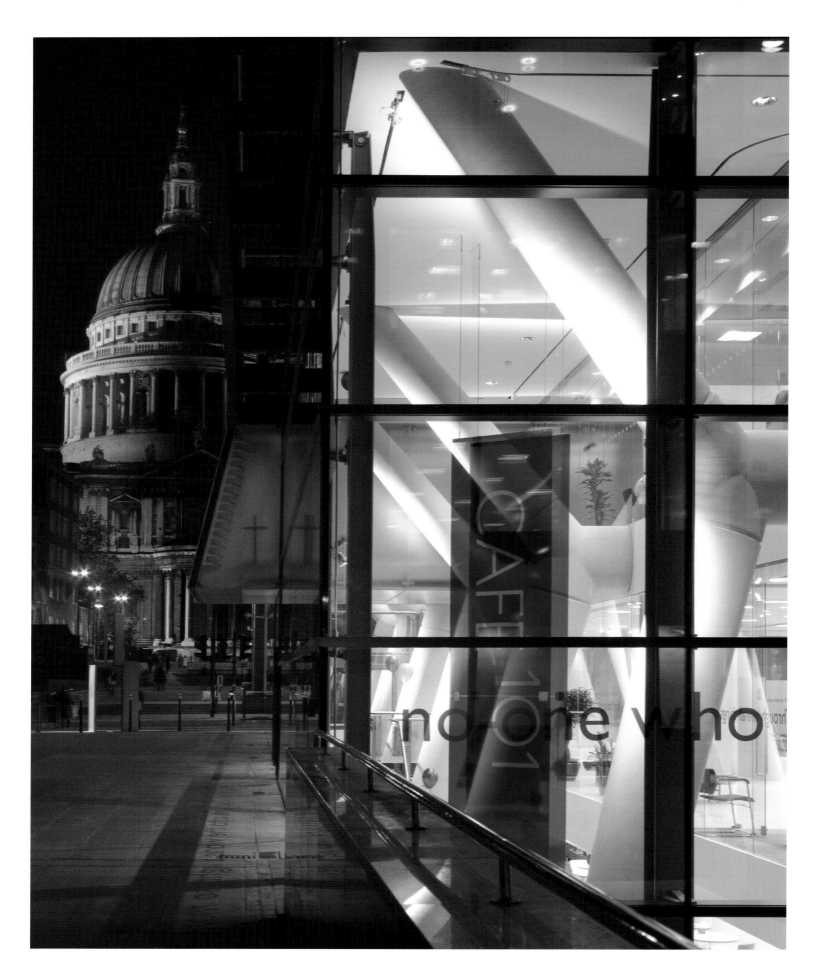

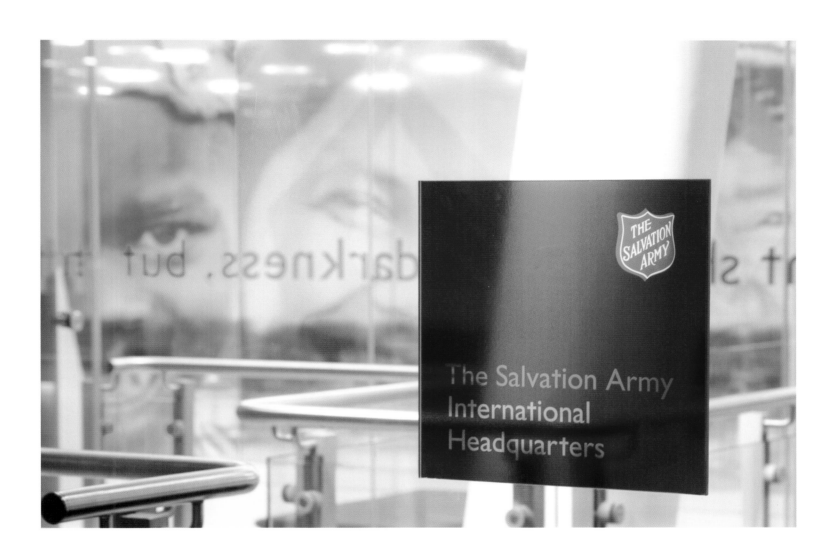

The Salvation Army commissioned the Hat-trick team to design the new graphic identity of its new international branch in London. The challenge was to achieve an up-to-date image within the parameters of the corporate image of the Salvation Army. The project, which won the DW Awards 2005, consisted of the signing design, vinyls, and graphics of the cafeteria.

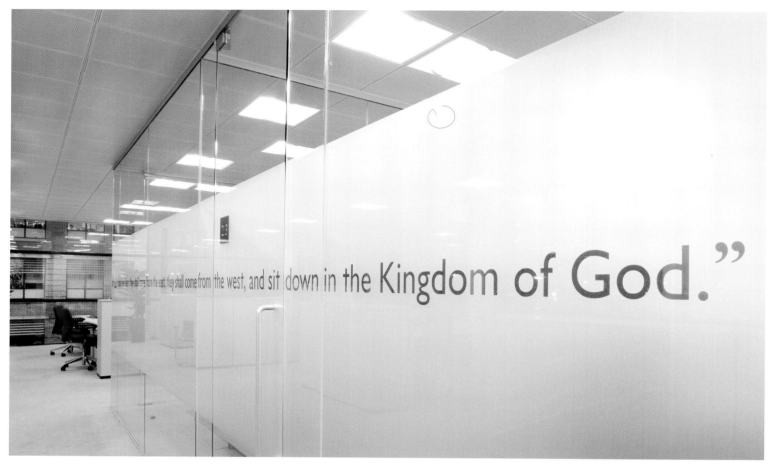

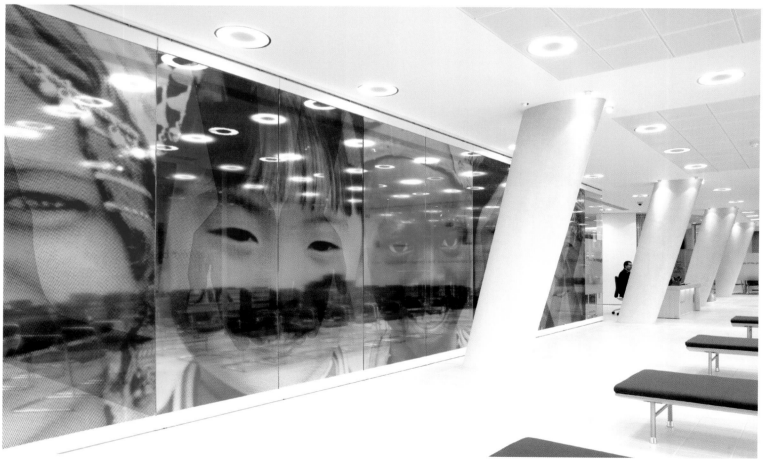

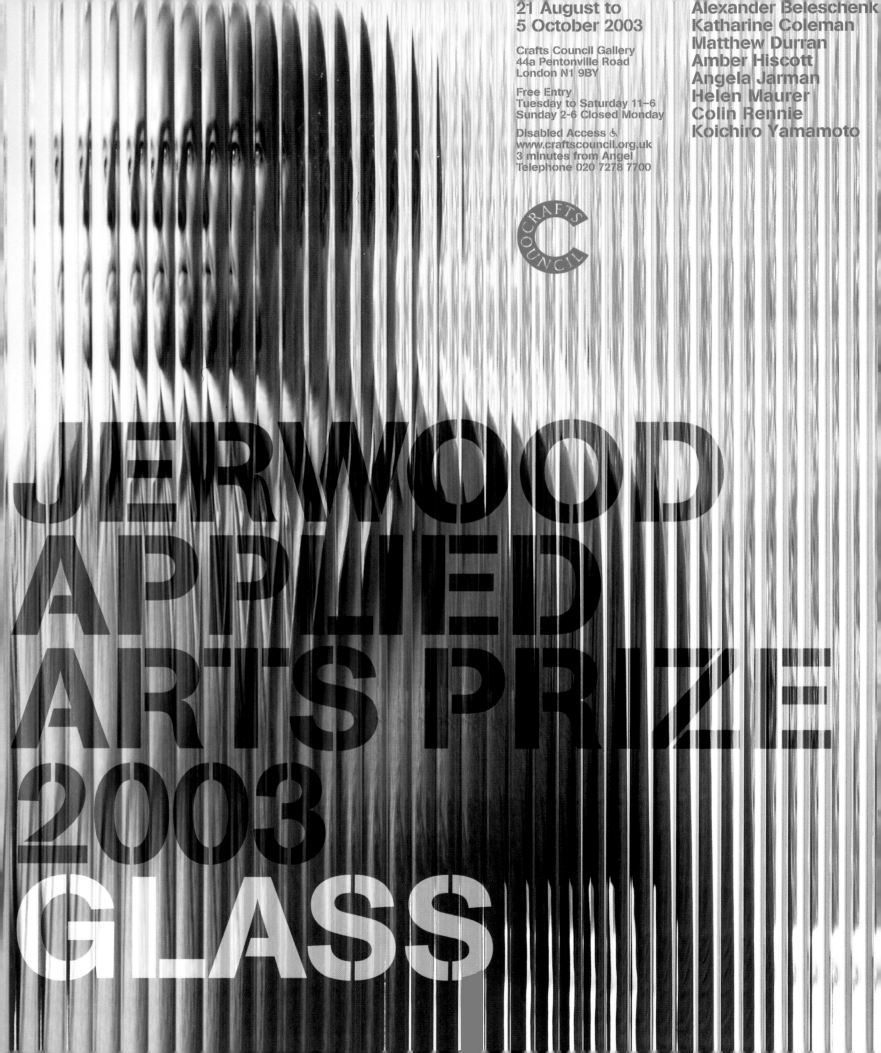

21 August to
5 October 2003

Crafts Council Gallery
44a Pentonville Road
London N1 9BY

Free Entry
Tuesday to Saturday 11–6
Sunday 2–6 Closed Monday

Disabled Access ♿
www.craftscouncil.org.uk
3 minutes from Angel
Telephone 020 7278 7700

CRAFTS COUNCIL

Alexander Beleschenk
Katharine Coleman
Matthew Durran
Amber Hiscott
Angela Jarman
Helen Maurer
Colin Rennie
Koichiro Yamamoto

JERWOOD
APPLIED
ARTS PRIZE
2003
GLASS

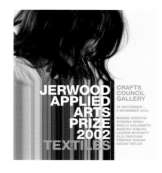

The concept of this project was born from graphic experimentation on glass. NB Studio had to create a system to exhibit the work of six artists on glass. The difficulty of putting graphics on a solid material with a variable perception made this experiment all the more attractive. The result is a direct interaction between designer and glass that forms the spirit of the exhibition and makes it an unsurpassable marketing image.

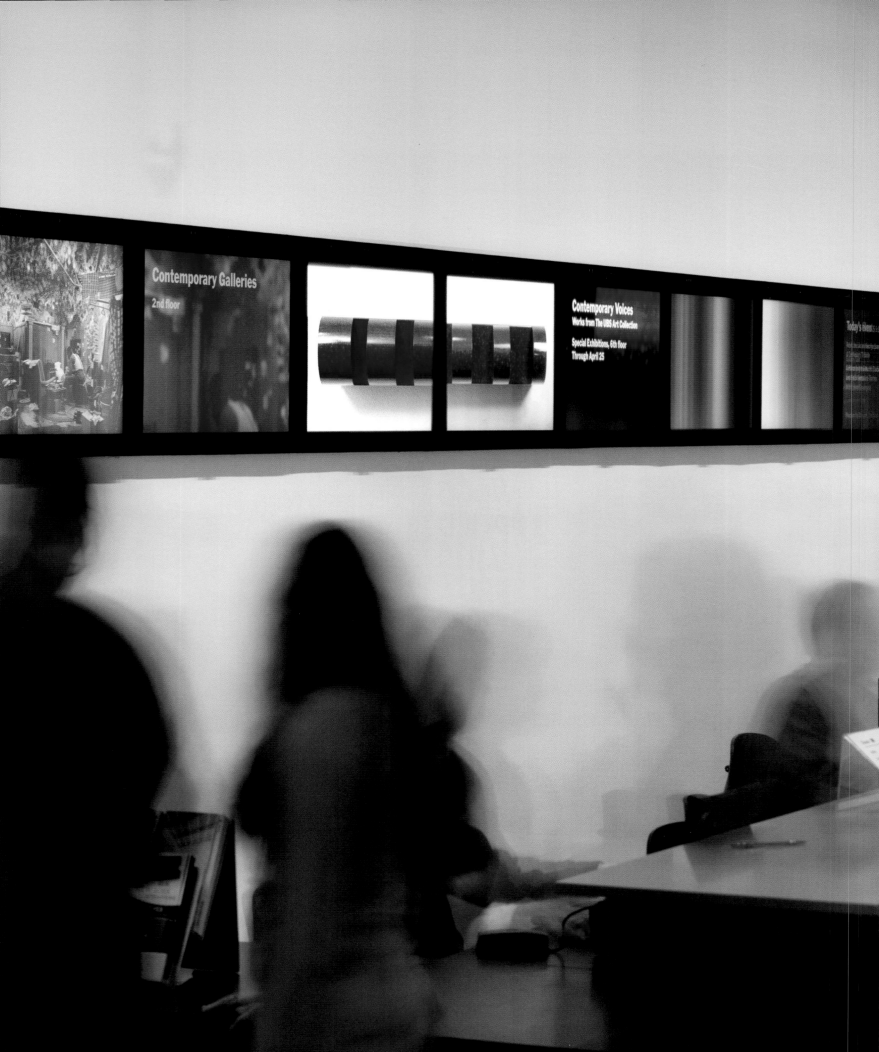

MoMA Lobby Screens

Design: **Imaginary Forces** Photography: © **Frederick Charles** Location: **New York, USA**

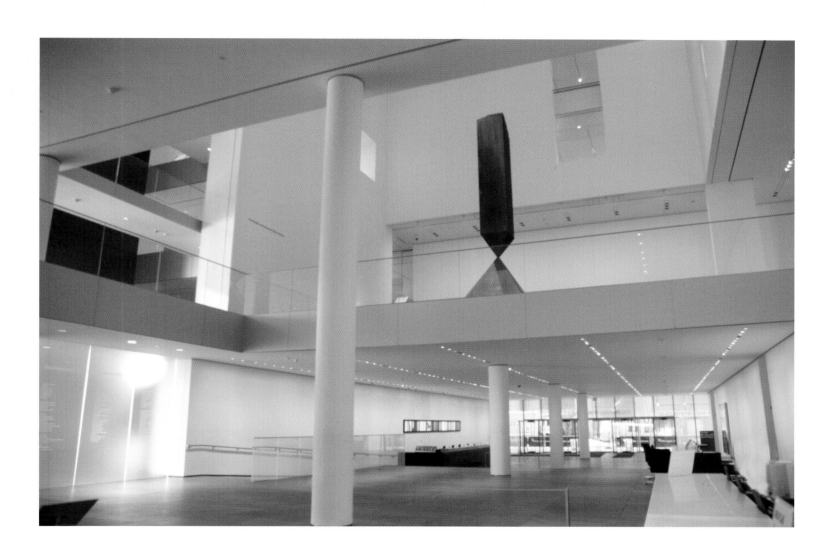

MoMA commissioned Imaginary Forces (IF) to design the digital screens of the new museum's cloakroom. The main objective was to offer visitors the information necessary to plan their visit by showing fragments of the museum's permanent collection and its various exhibitions through new 40-inch LCD screens. The result is a digital panorama that achieves the perfect combination between information, art, and entertainment.

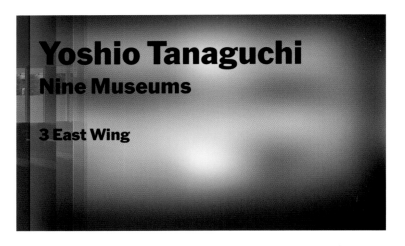

Yoshio Tanaguchi
Nine Museums

3 East Wing

75px 75px 80px

80px 160px

Yoshio Taniguchi: 75pt/79pt
Nine Museums 75pt/90pt

Special Exhibitions, 3rd floor 50pt/110pt
Through January 31 50pt/70pt

Text live area

75px 75px

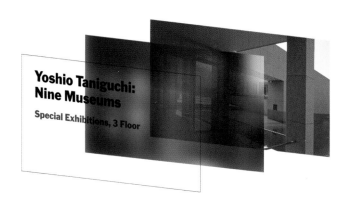

Yoshio Taniguchi:
Nine Museums

Special Exhibitions, 3 Floor

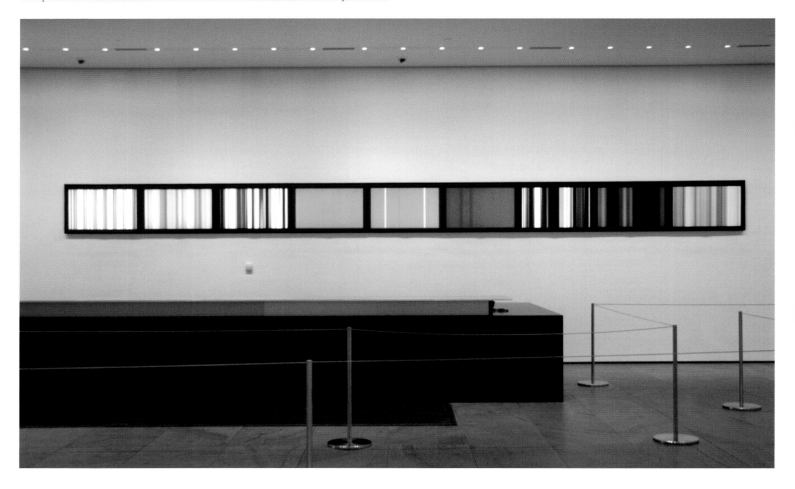

IMAGE

CONTEXT

PROCESS

IMAGE BLUR

FINGERPRINT

HEADINGS

LOCATION

DATES

**Charles & Ray Eames:
A Retrospective**

Special Exhibitions, 3 Floor

Through January 31

**Charles & Ray Eames:
A Retrospective**

**Special Exhibitions, 3 Floor
Through January 31**

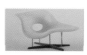

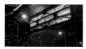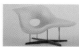

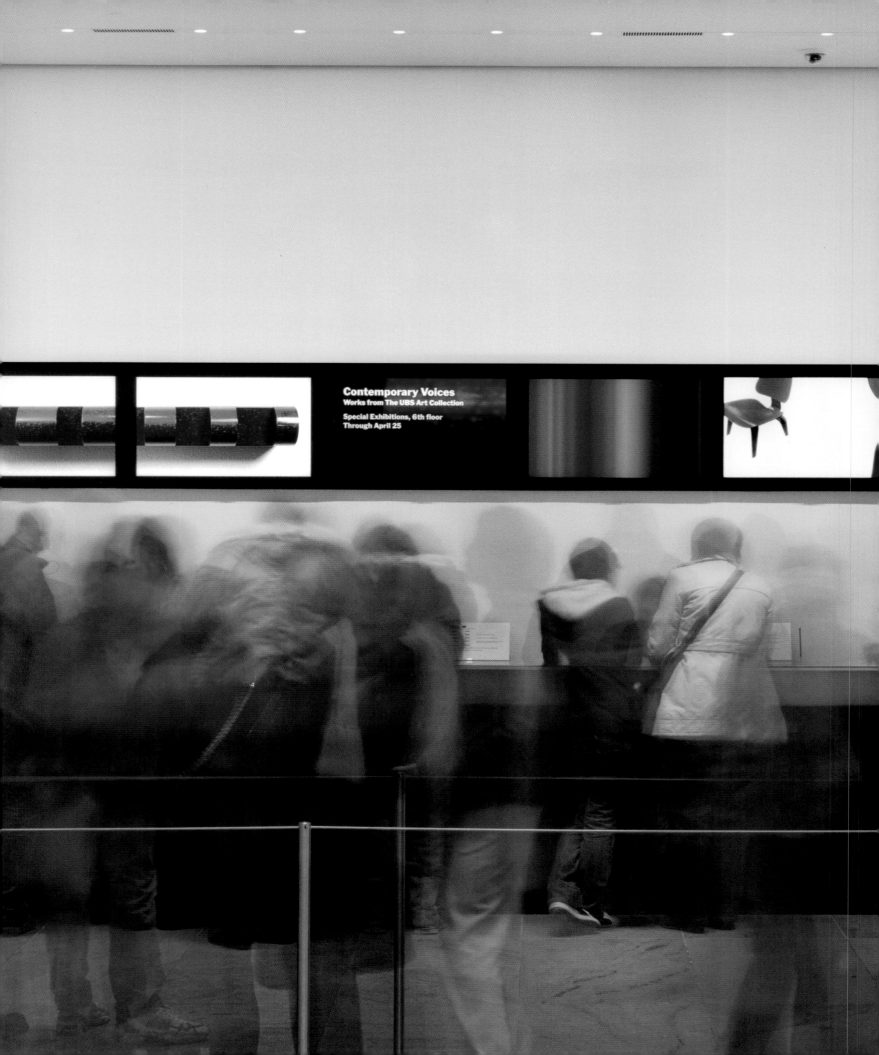

Contemporary Voices
Works from The UBS Art Collection

Special Exhibitions, 6th floor
Through April 25

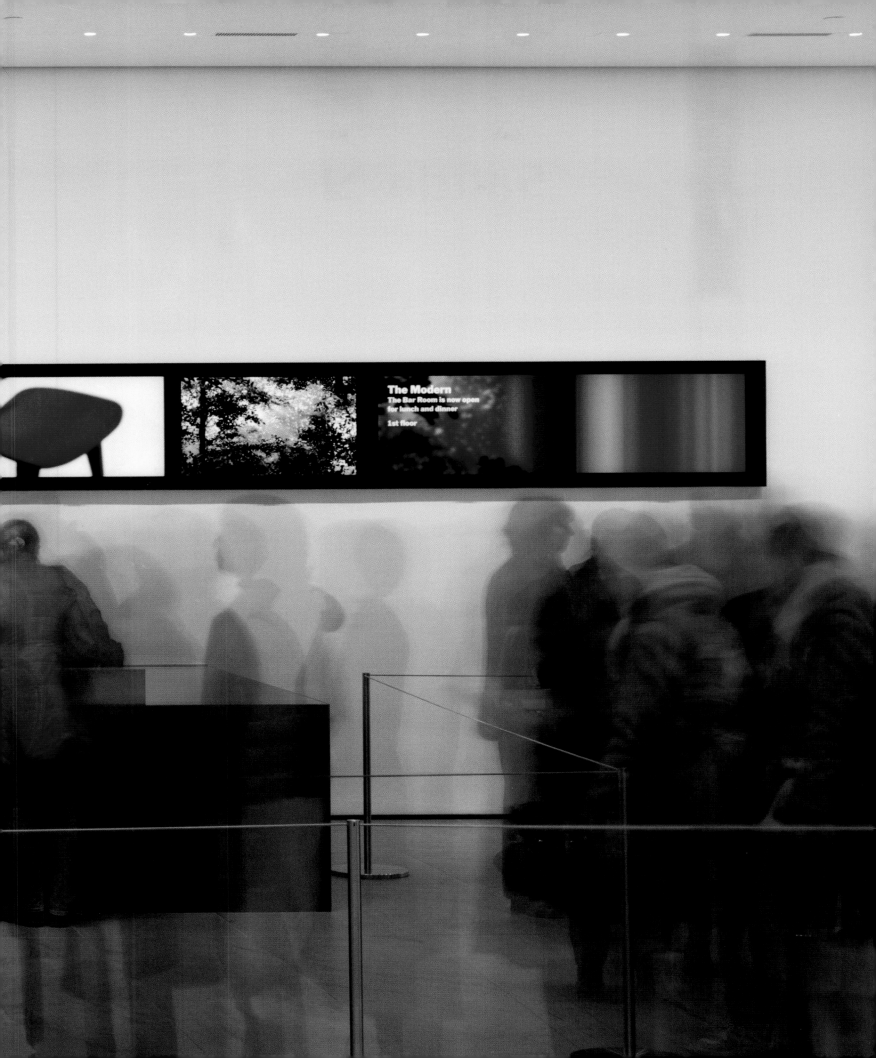

The Modern
The Bar Room is now open
for lunch and dinner

1st floor

Buenos Aires Subway Signage

Design: **Diseño Shakespear** Photography: © **Juan Hitters** Location: **Buenos Aires, Argentina**

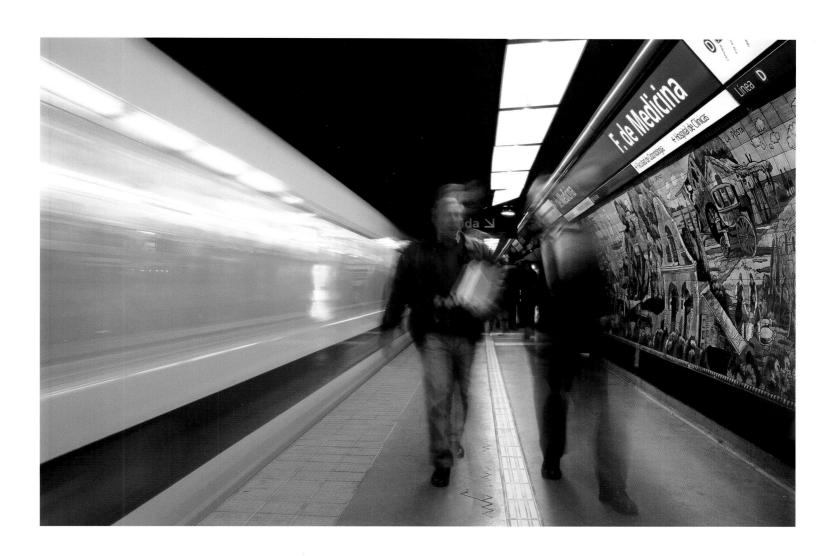

The signage of the subterranean network of Buenos Aires was taken on by Diseño Shakespear in the same vein as in the large European and American networks. The brainchild was the revival of the popular name for the service, "Subte", with which its urban and social identity is preserved as a label and culture. The project is not a program of posters but the generation of a channel of communication and transit flows that configures the network's identity.

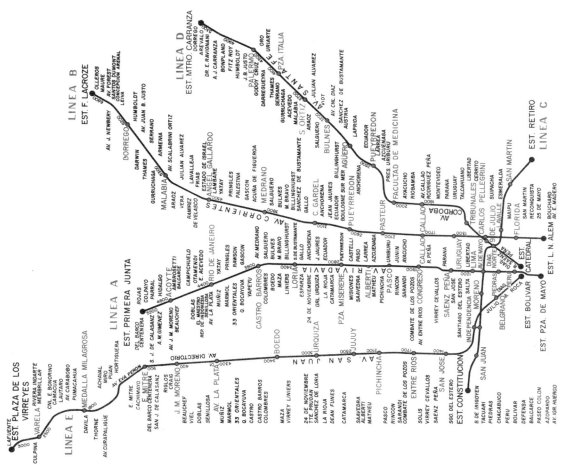

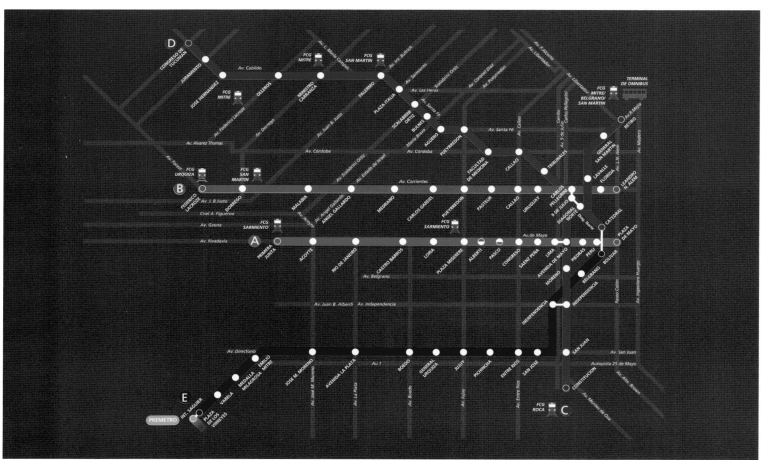

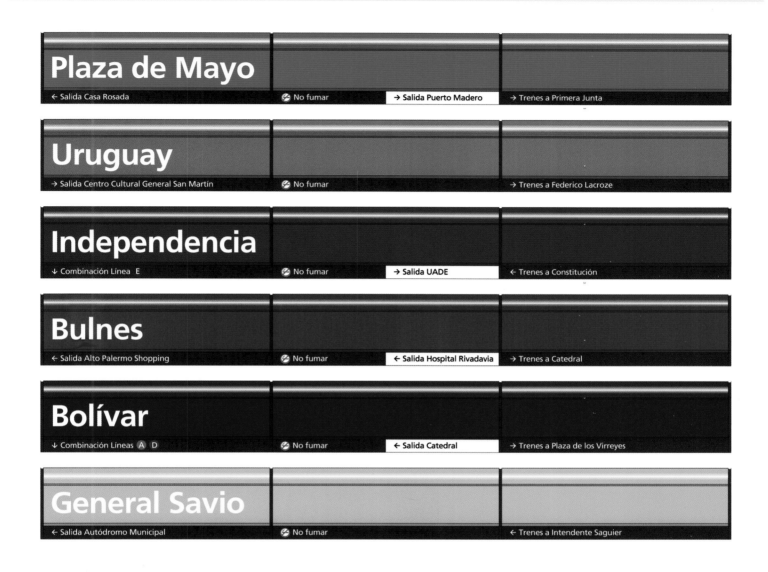

Plaza de Mayo			
← Salida Casa Rosada	No fumar	→ Salida Puerto Madero	→ Trenes a Primera Junta

Uruguay			
→ Salida Centro Cultural General San Martín	No fumar		→ Trenes a Federico Lacroze

Independencia			
↓ Combinación Línea E	No fumar	→ Salida UADE	← Trenes a Constitución

Bulnes			
← Salida Alto Palermo Shopping	No fumar	← Salida Hospital Rivadavia	→ Trenes a Catedral

Bolívar			
↓ Combinación Líneas A D	No fumar	← Salida Catedral	→ Trenes a Plaza de los Virreyes

General Savio			
← Salida Autódromo Municipal	No fumar		← Trenes a Intendente Saguier

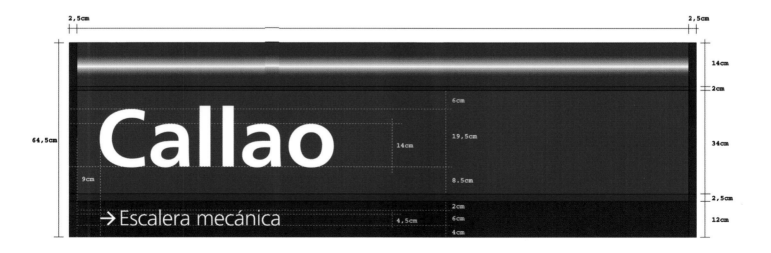

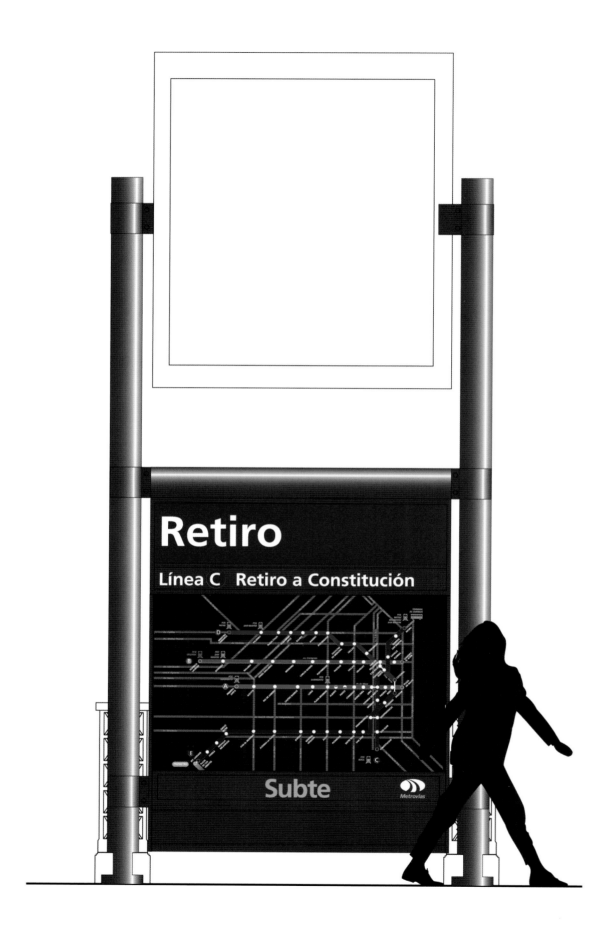

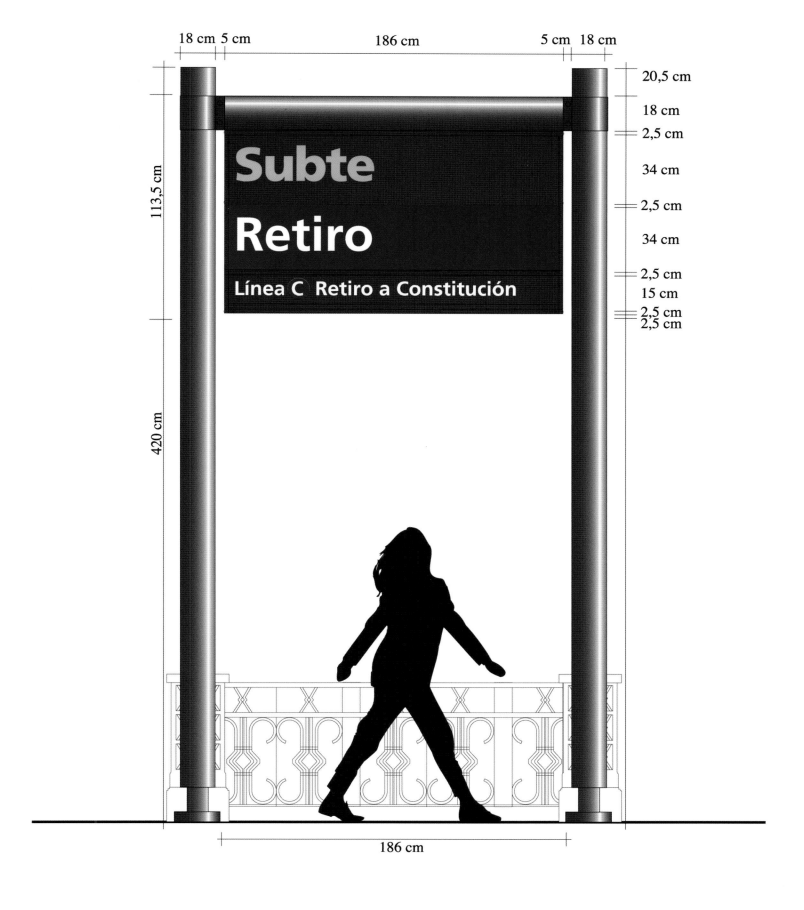

Subte

Retiro

Línea C Retiro a Constitución

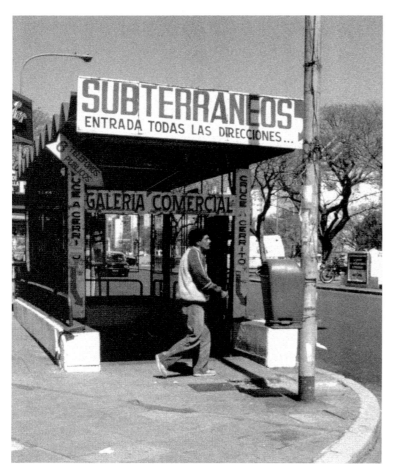
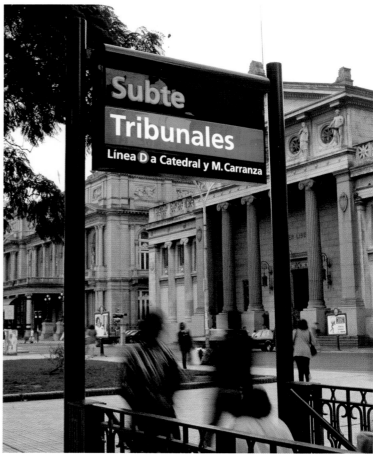
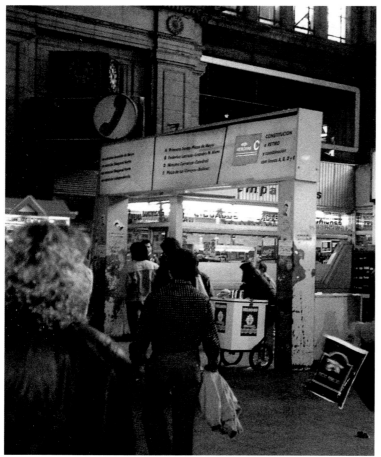
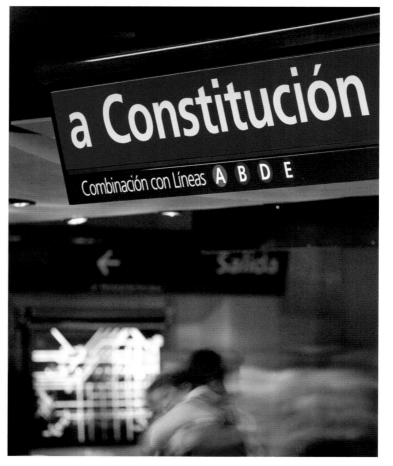

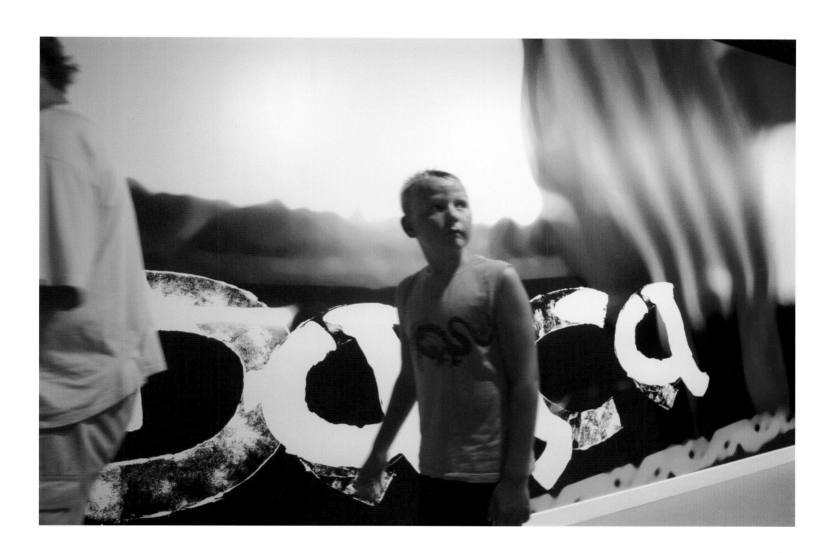

Why Not Associates is responsible for the designs and application of the interior graphics of the FC Barcelona shop. References to the sports club and its victories are reinforced with the combination of blues and claret applied to the murals, where silhouettes of the players appear. The word "Barça," applied in different areas of the shop, facilitates recognition and publicity for the already well-known name.

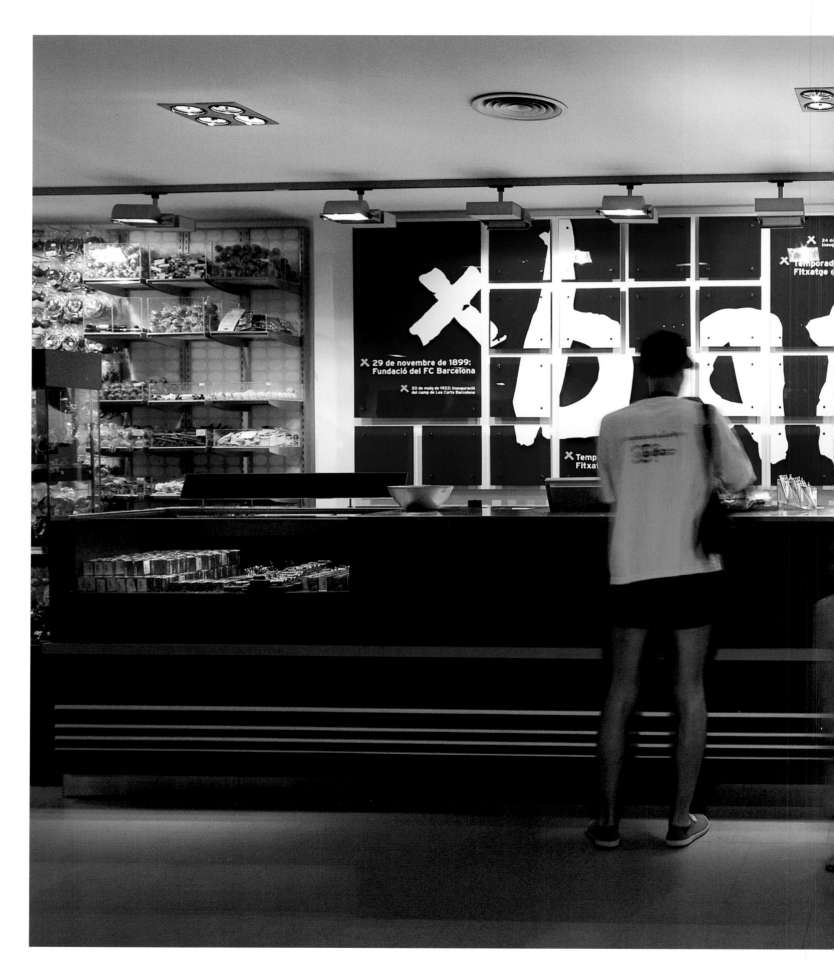

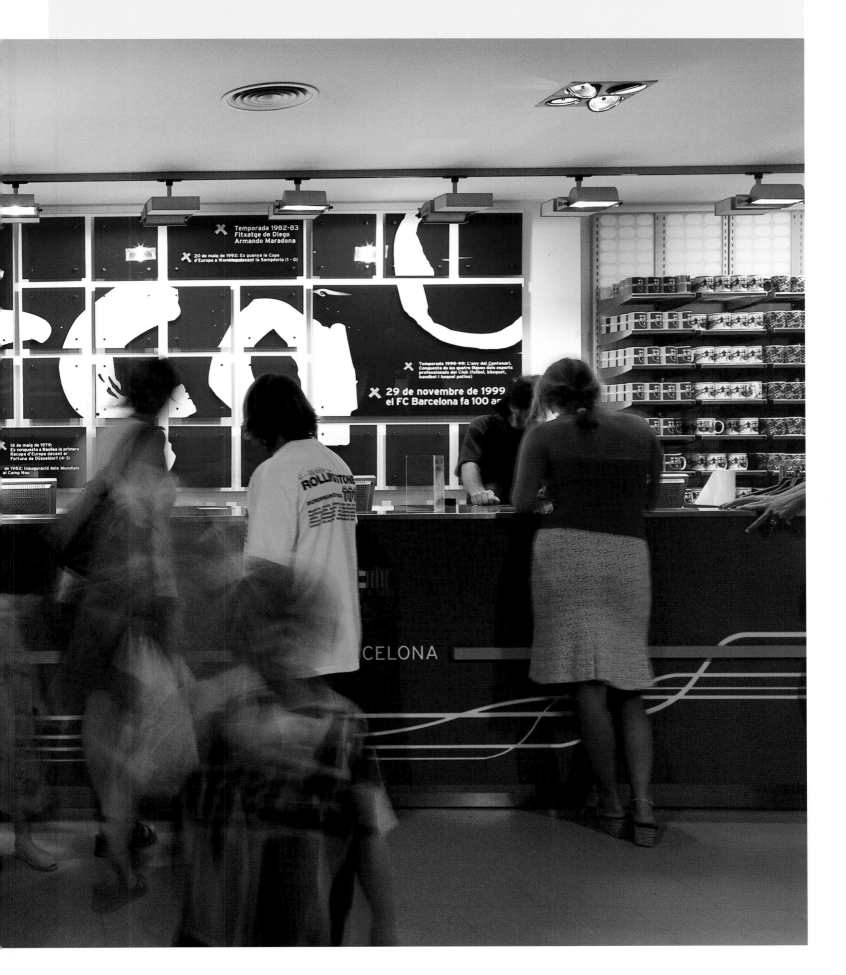

Temporada 1982-83
Fitxatge de Diego
Armando Maradona

20 de maig de 1992: Es guanya la Copa
d'Europa a Wembley davant la Sampdoria (1 - 0)

Temporada 1998-99: L'any del Centenari.
Conquesta de les quatre lligues dels esports
professionals del Club (futbol, bàsquet,
handbol i hoquei patins)

29 de novembre de 1999
el FC Barcelona fa 100 an

16 de maig de 1979:
Es conquesta a Basilea la primera
Recopa d'Europa davant el
Fortuna de Düsseldorf (4-3)

e 1982: Inauguració dels Mundials
al Camp Nou

CELONA

163

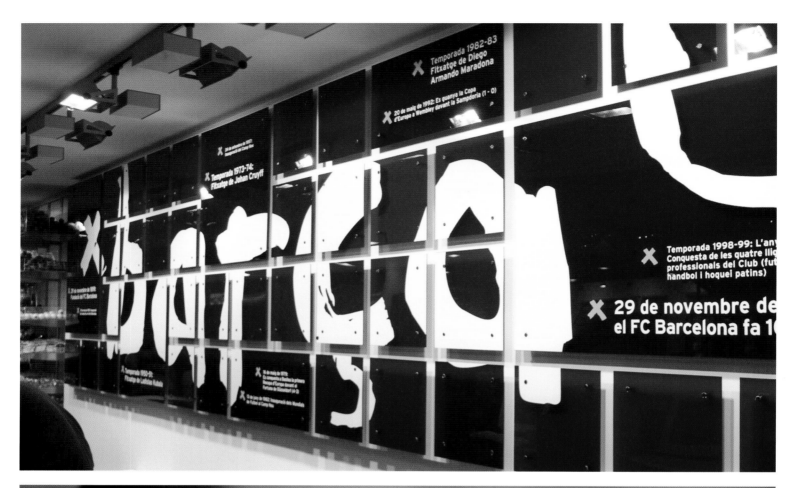

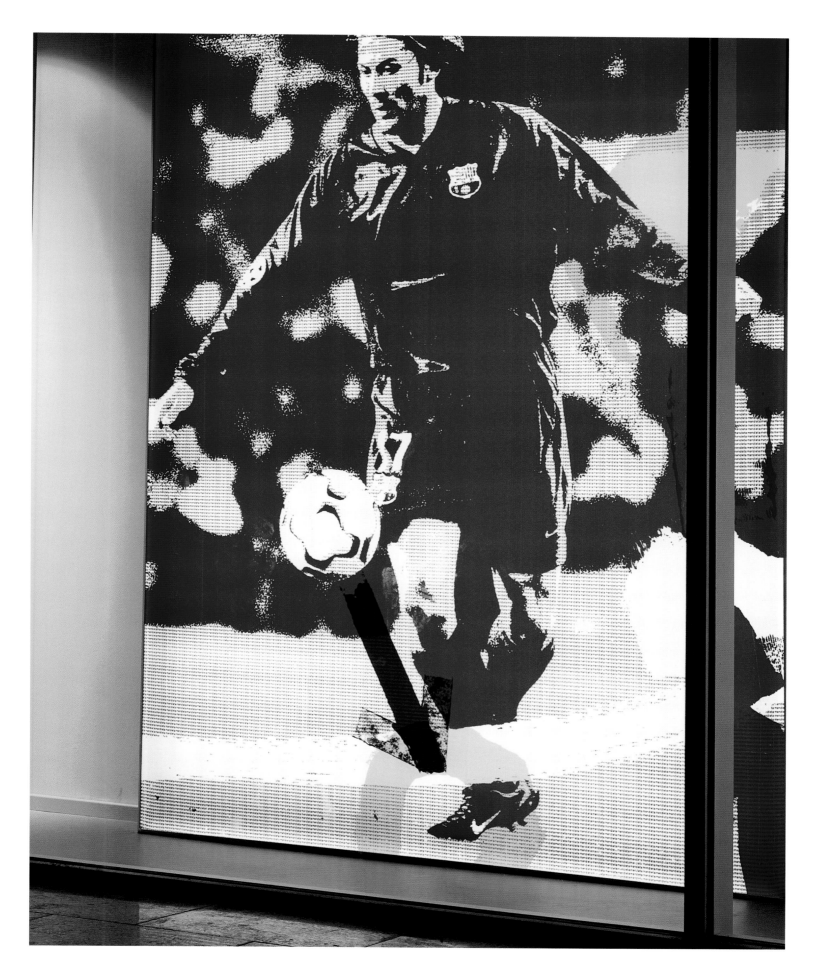

Simple Pleasures

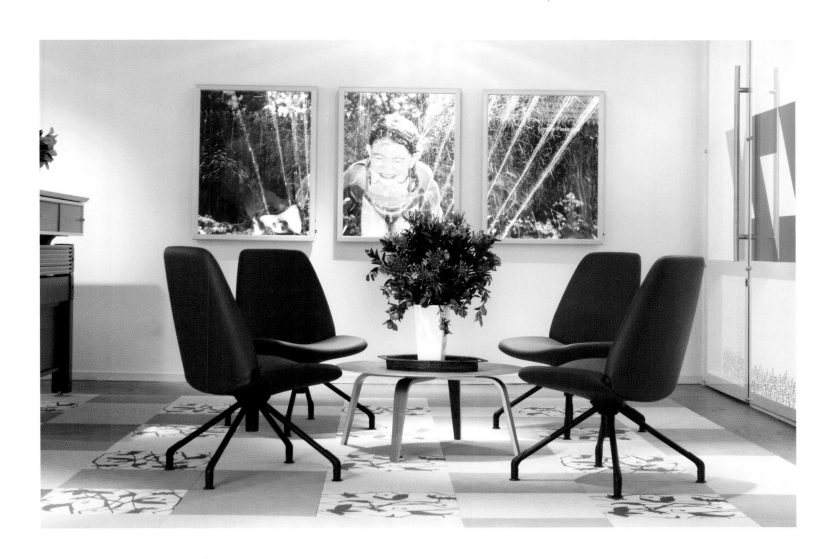

BBK Studio was the team chosen by Izzy Design to create its new permanent showroom. A green translucid vinyl with the identifying letters of the label stands out on the façade, and, on the lower part, minute words reproduce the word 'izzy.' The luminous murals on the entrance, as well as the panels of the offices, the café, and the exhibition area, are also BBK Studio's design.

6"

Simple Pleasures

Biblioteca de Roses

Design: **Zona Comunicació** Photography: © **Jordi Miralles** Location: **Roses, Spain**

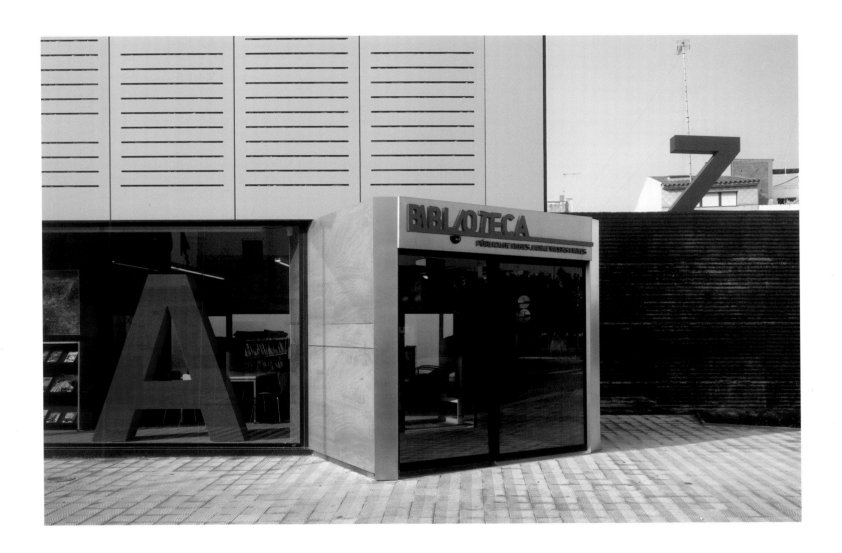

The studio Zona, together with the collaboration of the architect Jordi Casadevall, designed the graphic concept of this library's interior based on some gigantic graphics that situate the public in the middle of an attractive and recurrent space. Numerous graphic applications inspired in calligraphic typography are exhibited on the columns, walls, and windows of the library. On the exterior, an A and a Z preside over the entrance to portray the beginning and the end of the alphabet.

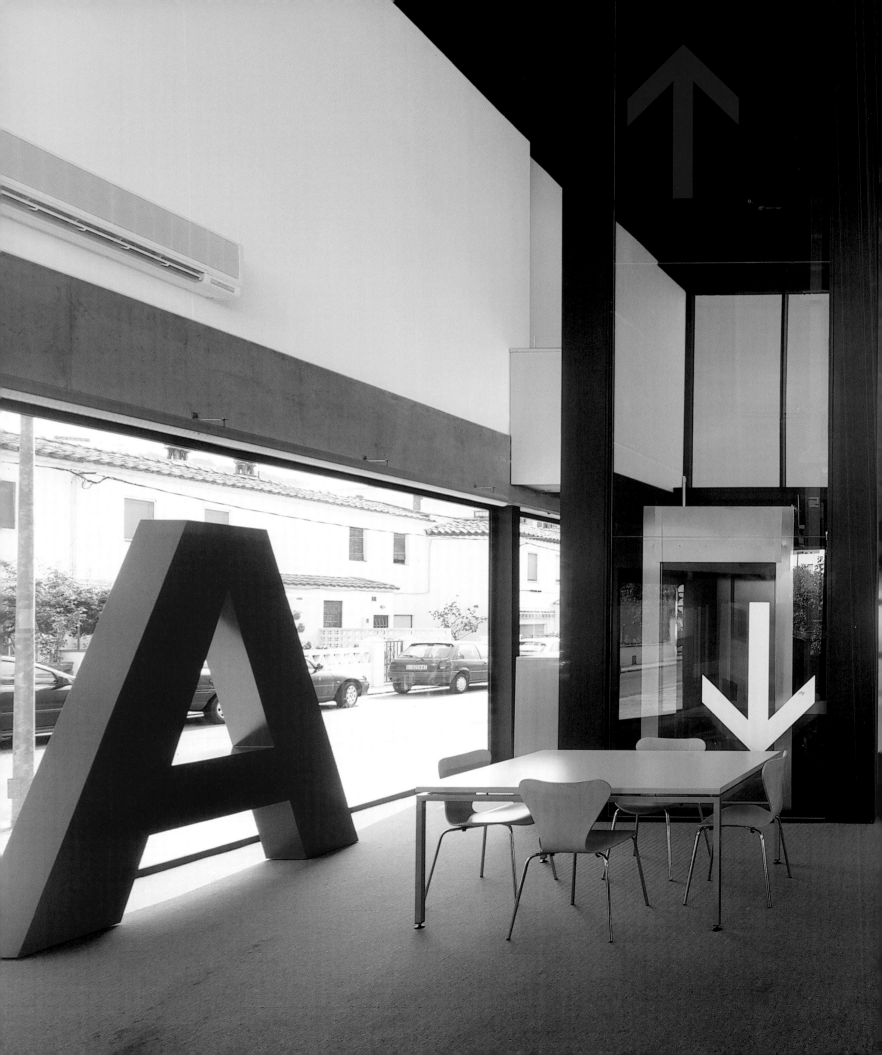

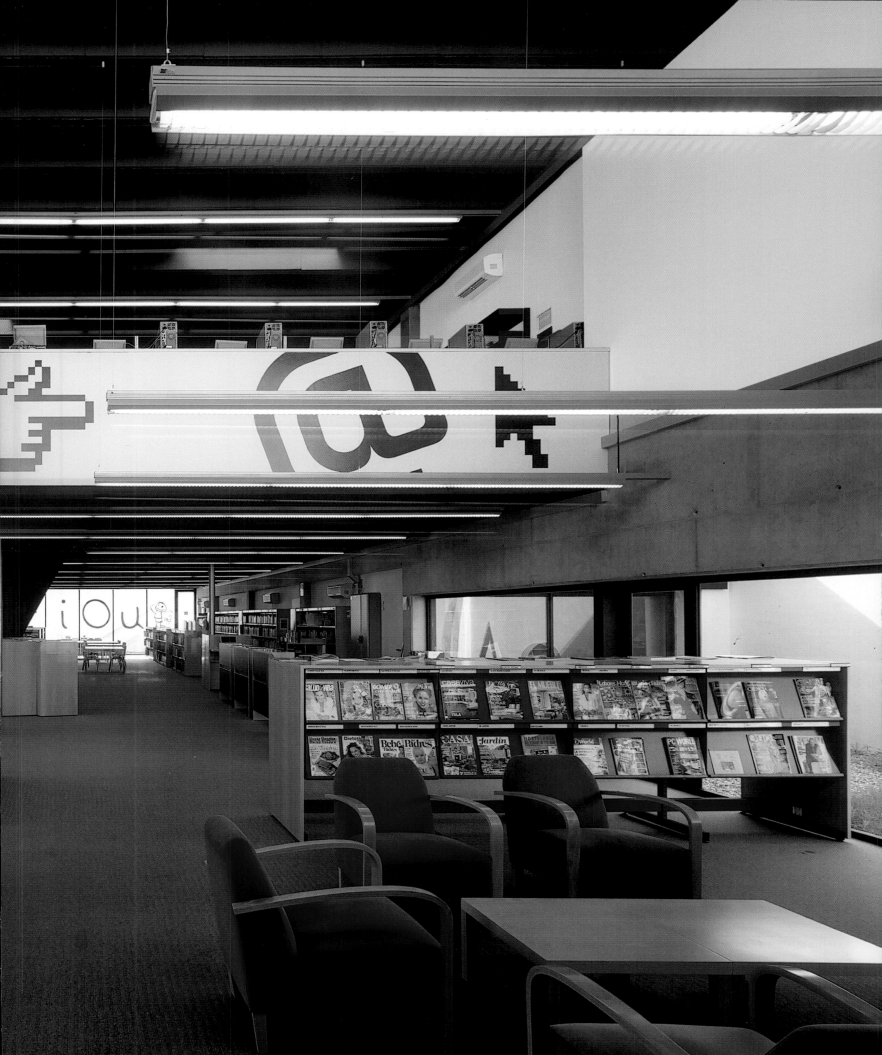

←	**B**	**PLANTA BAIXA**
←	ⓘ	INFORMACIÓ
←	⊕	PRÉSTEC I DEVOLUCIONS
←	⊞	HEMEROTECA (DIARIS I REVISTES)
←	🔍	CATÀLEGS
←	🐦	SECCIÓ INFANTIL
←	🎵	FONOTECA
→	✳	ESPAI MULTIÚS
←	ⓓ	DIRECCIÓ
←	🚻	WC
↖	**P**	**PLANTA PRIMERA**
↖	Ⓖ	SECCIÓ D'ADULTS
↖	ⓘ	INFORMACIÓ
↖	🔖	ÀREA DE CONSULTA
↖	👁	VIDEOTECA
↖	⬆	MULTIMEDIA
↖	ⓒⓛ	COL·LECCIÓ LOCAL

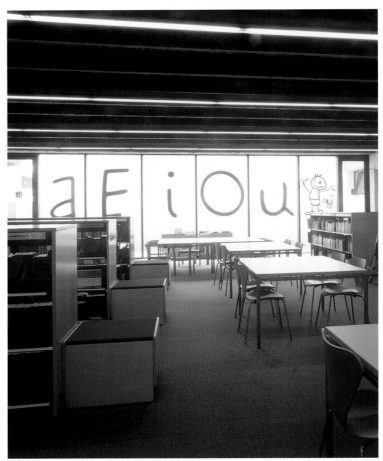

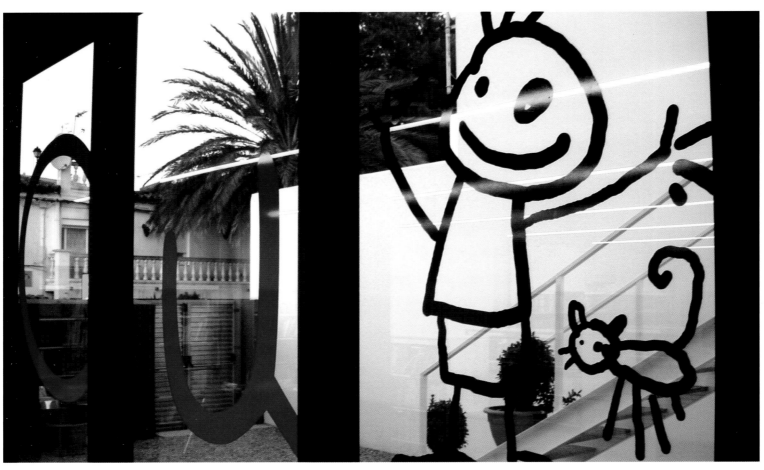

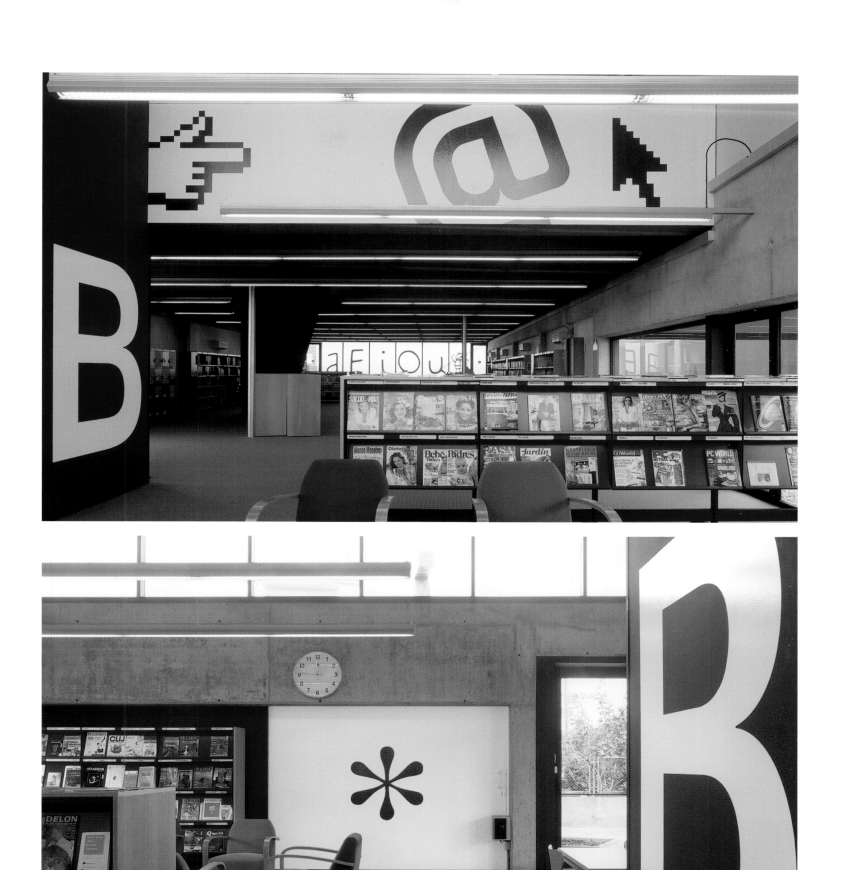

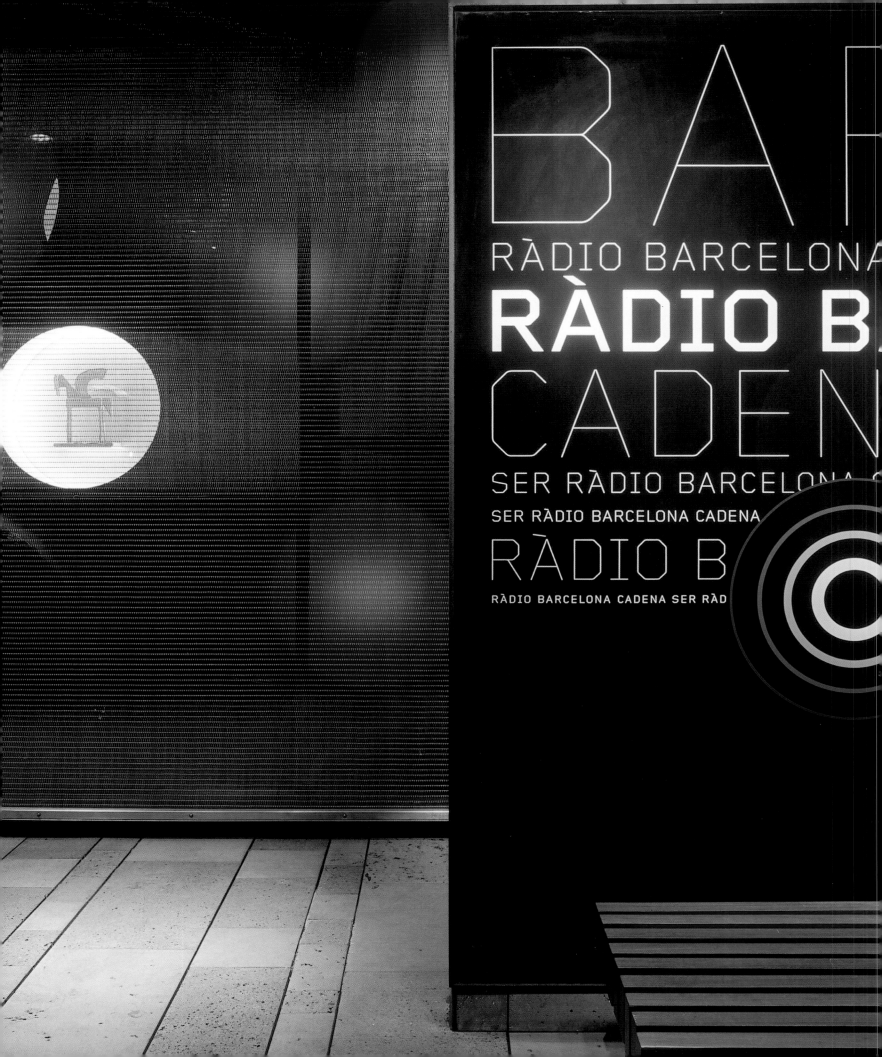

Ràdio Barcelona

Design: **Martín Ruiz de Azúa, Base** Photography: © **Jordi Miralles** Location: **Barcelona, Spain**

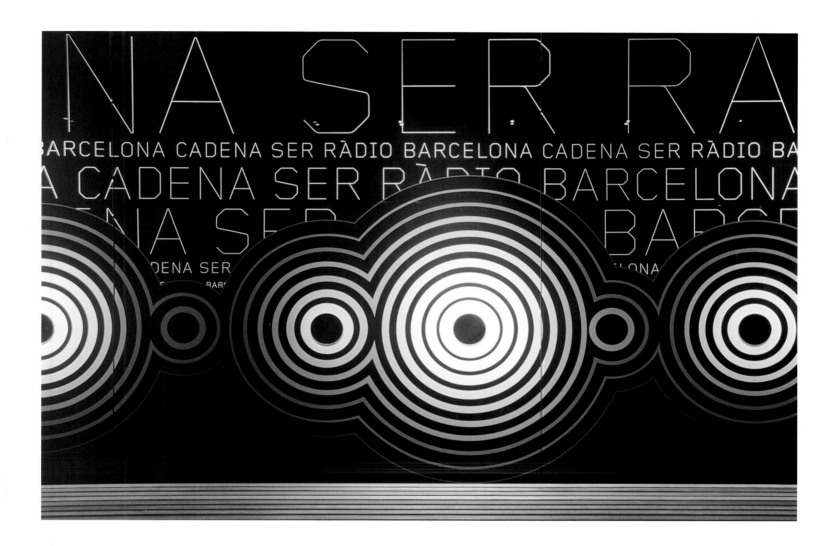

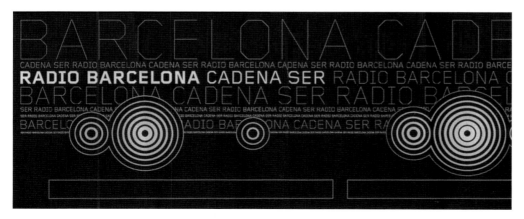

Martín Ruiz de Azúa and the Base team of graphic designers designed the space and graphic image of the new offices of Ràdio Barcelona. The result is an energetic and dynamic image inspired by radio waves. The image, with circular shapes in blue tones, was applied on the wall of the main cloakroom. Behind, a metal meshing emits illuminated circles that accentuate the circular spiral of the whole ensemble.

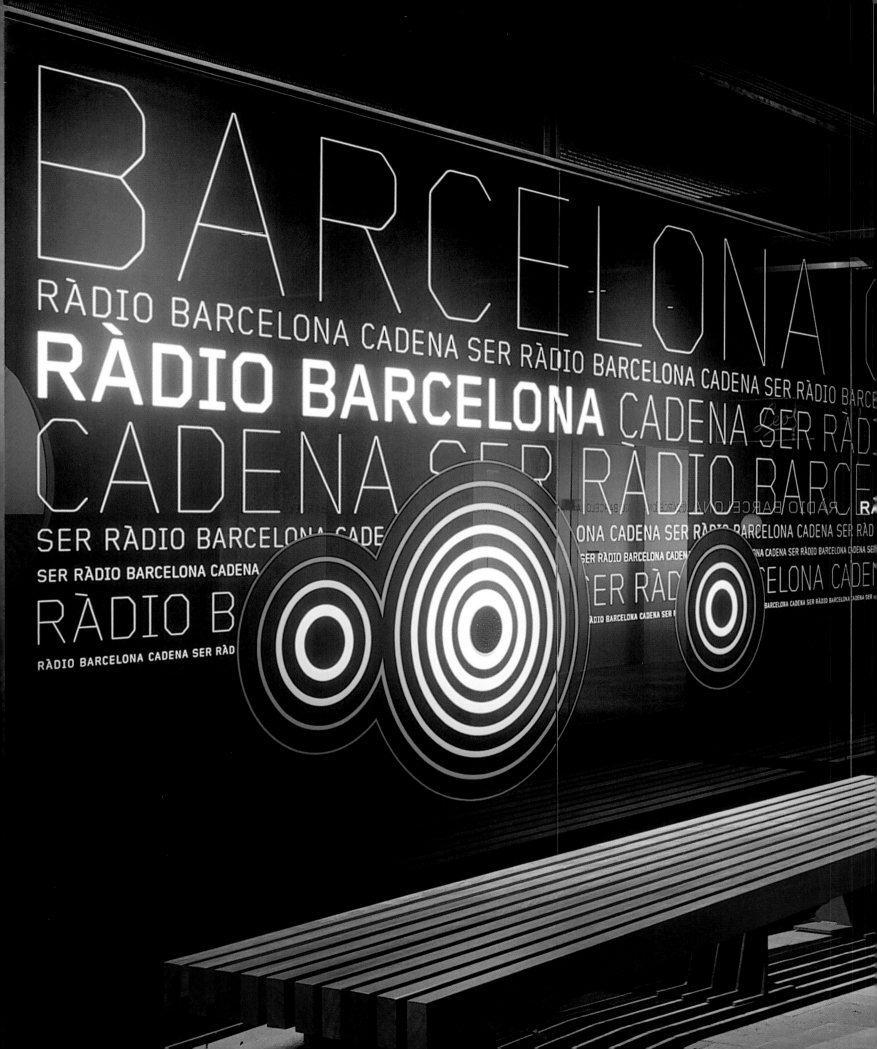

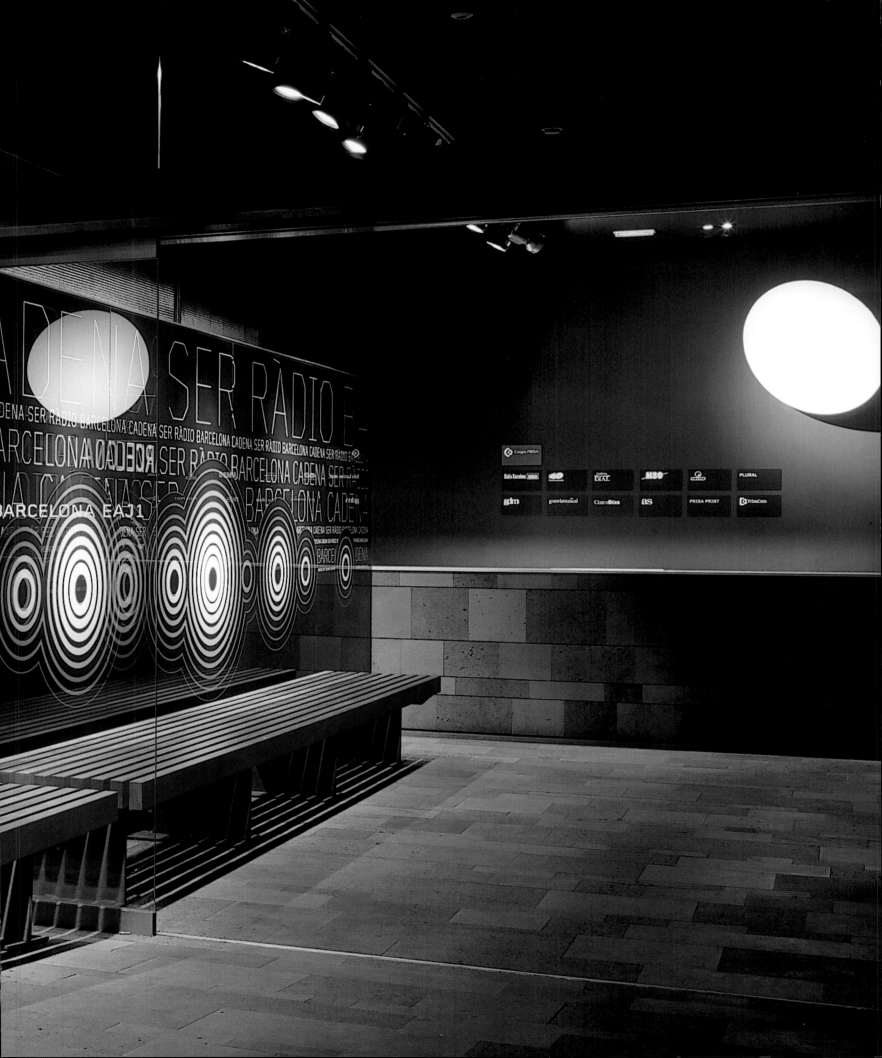

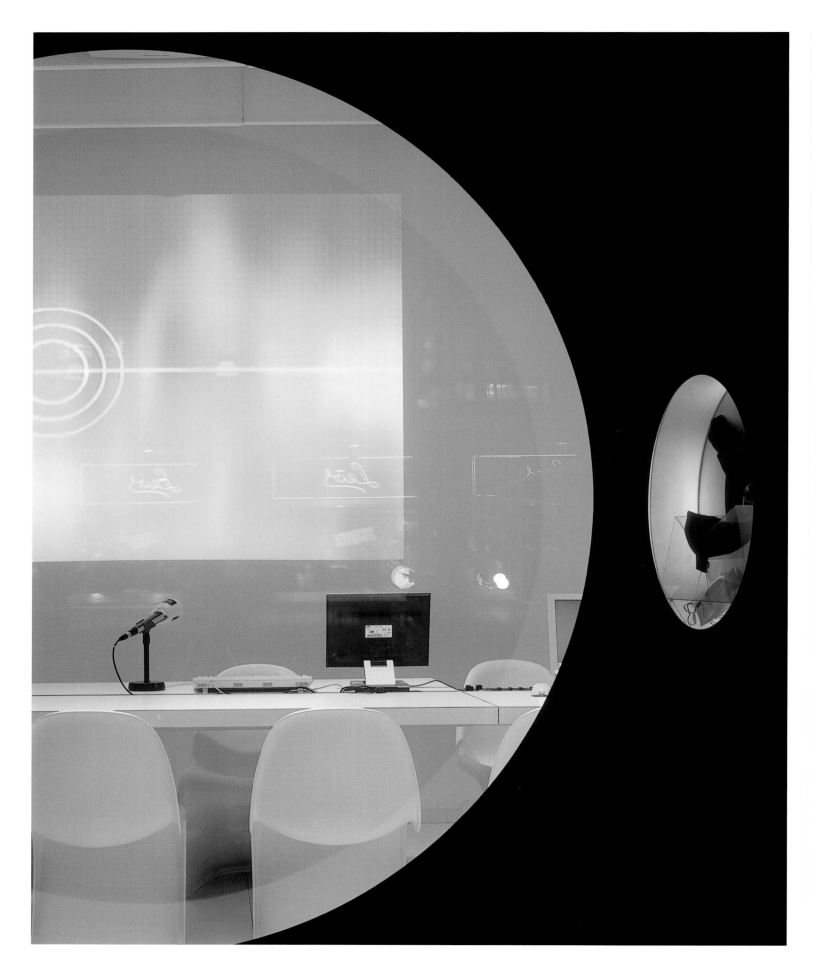

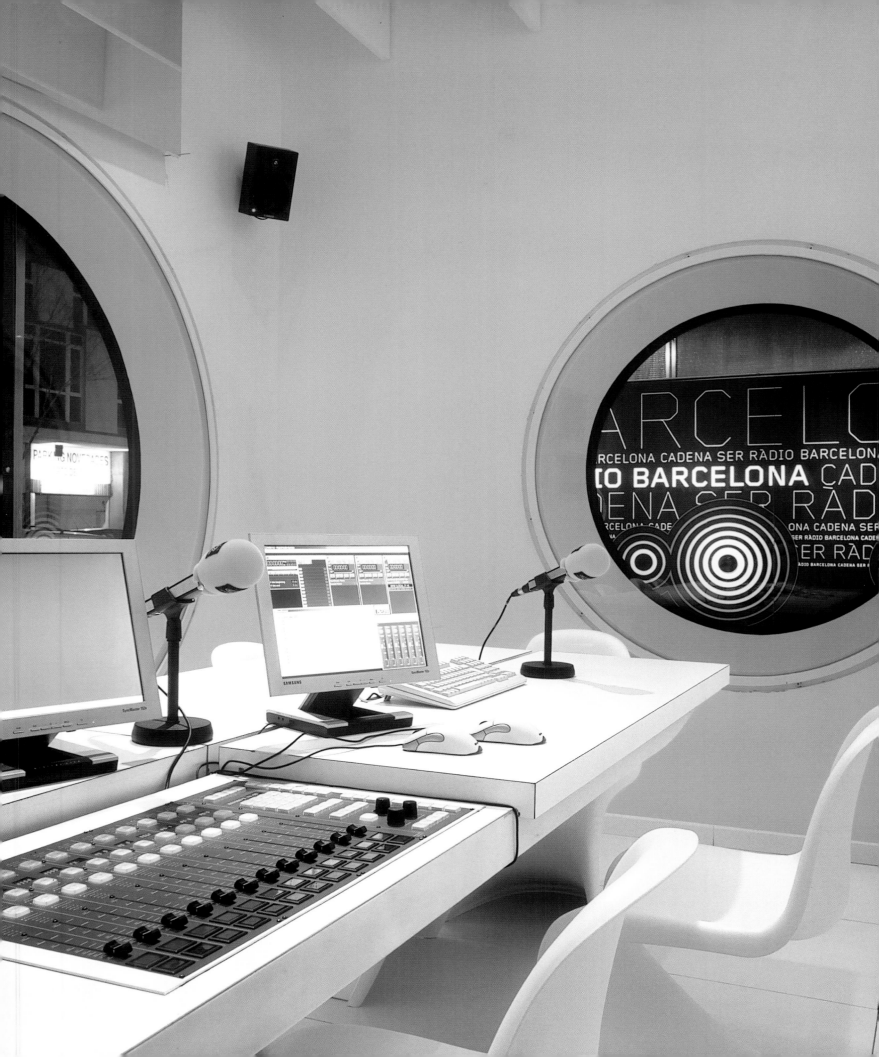

Urban Graphics

This chapter presents a selection of the best graphic projects applied in landscape environments. Each project transforms its environment into a graphic message that captures attention. Understanding what we see is difficult when what we are perceiving is found outside. The message can be ambiguous and difficult to process due to the amount of information and its incompatibility with or similarity to signs that we receive outside.

The projects presented in this chapter achieve perfect integration with the landscape. The graphics and the environment cannot be understood as independent elements, since the synergy between them is essential for comprehending the whole. The graphic element has no meaning if it is not integrated into the landscape, and we cannot decipher the landscape if there is no element that interprets the signs and creates the connection.

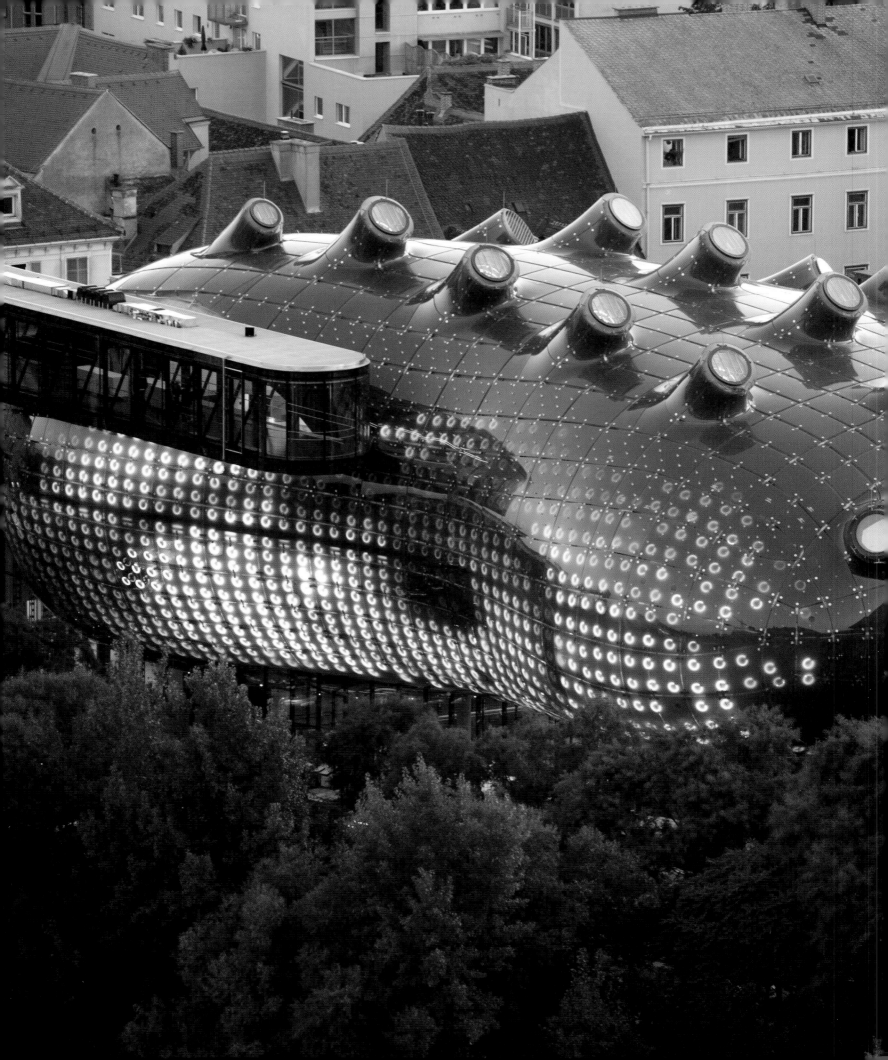

BIX Communicative Display Skin

Design: **Jan Edler & Tim Edler/Realities United** Photography: © Harry Schiffer, E. Klamminger, Landesmuseum Joanneum, United Architects, ArGe Kunsthaus, Pichlerwerke Location: **Graz, Austria**

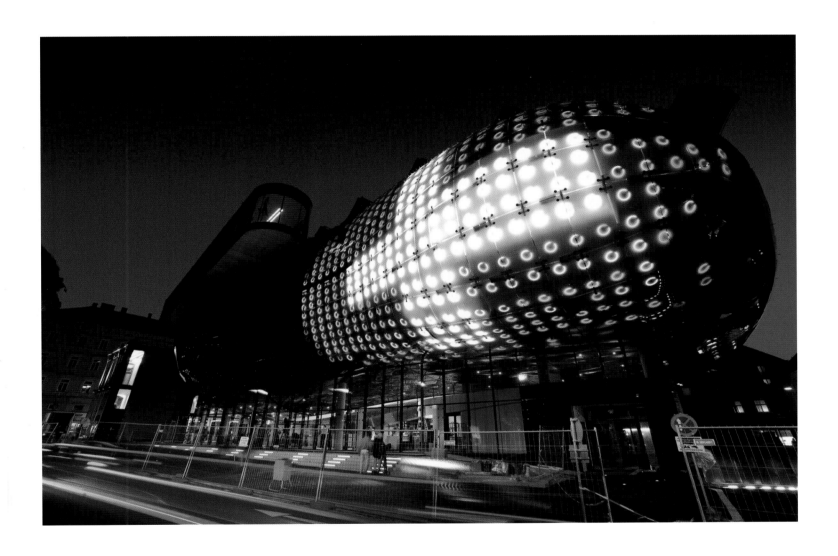

BIX is a luminous installation at Kunsthaus Graz that redefines the classic concept of a static building façade. Thanks to the digital projection of different images onto panels of blue acrylic glass, the shell of this contemporary art museum becomes an alterable membrane that transforms its identity. It is the first permanent non-advertising-related urban installation designed to show artistic productions.

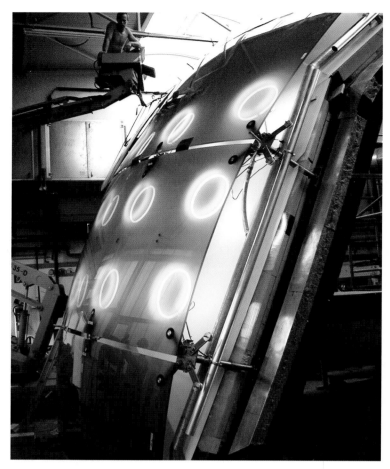

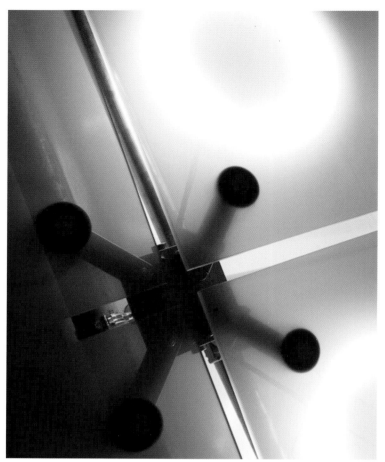

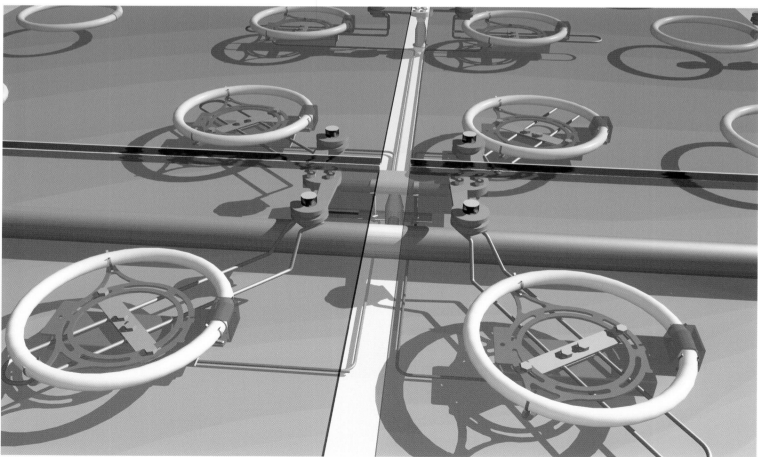

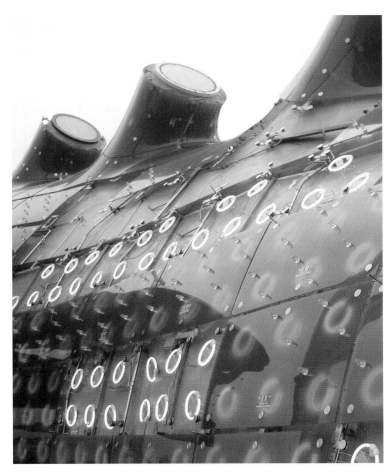

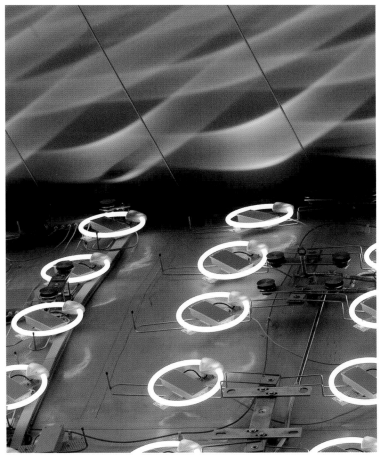

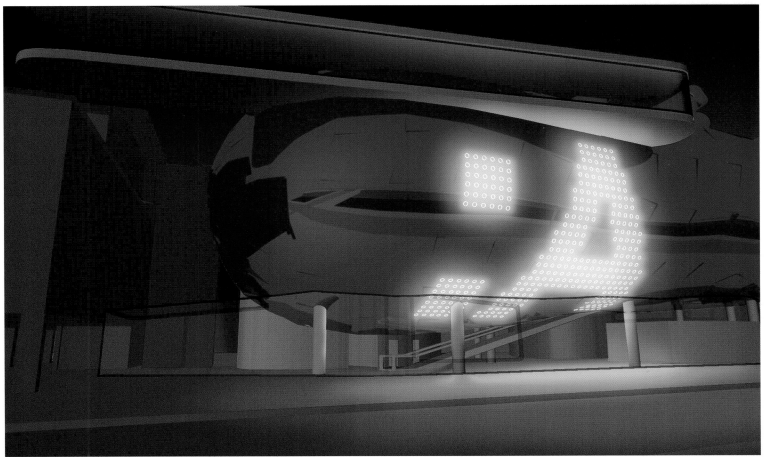

BAUSEKTOR 1 BAUSEKTOR 2 BAUSEKTOR 3

BAUSEKTOR 4 BAUSEKTOR 5 BAUSEKTOR 6 BAUSEKTOR 7

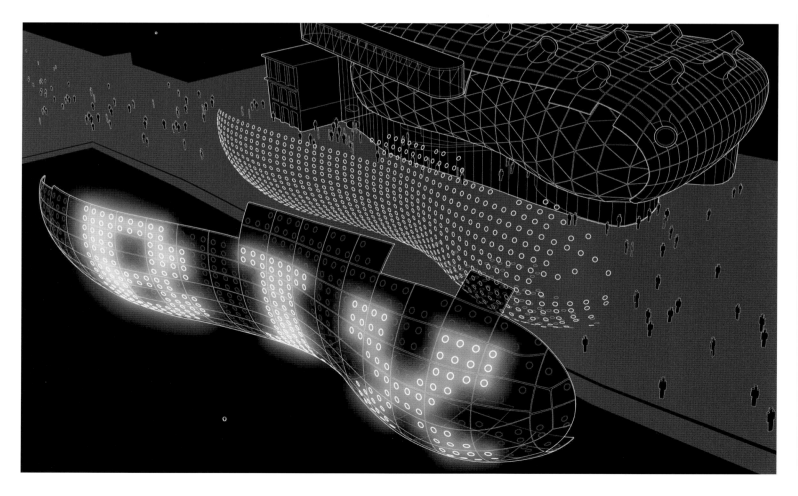

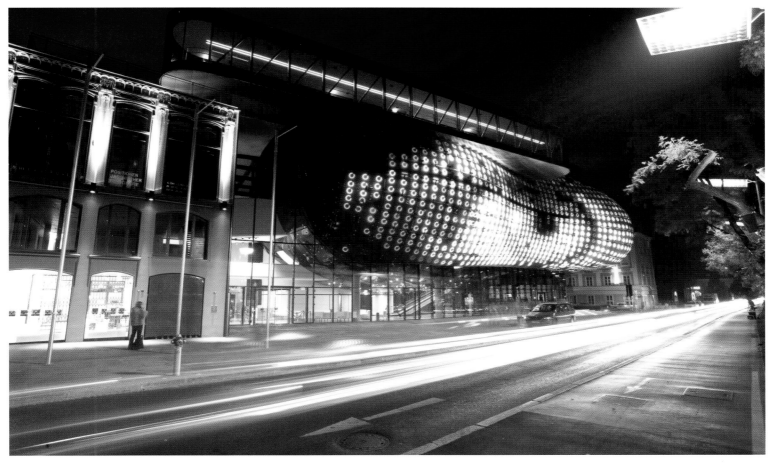

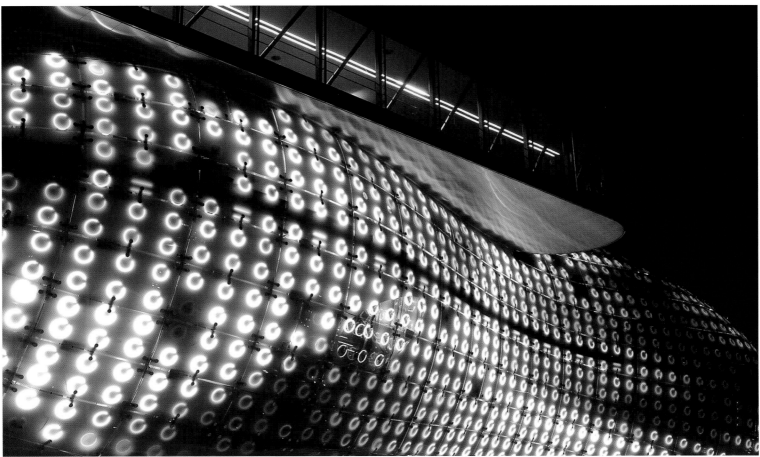

Des Menschen Herz,
es möcht im Busen springen
Er fühlet die Geburt
der neuen Welt.
Sie kommt die Zeit,
da Blum' und Blüten sprießt
Die Farben überall
ihm unverständlich, grüßen

Philipp Otto Runge

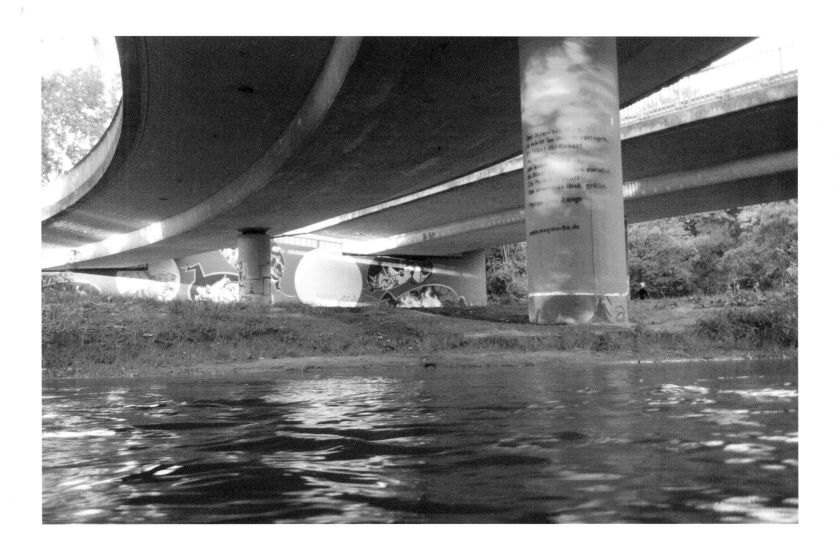

Graffiti Romantik explores the possibilities of public walls through the application of poetry. After obtaining permission from the town council of Karlsruhe, the decision was made to apply poetry as a graphic resource to the walls situated beneath the motorway where no one had drawn any graffiti. The poems use Fraktendon typography, designed by the Magma team itself, a combination of Fraktur and Clarendon typographies.

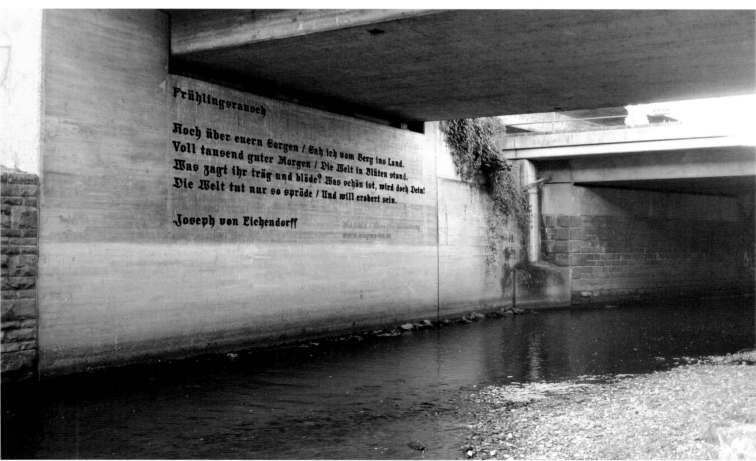

Frühlingsrausch

Hoch über euern Sorgen / Sah ich vom Berg ins Land.
Voll tausend guter Morgen / Die Welt in Blüten stand.
Was zagt ihr träg und blöde? Was schön ist, wird doch Dein!
Die Welt tut nur so spröde / Und will erobert sein.

Joseph von Eichendorff

MAGMA / Büro für Gestaltung
www.magma-ka.de

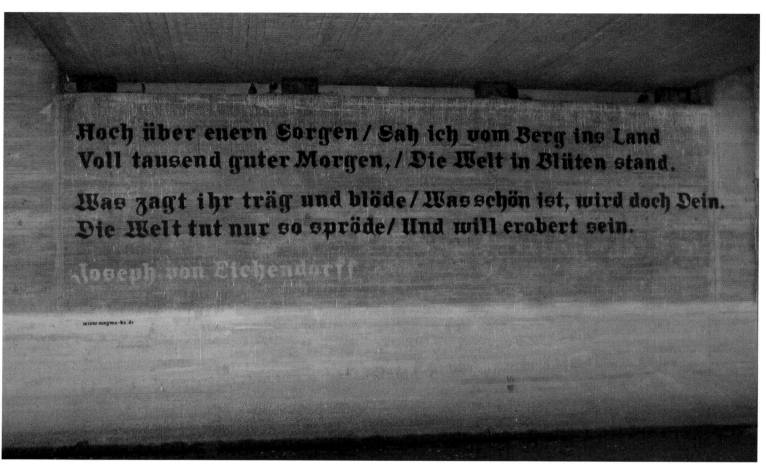

Hoch über euern Sorgen / Sah ich vom Berg ins Land
Voll tausend guter Morgen, / Die Welt in Blüten stand.

Was zagt ihr träg und blöde / Was schön ist, wird doch Dein.
Die Welt tut nur so spröde / Und will erobert sein.

Joseph von Eichendorff

www.magma-ks.de

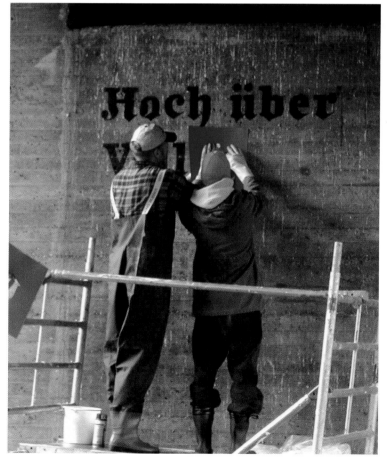

Philipp Otto Runge

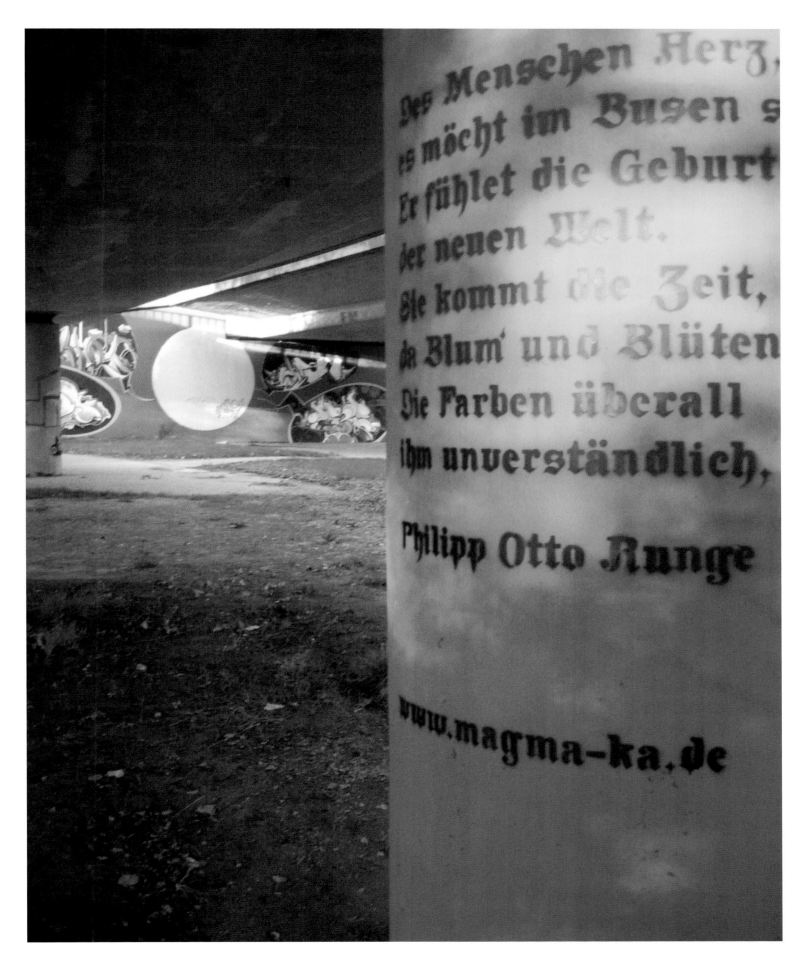

Des Menschen Herz,
es möcht im Busen s
Er fühlet die Geburt
der neuen Welt.
Sie kommt die Zeit,
die Blum' und Blüten
Die Farben überall
ihm unverständlich,

Philipp Otto Runge

www.magma-ka.de

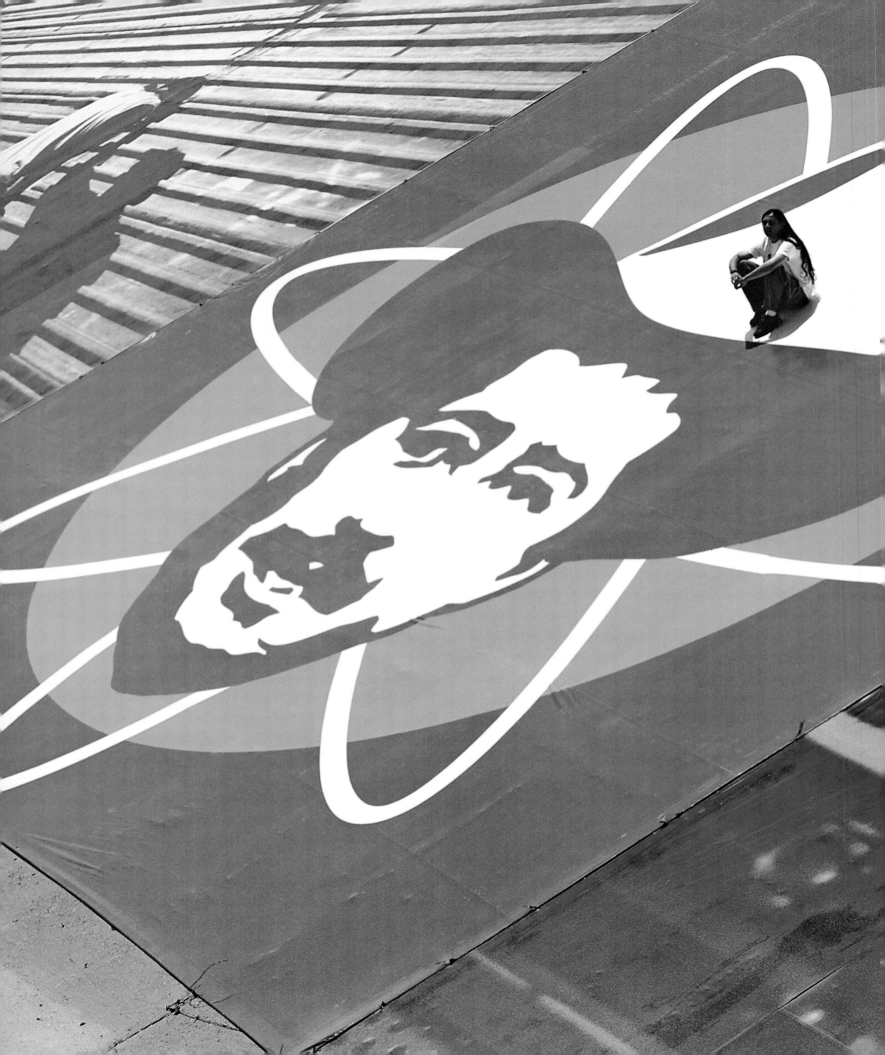

Tijuana Project

Design: **Cato Purnell Partners** Photography: © **Cato Purnell Partners** Location: **Tijuana, Mexico**

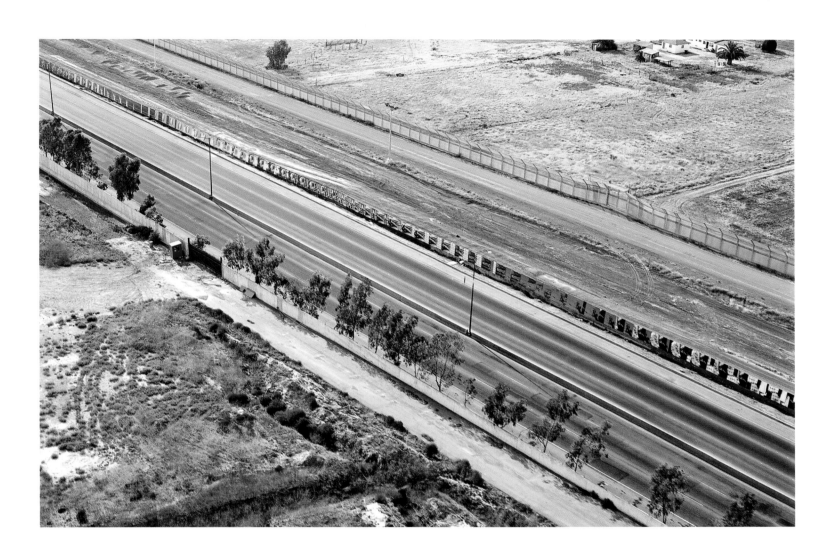

The Cato Purnell Partners team designed this project for one of the most important cultural celebrations of the city of Tijuana. Among other graphic contributions in different public spaces around the city, it developed this megaproject on the motorway that divides Mexico and the United States. Along the road, different large-scale murals were applied with references to the Mexican city, converting it into an attractive visual that transcends the traditional landscape.

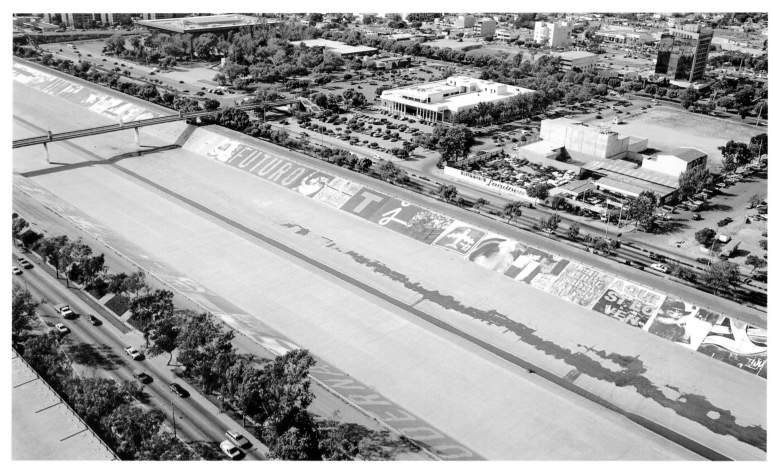

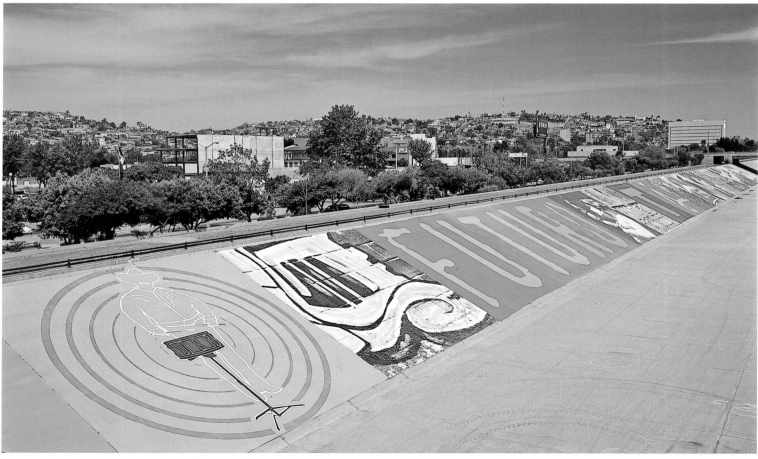

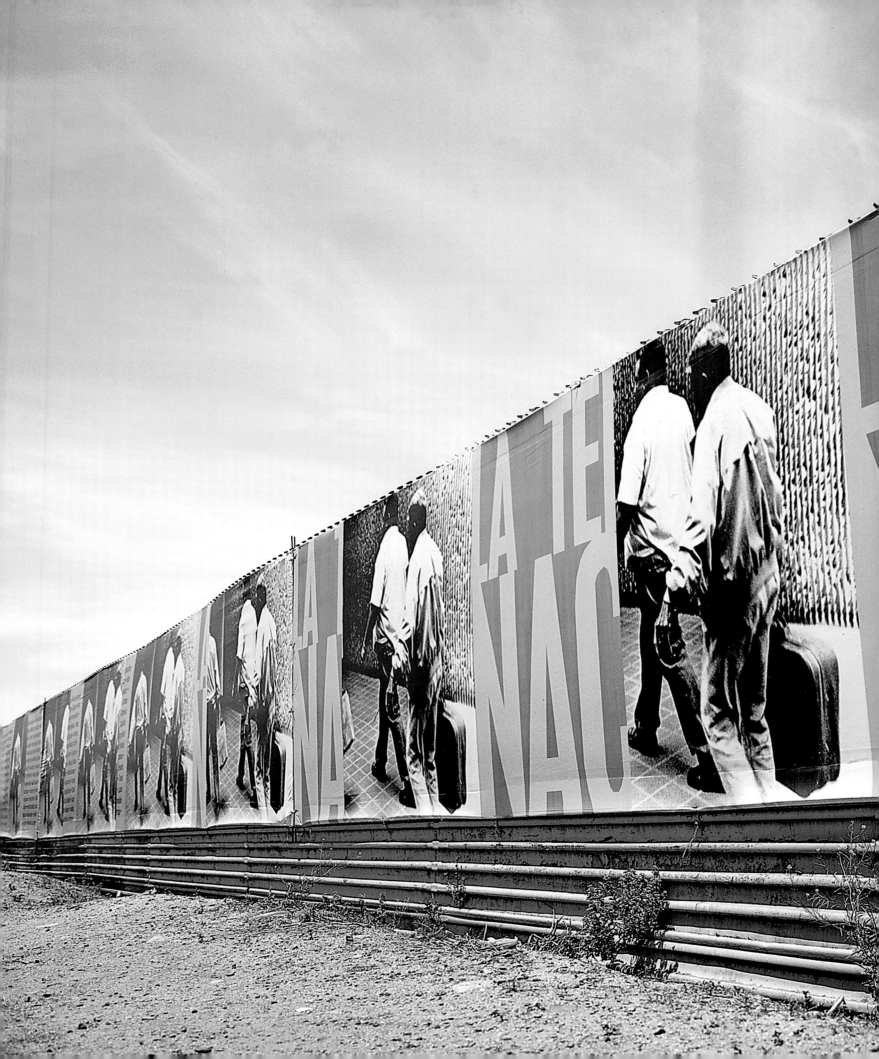

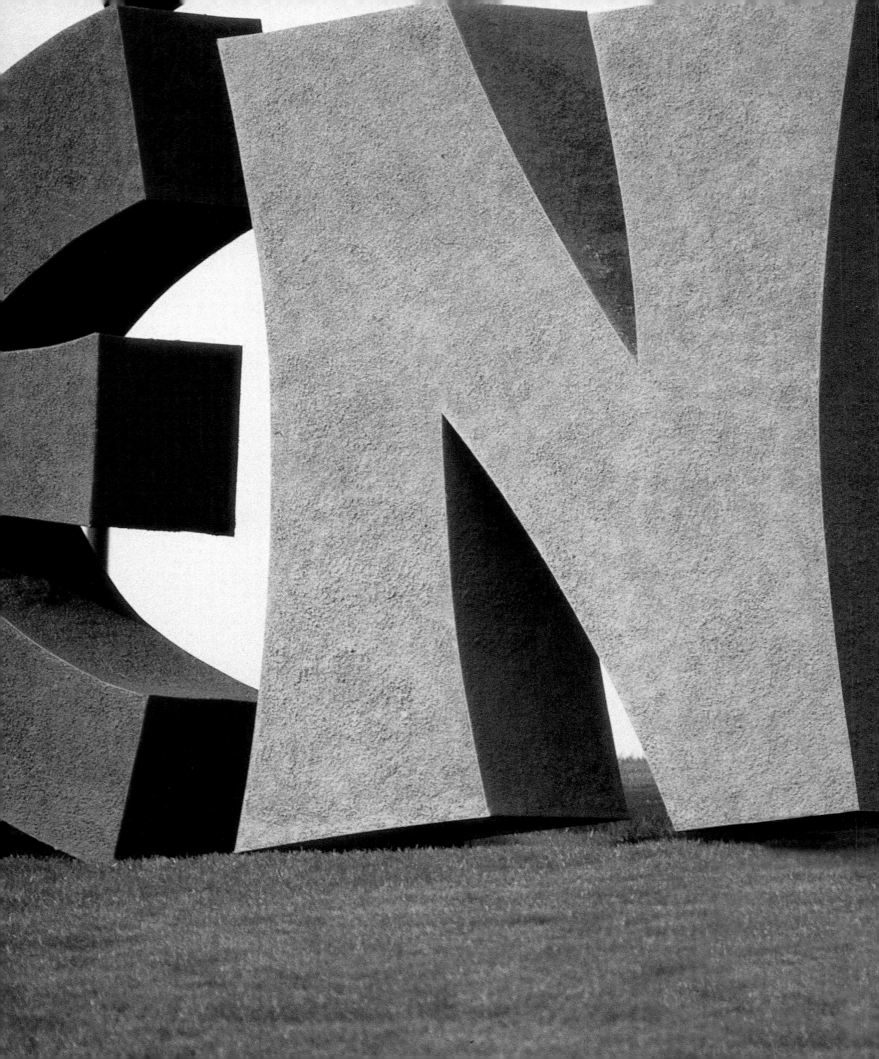

Design: **Diseño Shakespear** Photography: © **Juan Hitters** Location: **Buenos Aires, Argentina**

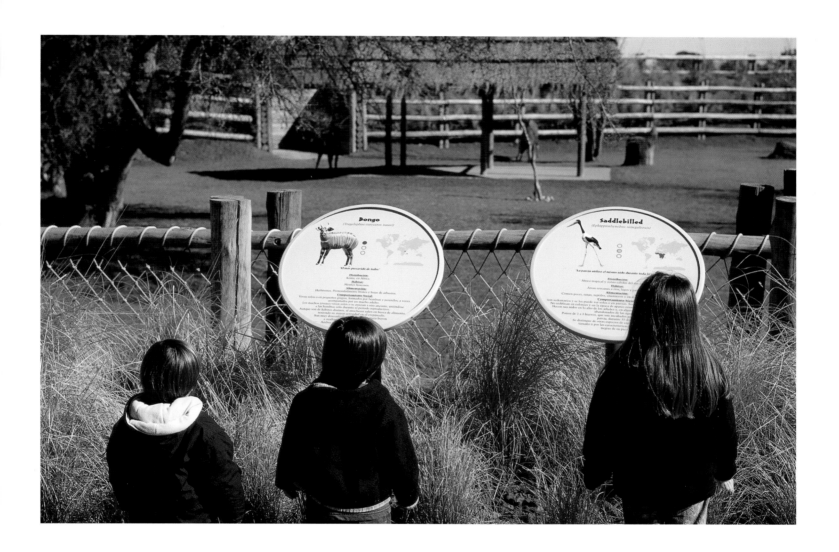

TEMAIKÈN

Diseño Shakespear developed a visual identity project as a vehicle for public recognition of the Temaikèn zoo. The logo and the monogram were created with a ductile and organic typography, and show the name with colors in a range of earth tones, linked with nature. This triad of basic elements of identity—logo, iso, and color—creates a unit of acknowledgment and value for the label.

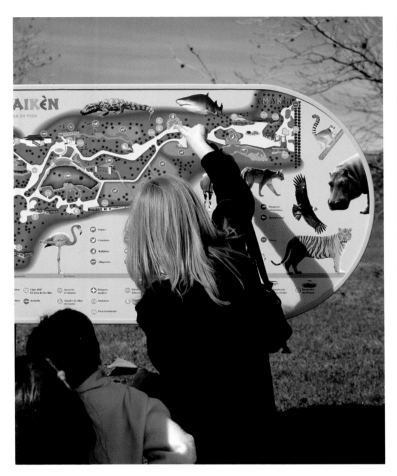

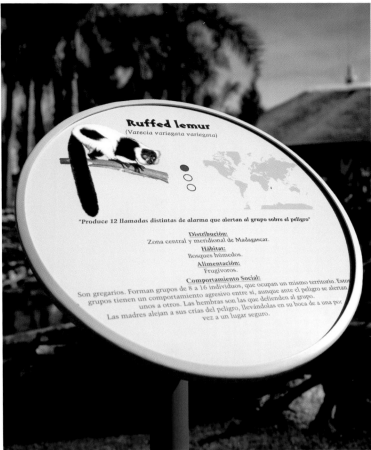

Ruffed lemur
(*Varecia variegata variegata*)

"Produce 12 llamadas distintas de alarma que alertan al grupo sobre el peligro"

Distribución:
Zona central y meridional de Madagascar.
Hábitat:
Bosques húmedos.
Alimentación:
Frugívoros.
Comportamiento Social:
Son gregarios. Forman grupos de 8 a 16 individuos, que ocupan un mismo territorio. Estos grupos tienen un comportamiento agresivo entre sí, aunque ante el peligro se alertan unos a otros. Las hembras son las que defienden al grupo. Las madres alejan a sus crías del peligro, llevándolas en su boca de a una por vez a un lugar seguro.

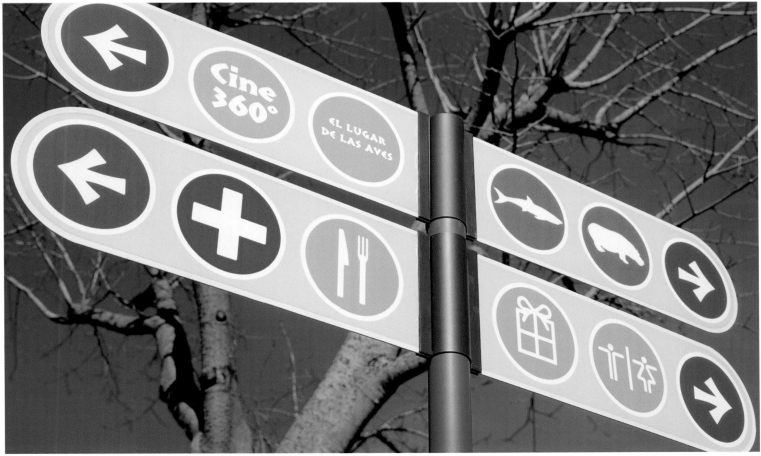

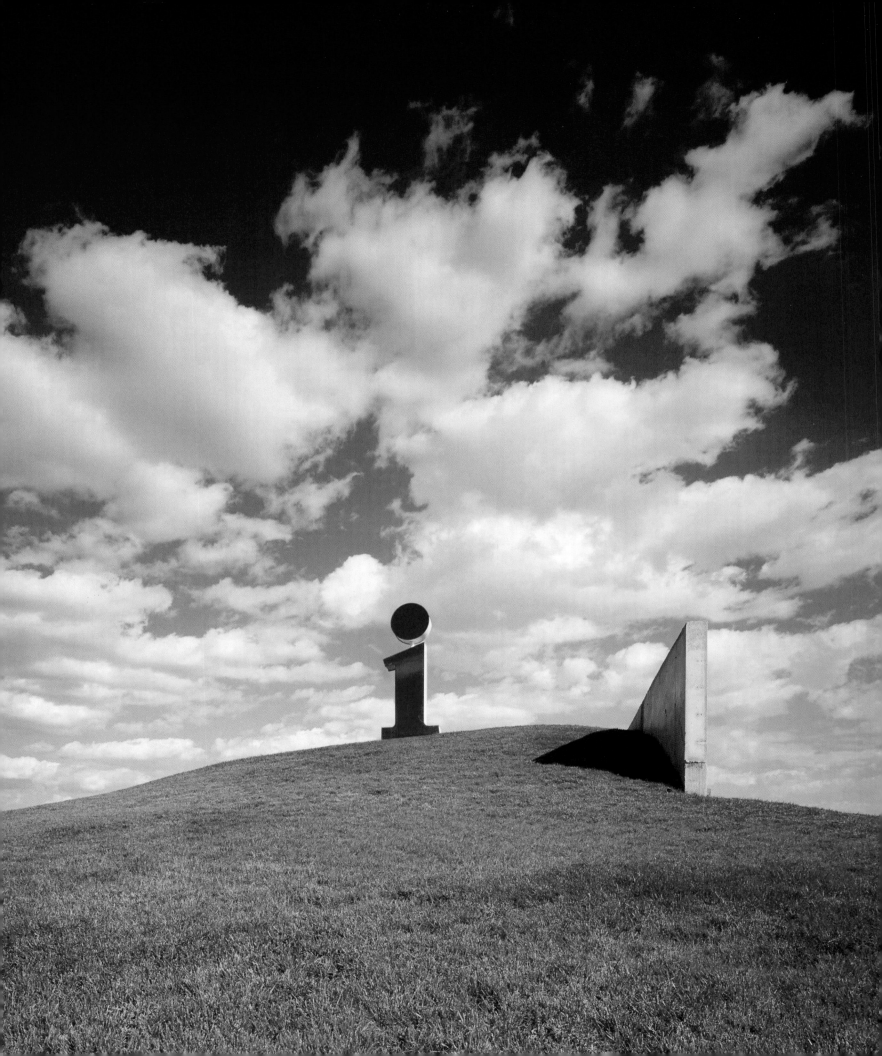

Oficina de turismo

Design: **Ad Hoc** Photography: © **David Frutos** Location: **Murcia, Spain**

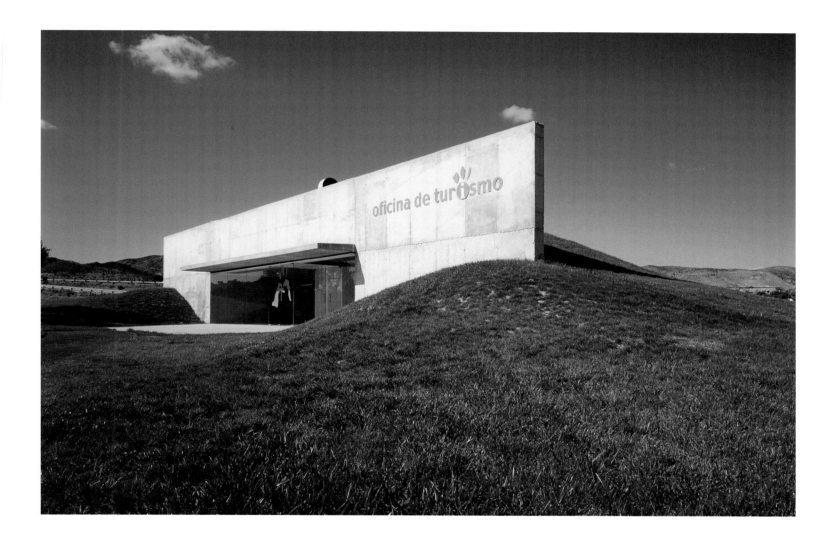

From the Mediterranean coast road that leads to the village of Puerto Lumbreras, the pictogram information symbol can be seen up on the hill, homage to Claes Oldenburg. At night, this symbol opposite the village's tourist office, turns into a floating luminous sign; a hint at the interrelation between design and landscape that has remained intact throughout the application.

With the collaboration of the firm of architects, Kohn Pedersen Fox, Imaginary Forces designed the digital screens for Morgan Stanley, which reflect the spirit of the company in the middle of Times Square. One of the most important challenges was to achieve perfect graphic and visual integration with the structure of the building. The screens are constantly showing different images depicting Morgan Stanley's company policies.

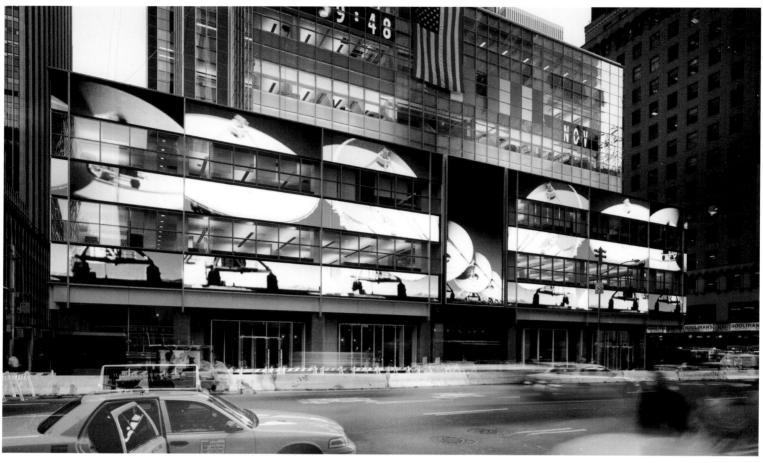

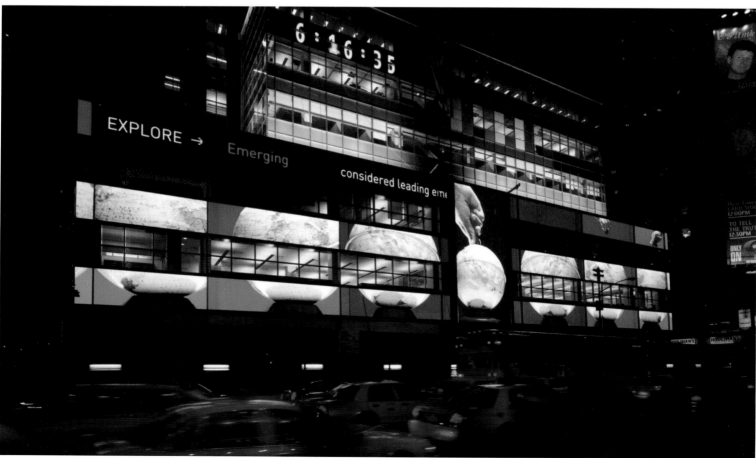

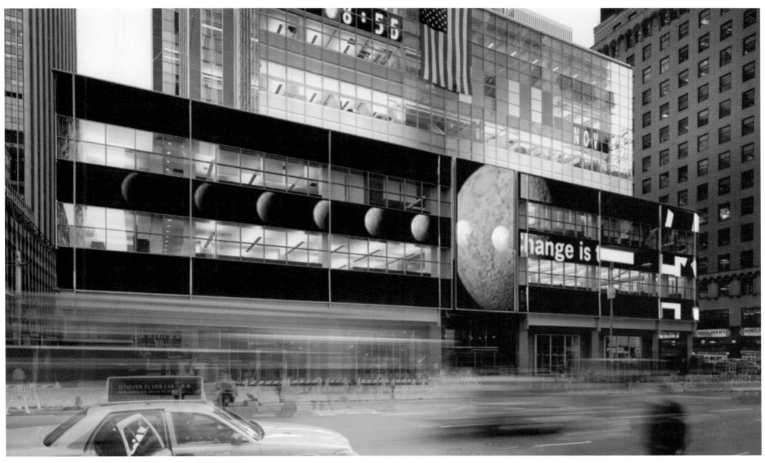

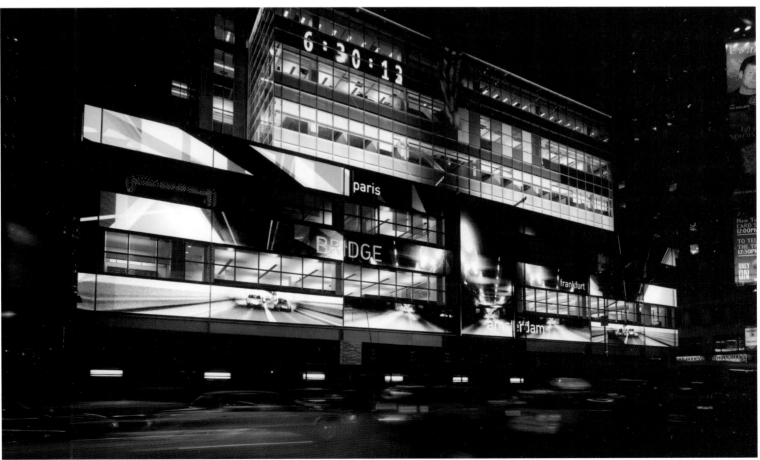

Rin Rin

Design: **Klein Dytham Architecture** Photography: © **Katsuhisa Kida** Location: **Tokyo, Japan**

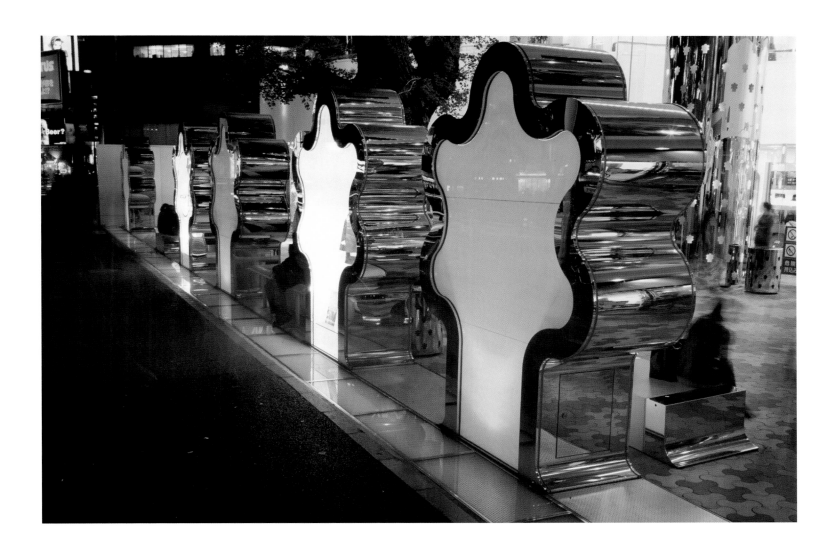

To celebrate its twenty-second anniversary, Laforet department store commissioned Klein Dytham to design a graphic ephemeral installation in the main entrance of the shop. The design consists of a row of stainless steel trees that, when seen from a lateral angle, appear as a single unbroken wall, but when seen from the front turn into different points of entry to the shop. Rin Rin means "small forest" in Japanese.

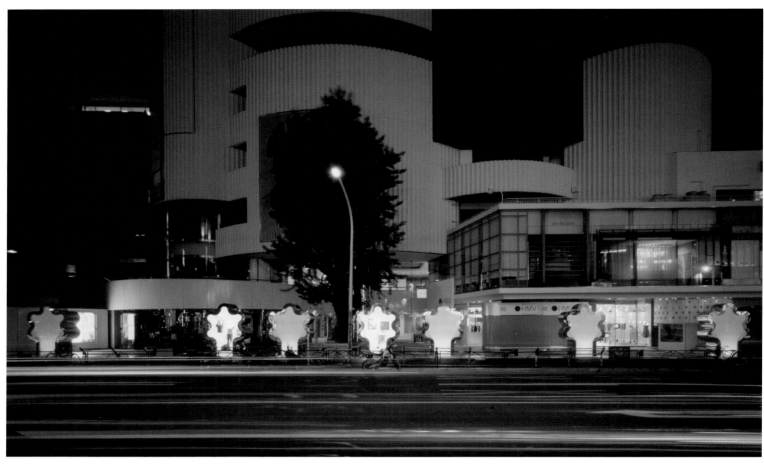

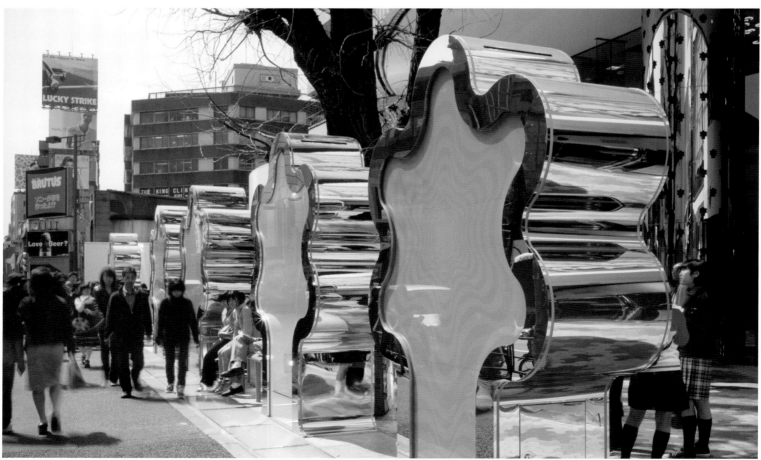

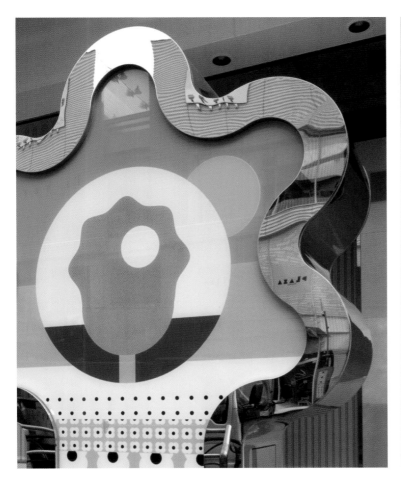

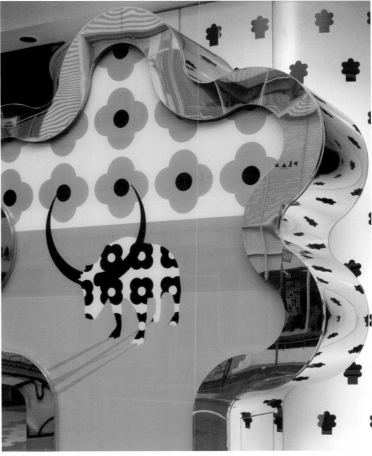

Address numbers

Design: **PFP Disseny Gràfic, AV62 Arquitectos** Photography: © **Eugeni Pons** Location: **Plentzia, Spain**

Achieving a relationship more visual than physical, these two shops colonize the topography through an audacious graphic resource that crowns the uppermost section: a volume of lacquered aluminium of intense greens and blues that displays the number of the shop. This graphic resource is the work of graphic designers Quim Pintó and Montse Fabregat (PFP Disseny Gràfic), who used colors inspired by the works of the artist Rodney Graham.

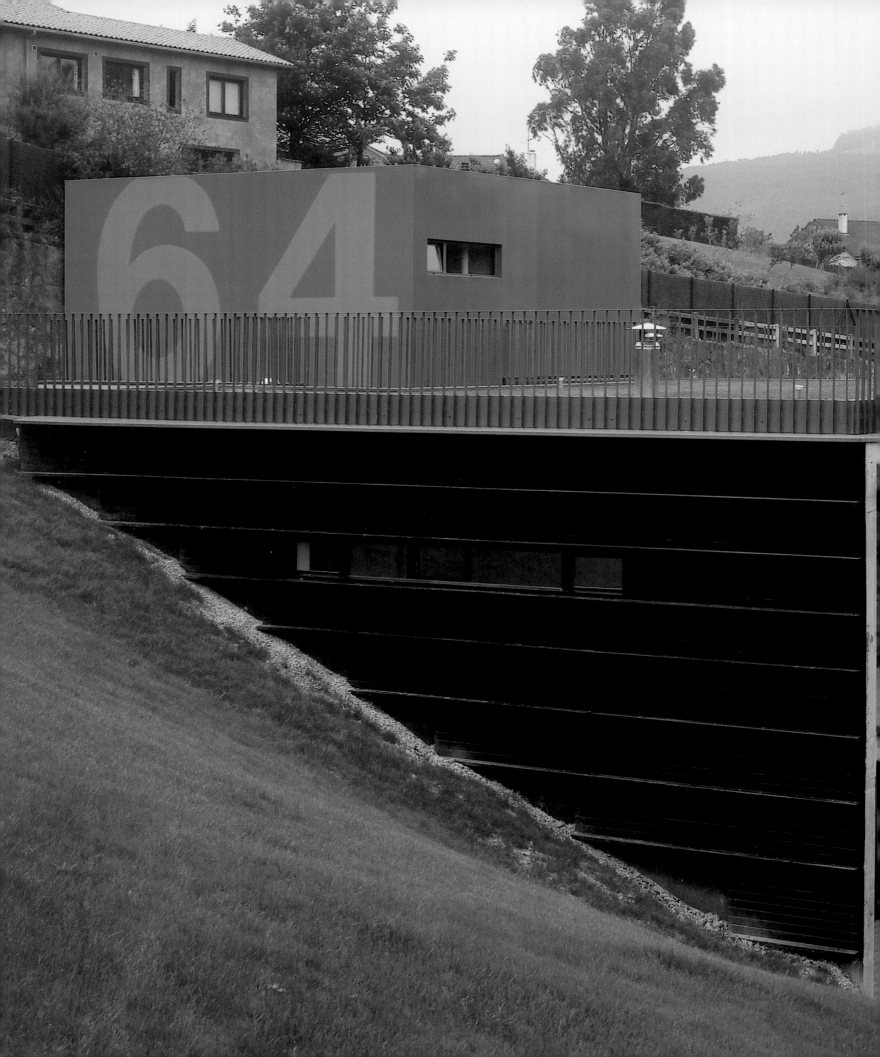

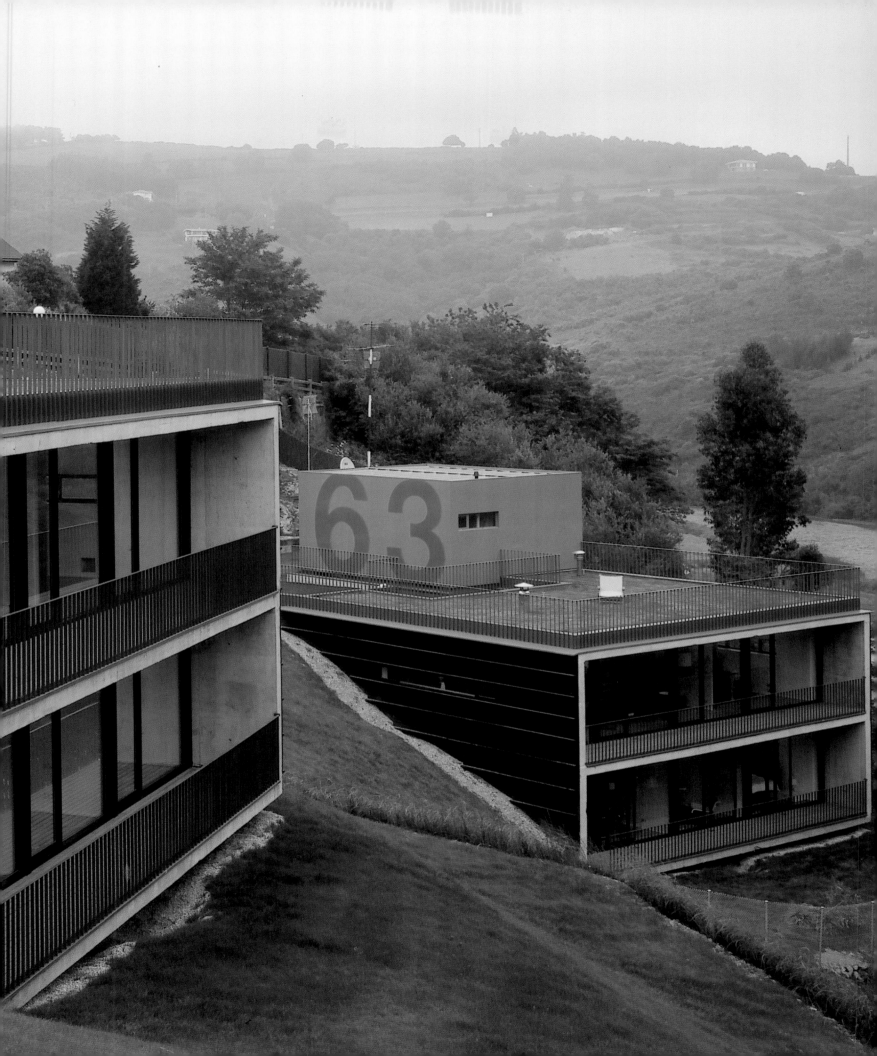

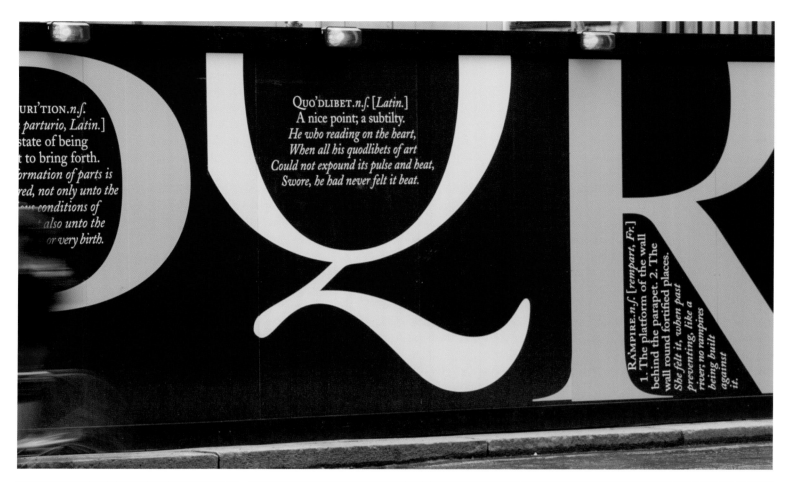

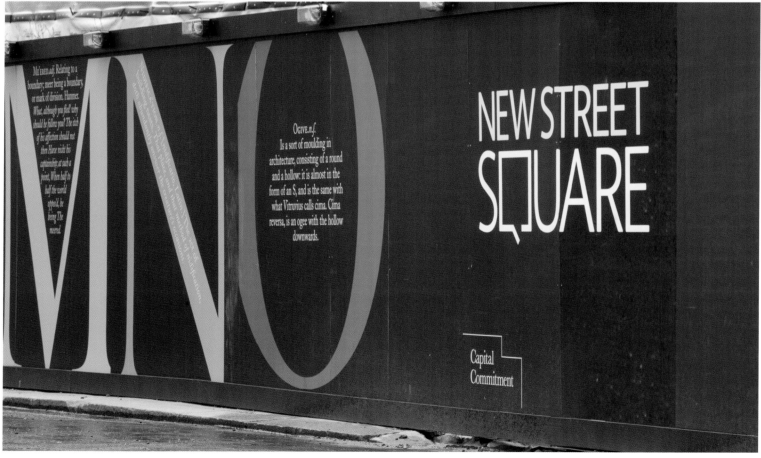

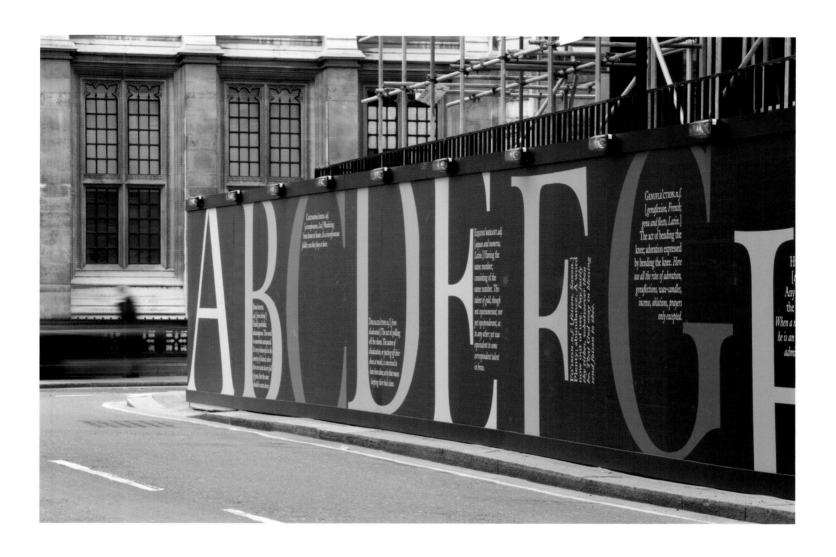

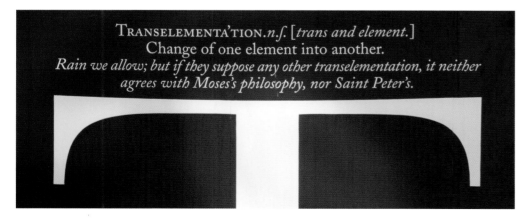

TRANSELEMENTA'TION. *n.ſ.* [*trans and element.*]
Change of one element into another.
Rain we allow; but if they suppose any other transelementation, it neither agrees with Moses's philosophy, nor Saint Peter's.

Hat-trick designed this advertising billboard for one of the corners of New Street, in London. The billboard stands out in the middle of the street because of the force of enormous letters that make up the alphabet. Each letter incorporates a word with its corresponding definition, as if it were a dictionary for public use. The design, which has gained notoriety in the middle of the street, stands out even more because of its use of vivid colors.

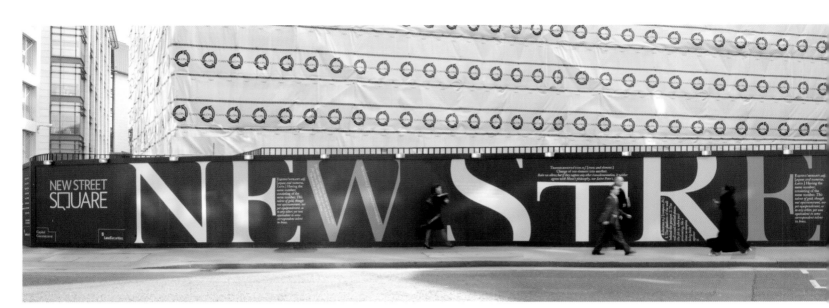

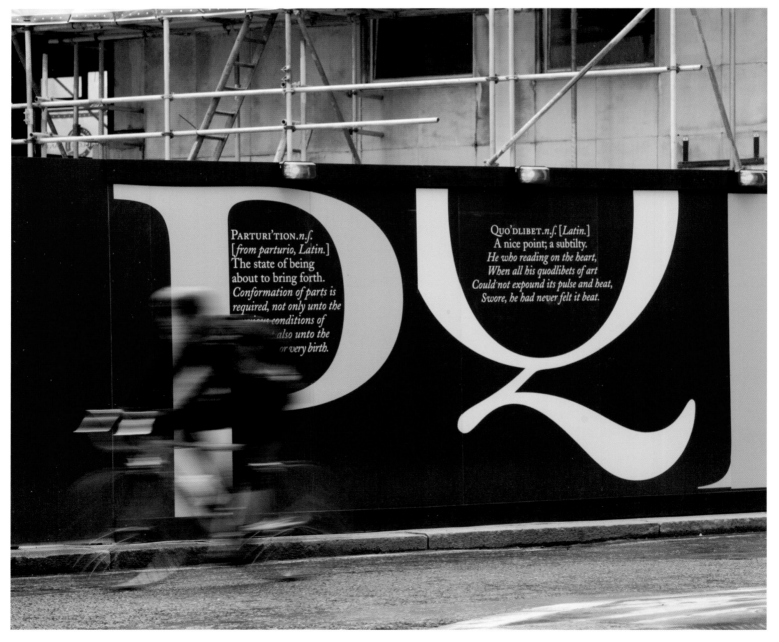

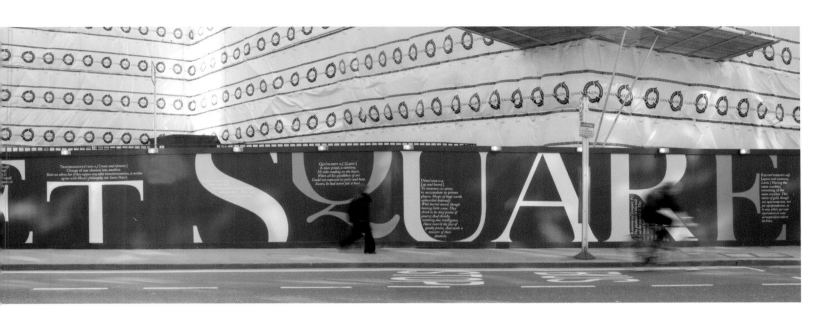

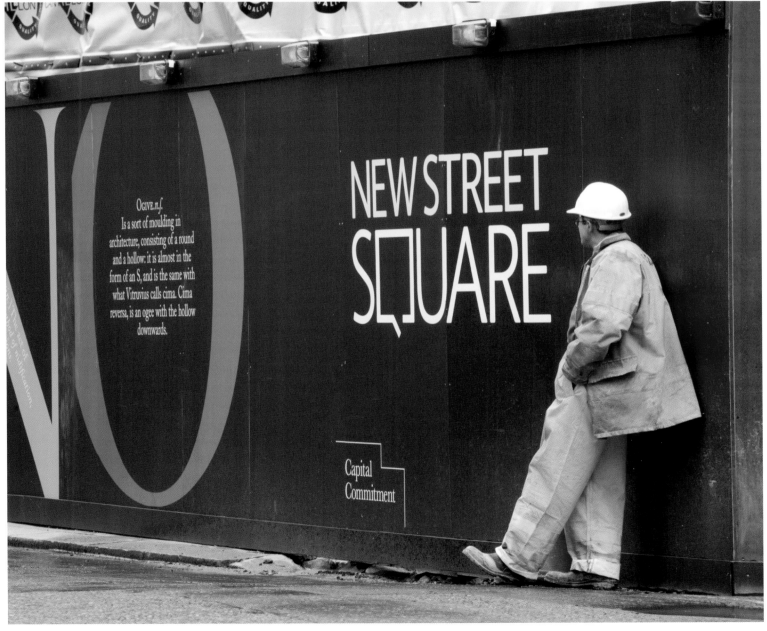

Love You to Death

Design: **Philip Foeckler** Photography: © **Melissa Chow** Location: **San Francisco, USA**

This logo was designed for an awareness campaign for human immunodeficiency virus (HIV) and above all to connote the relationship between sex, love, compromise, AIDS, and death. The logo was applied to various items like T-shirts, buttons, and stickers that were hung up at different points around San Francisco.

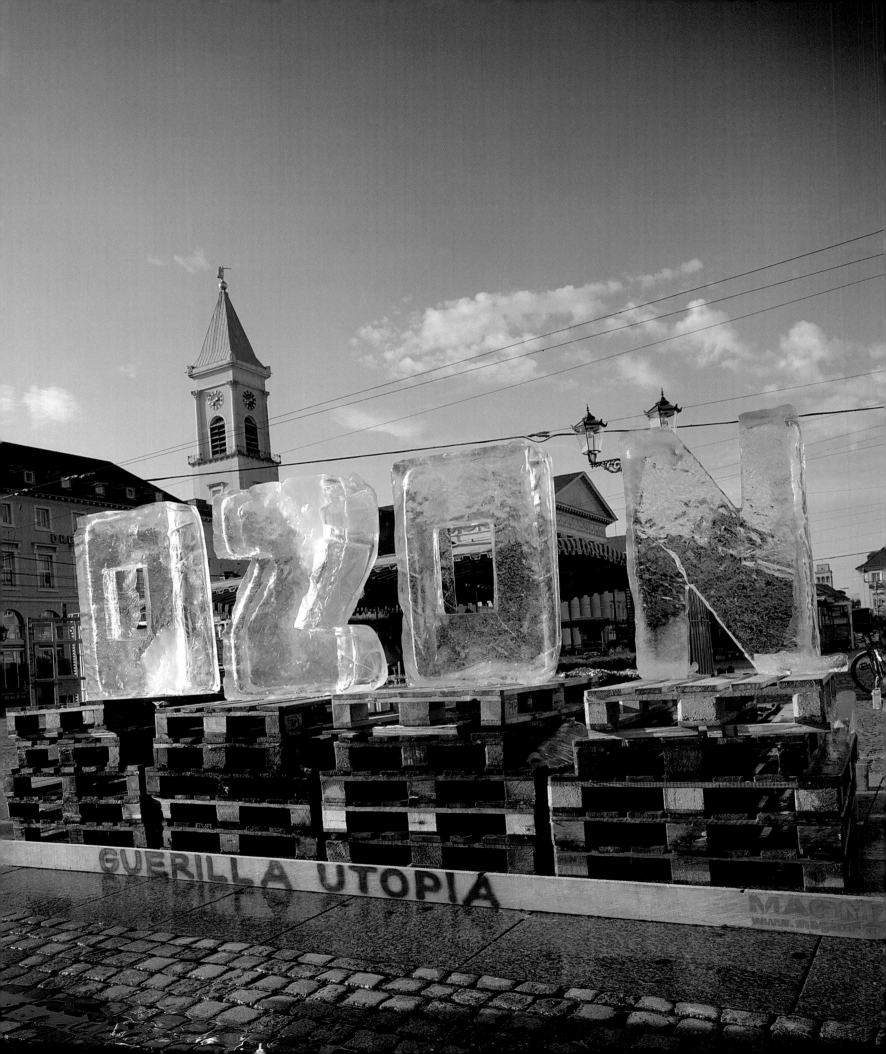

Ozon

Design: **Magma** Photography: © **Jochen Sand** Location: **Karlsruhe, Germany**

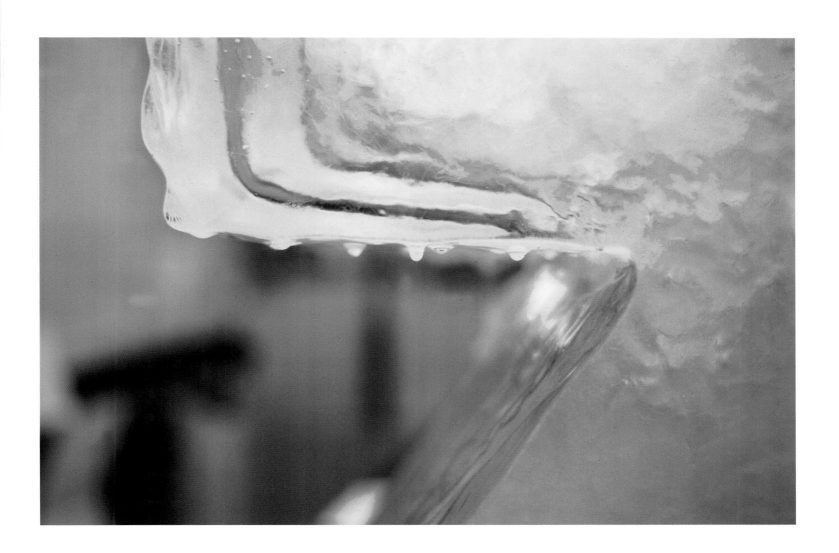

Ozon is one of the first projects of the Guerilla Utopia series developed to explore the possibilities of public space. Magma designed four letters, each made with more than 264 gallons of frozen water, together spelling "ozon," which were then placed in the middle of Karlsruhe market. This experimental project's objective is to show that the letters exposed to the sun melt at the same speed as the ozone layer.

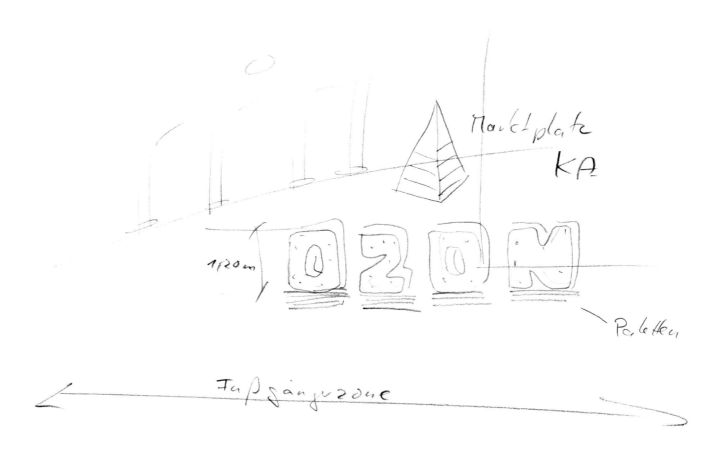

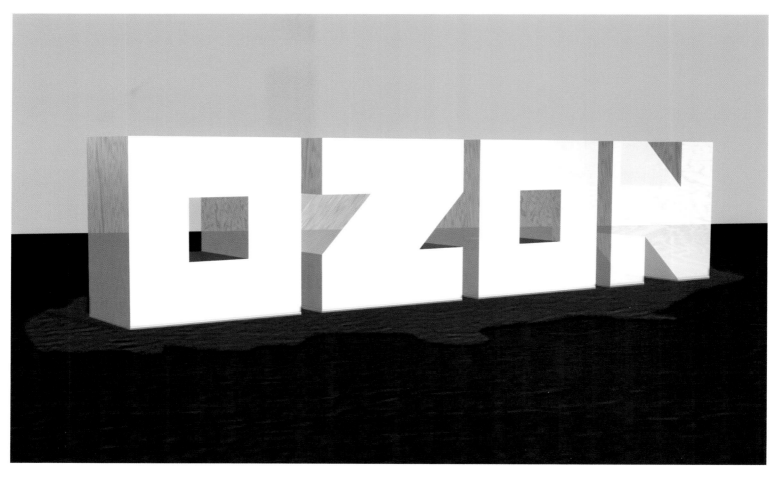

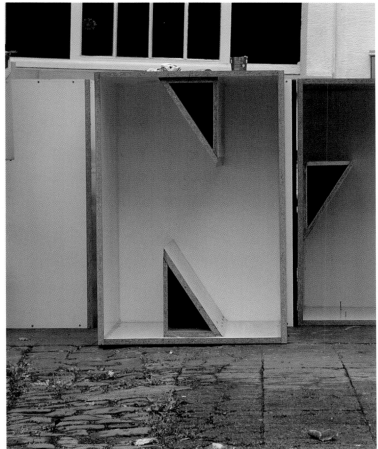

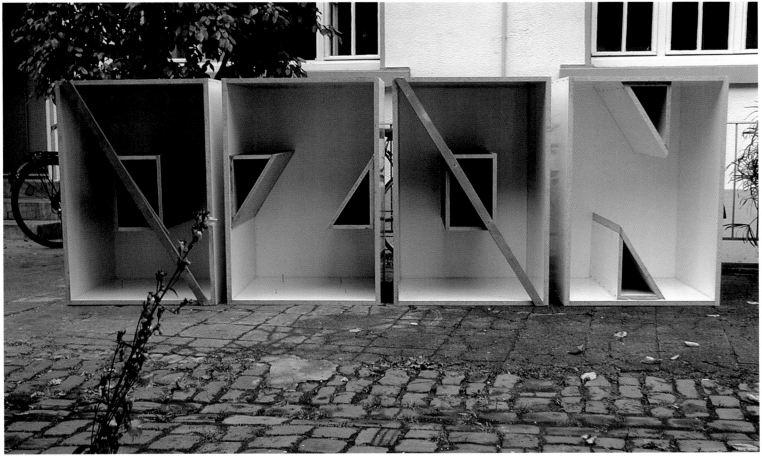

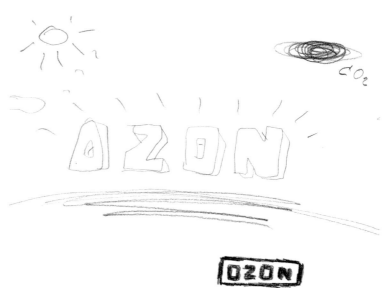

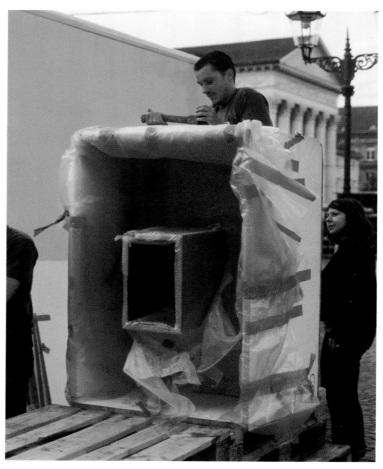

OZON

120 cm

80 cm

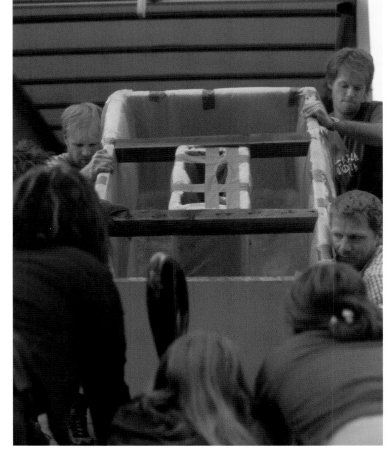

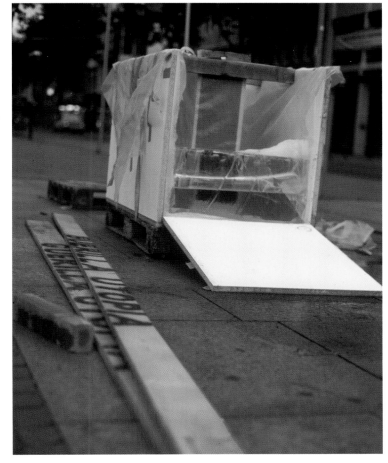

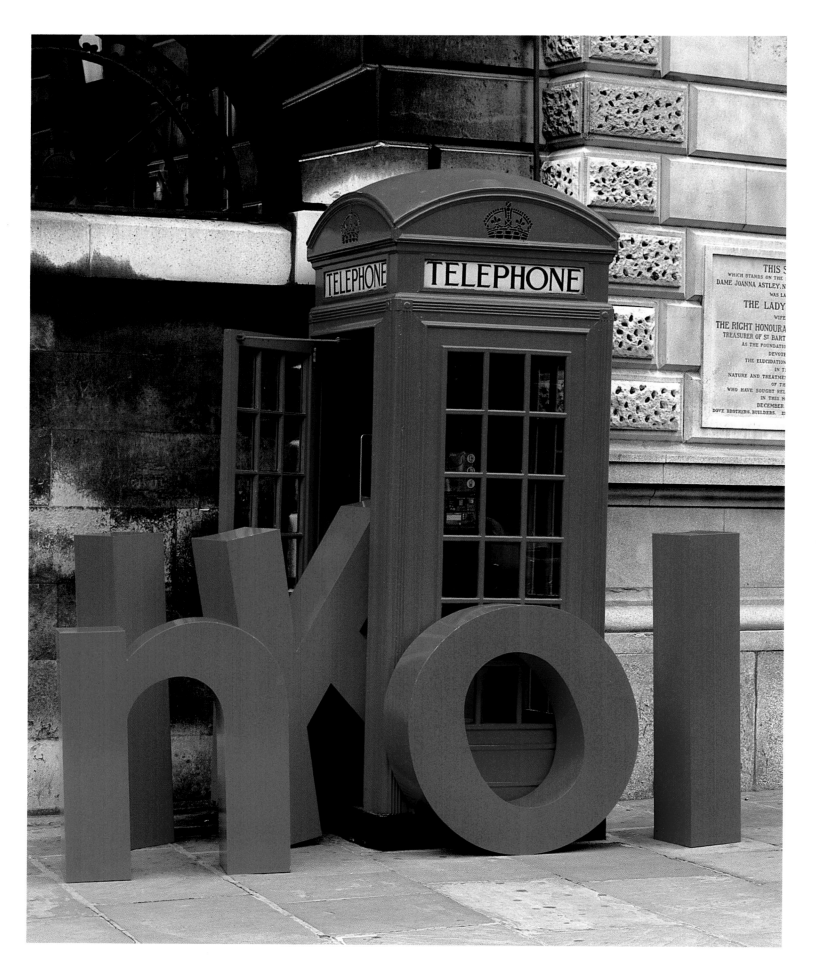

234

Design: **NB Studio** Photography: **© Jon Osborne** Location: **London, UK**

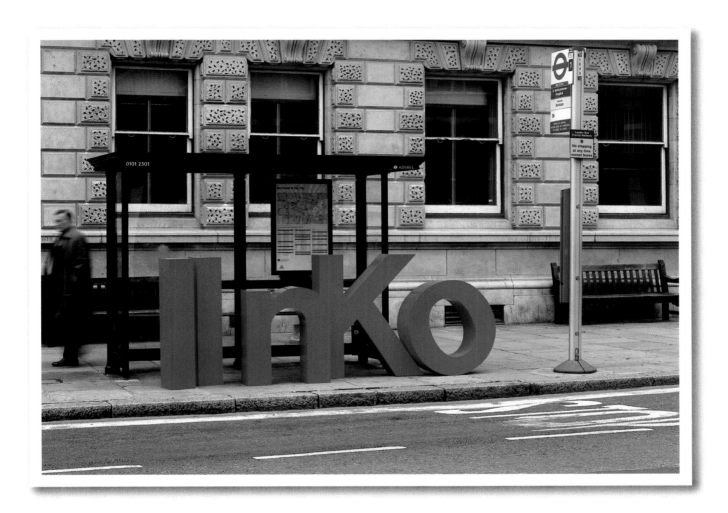

NB Studio used the enormous letters that formed the name of the brand Knoll in its old showroom as a graphic resource along the streets of London. Positioned randomly in front of telephone booths and bus stops, this ephemeral exhibition, titled "Big Red Letter Day," was created to announce the reopening of its new showroom in the city.

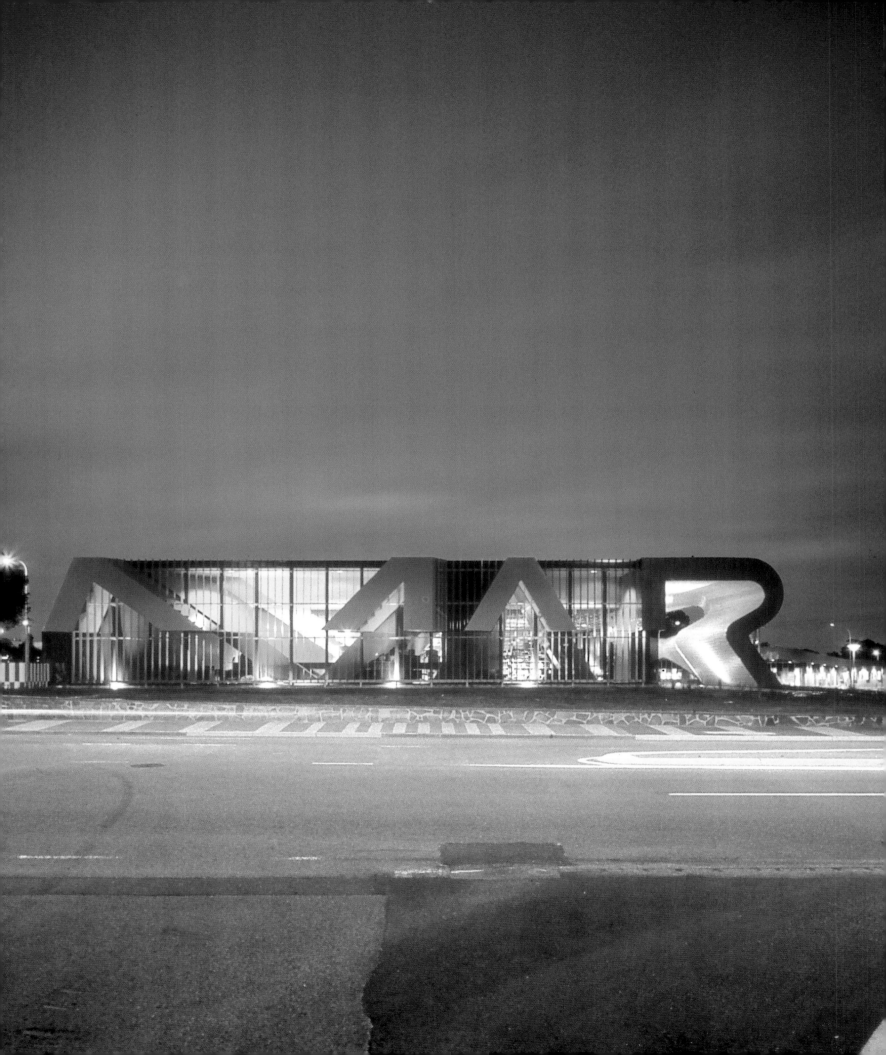

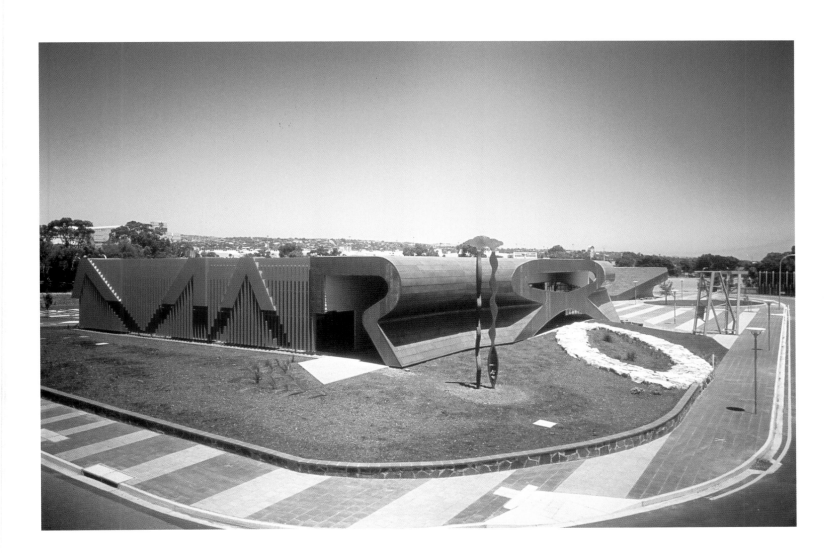

One of the most difficult challenges was to integrate the name of the city, Marion, into the façade of the building to create a tangible reference point. The visual image from the exterior has a strong impact. Not only was the structure used to position some of the graphic elements, even the shell of the building forms a giant R and creates an unbeatable optical effect. Around the building, diverse and reoccurring graphics invite the passerby to approach the building.

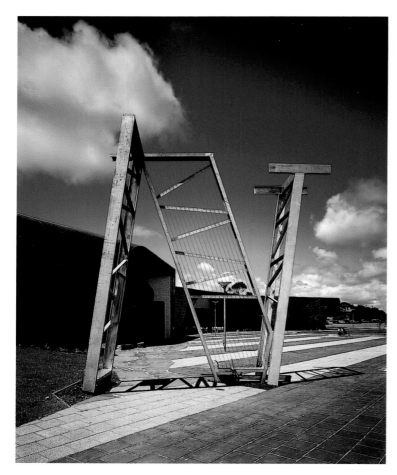

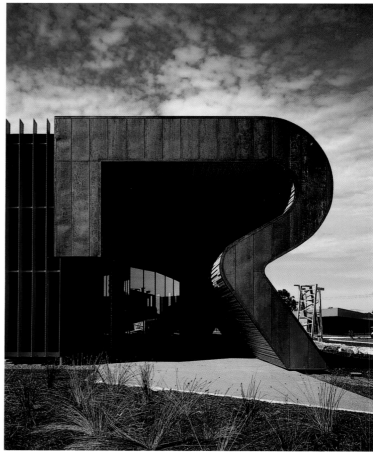

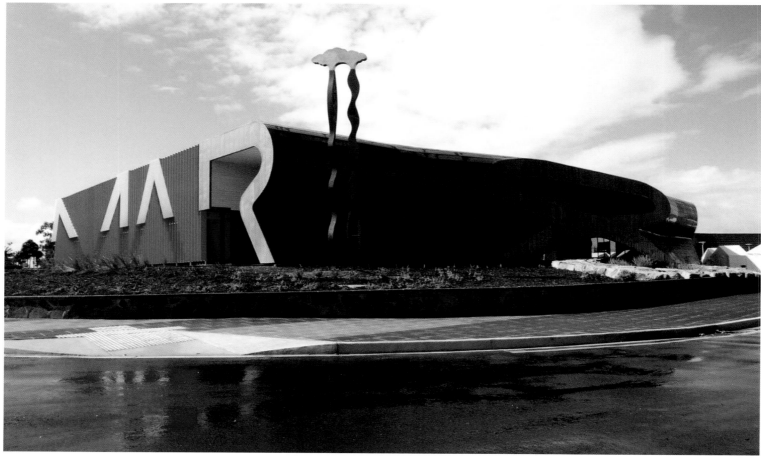

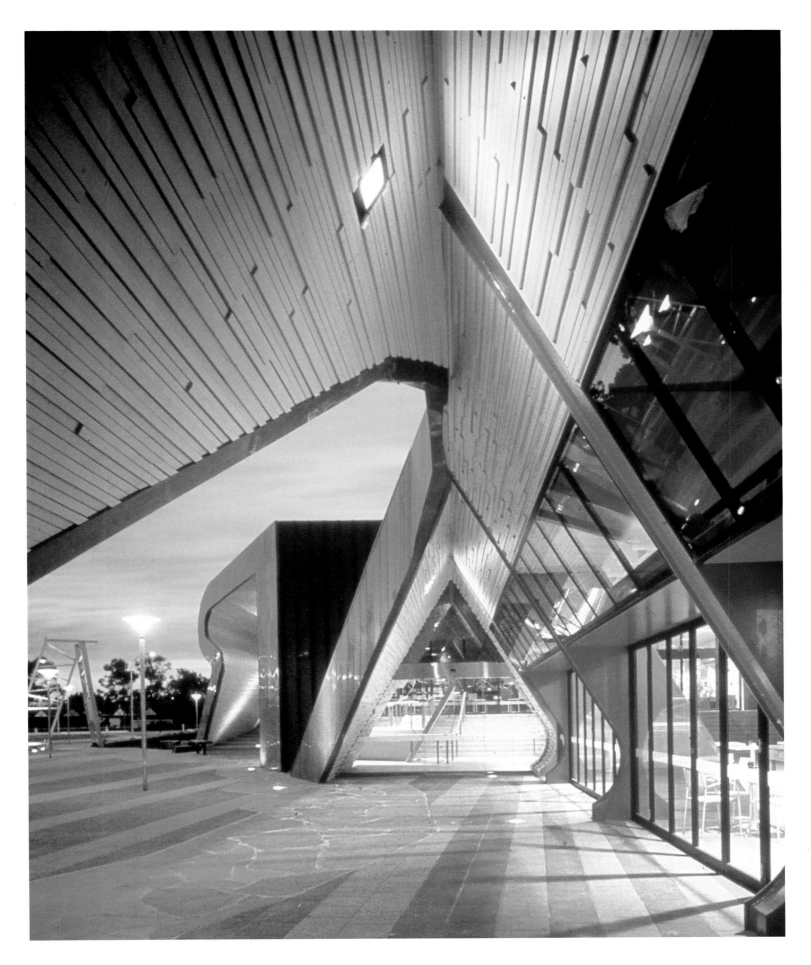

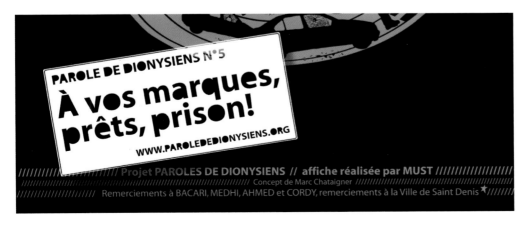

This project was started with the idea of creating a more visual public space. After obtaining subsidies from the French government, Marc Chataigner designed 120 posters to be exhibited in the streets of Saint Denis, in the north of Paris. The idea was to create a publicity campaign, Real Publicity, where everyone could anonymously tell their story. Each poster combined black with a colored background to maintain the chromatic uniformity of the campaign.

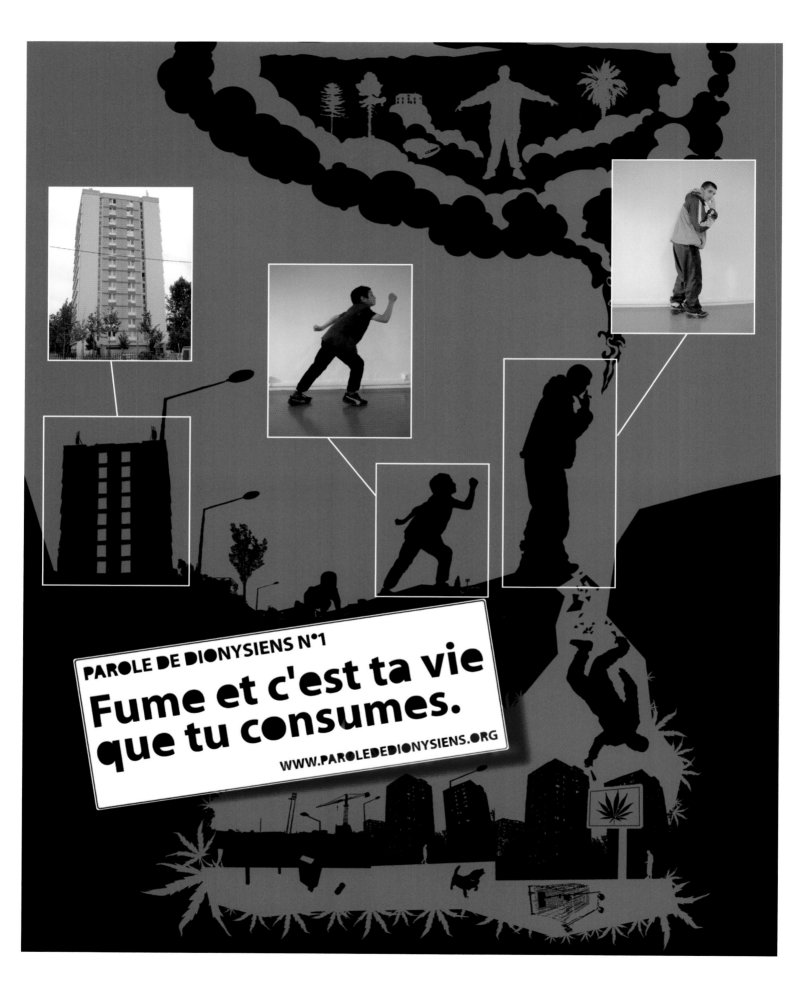

242

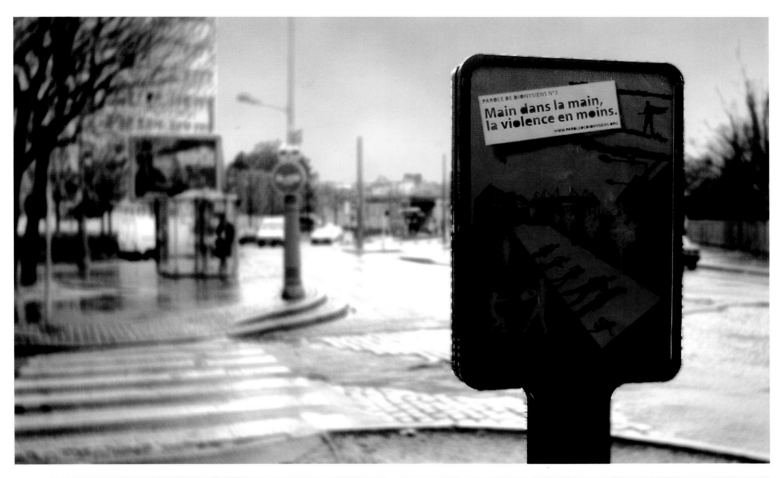

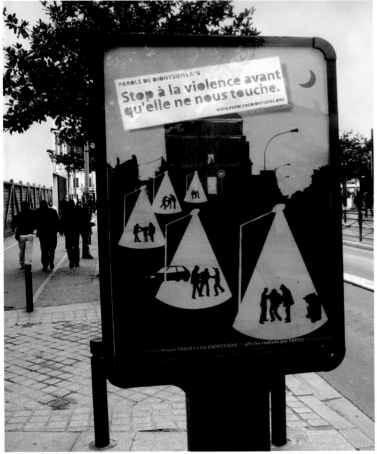

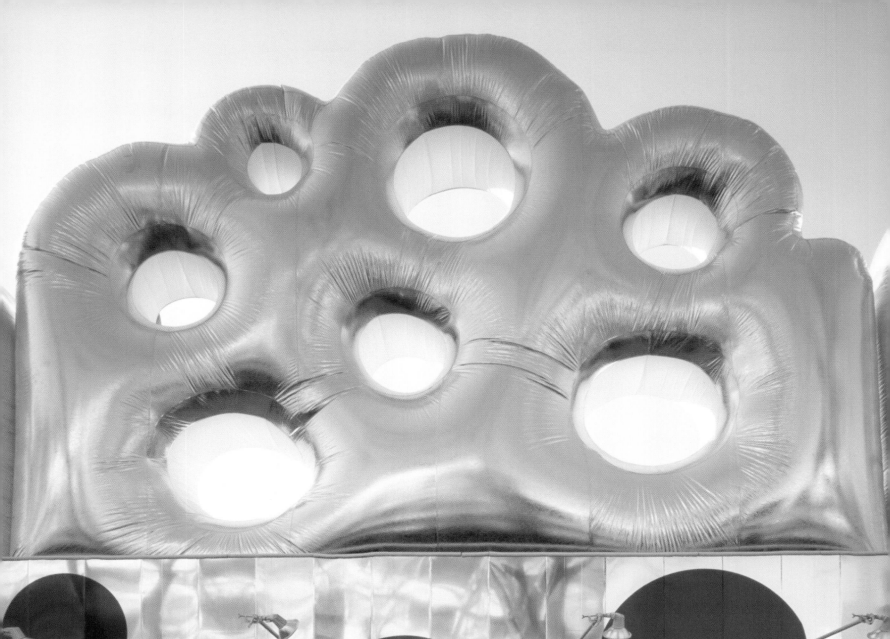

Pika Pika Pretzel

Design: **Klein Dytham Architecture** Photography: © **Katsuhisa Kida** Location: **Tokyo, Japan**

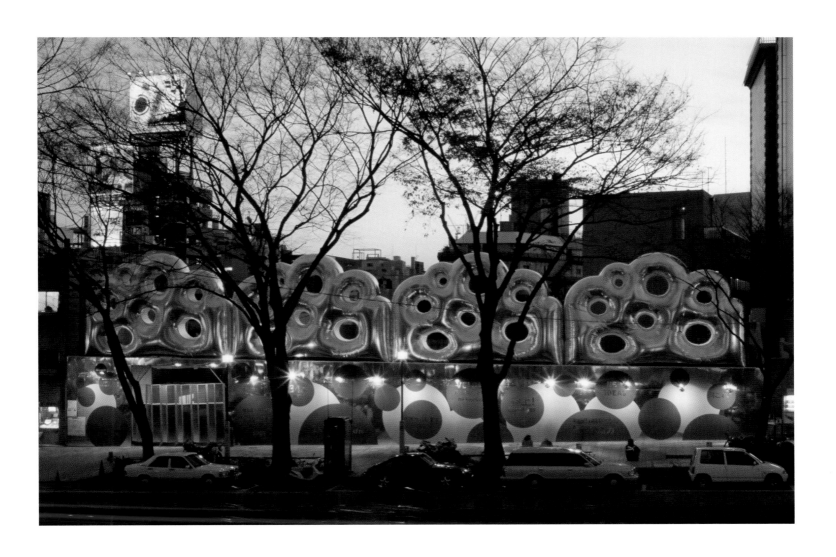

Klein Dytham was given the job of designing a temporary advertising billboard for one of the busiest commercial districts in Harajuku, in Tokyo. The main aim was to create an attraction in the middle of the chaos to draw the attention of the passerby. The installation is made up of 20-foot-high metallic balloons, which give the project its name. Pika Pika means 'shining' in Japanese.

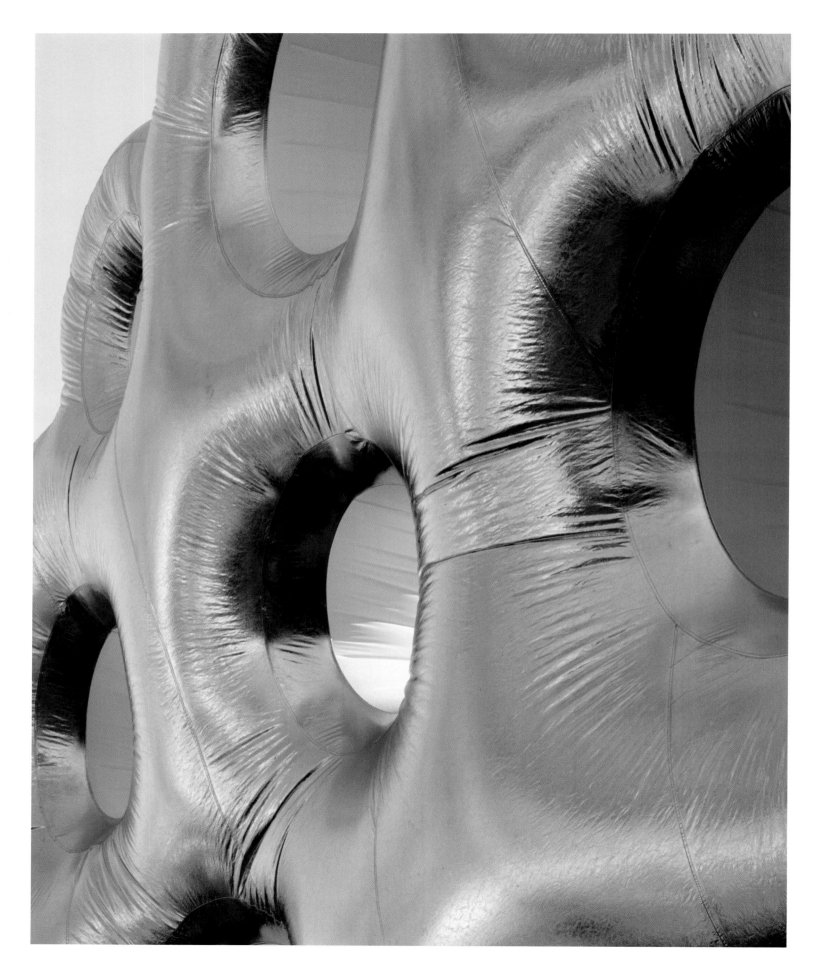

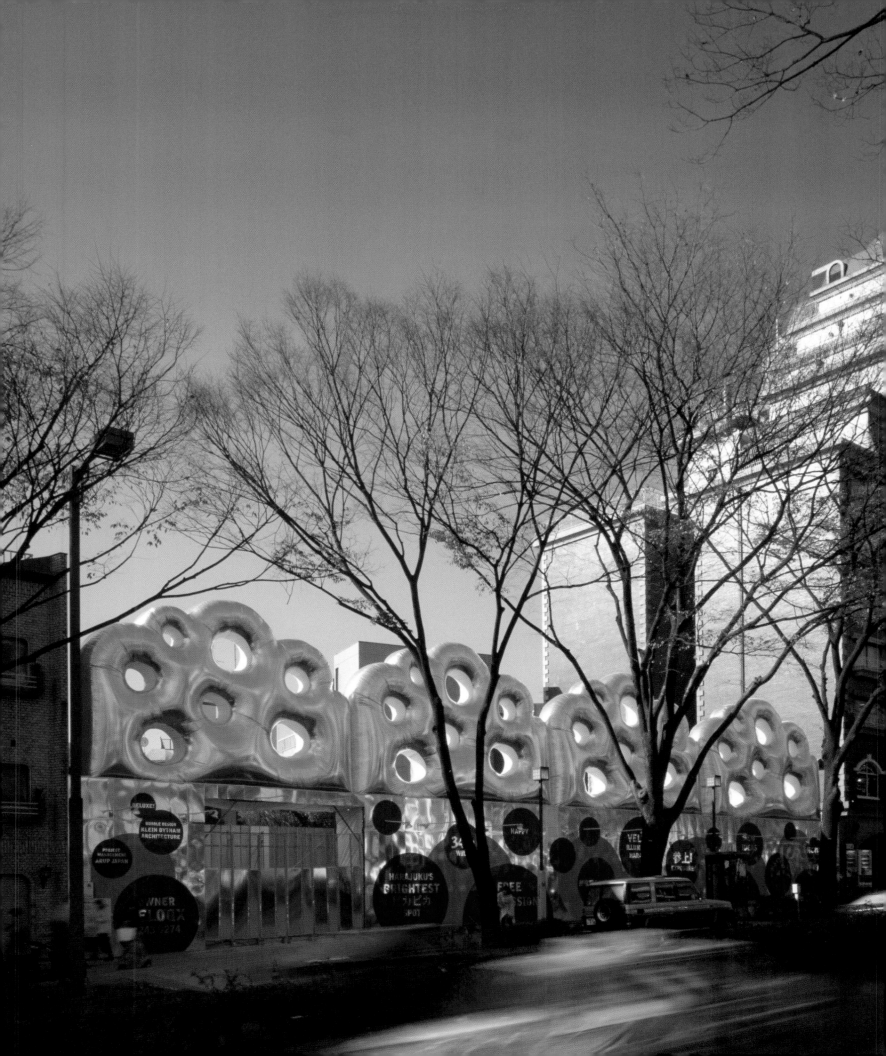

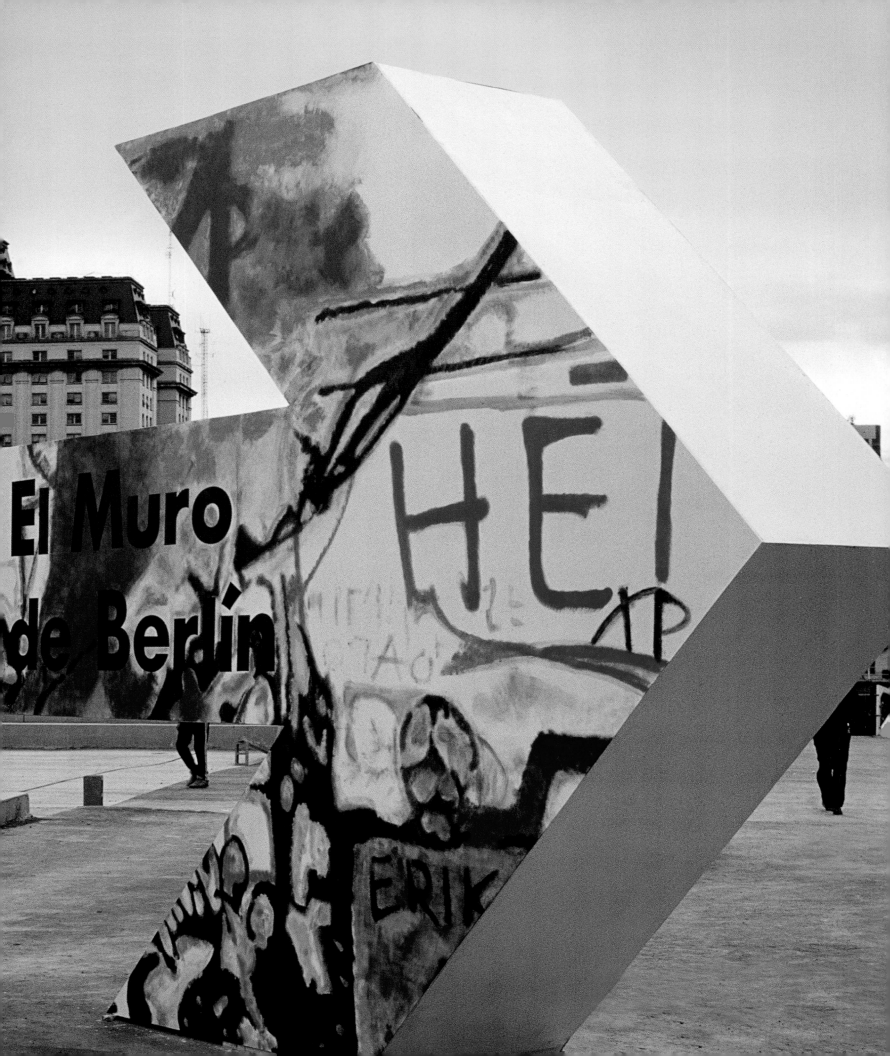

Design: **Diseño Shakespear** Photography: © **Juan Hitters** Location: **Buenos Aires, Argentina**

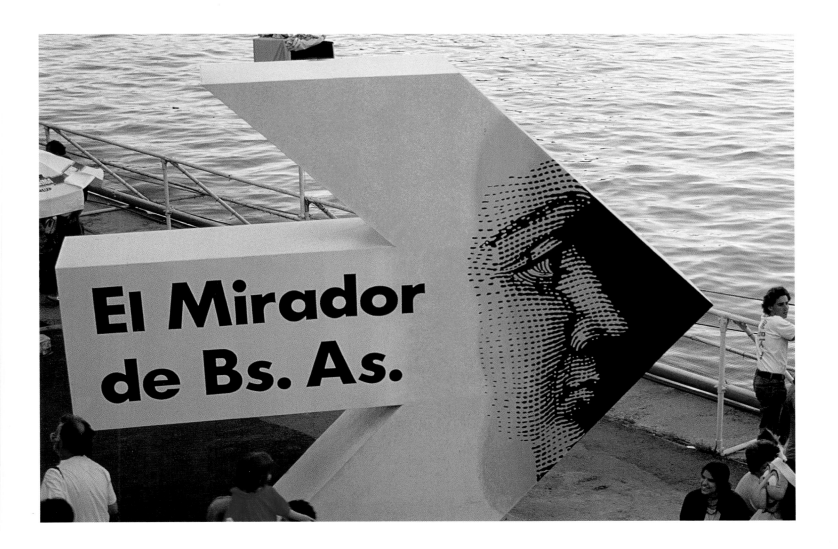

The signing system for América 92 configured, via volumetric signs, a monument to the arrow. The strength and scale of the vector counters the softness of the graphic content, which varies from piece to piece. In each arrow the system simultaneously establishes the direction and the name of the destination.

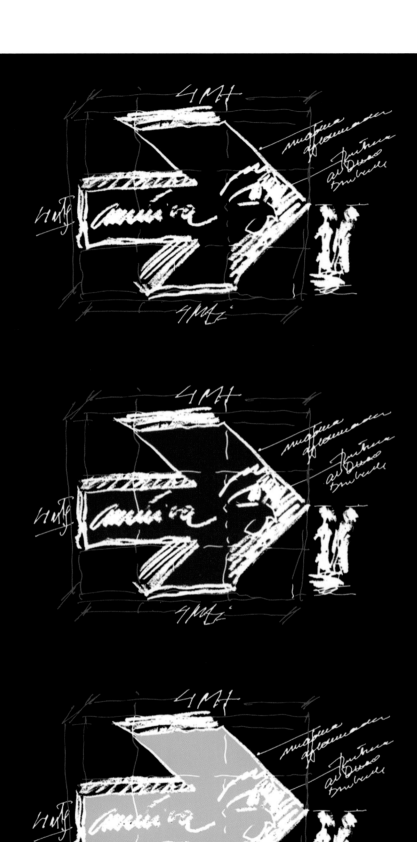

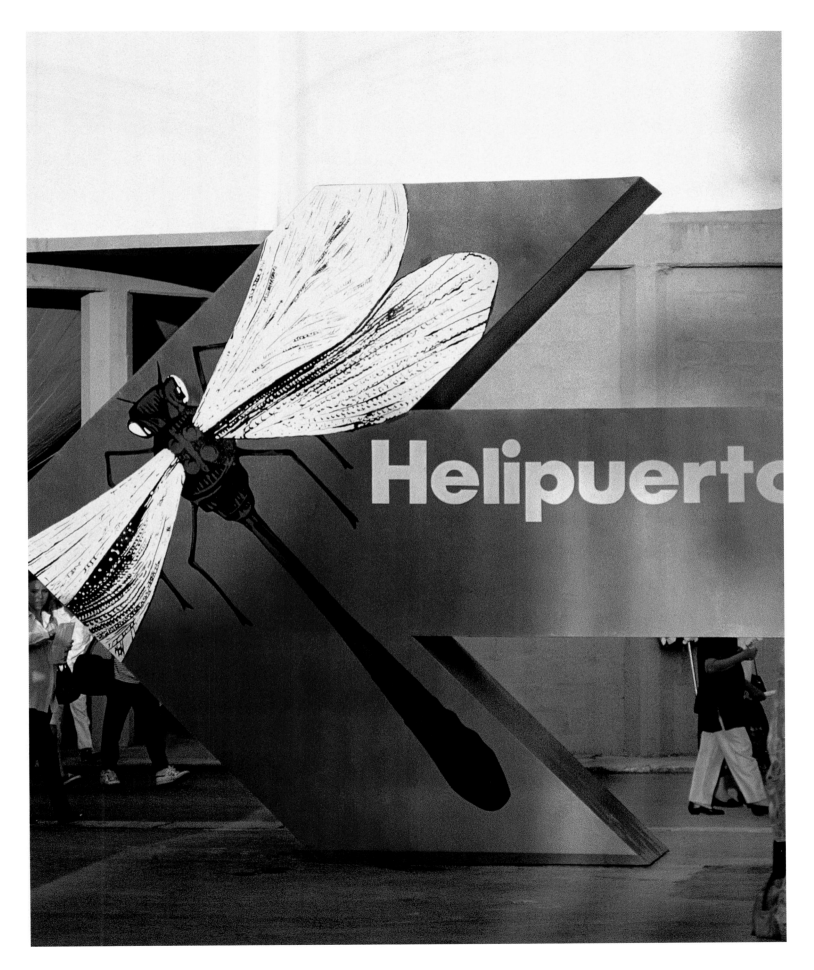

Directory

178 Aardige Ontwerpers
Cornelis Troost Straat 20-h
1072 JE Amsterdam
Netherlands
Tel.: +31 207 700 878
Fax: +31 207 700 878
www.178aardigeontwerpers.nl
info@178aardigeontwerpers.nl

Ad Hoc MSL
Véndame, 1 3.º
30005 Murcia
Spain
Tel.: +34 968 274 278
Fax: +34 968 298 686
www.adhocmsl.com
info@adhocmsl.com

Alonso Balaguer y Arquitectos Asociados
Bac de Roda, 40
08019 Barcelona
Spain
Tel.: +34 933 034 160
Fax: +34 933 034 161
www.alonsobalaguer.com
estudi@alonsobalaguer.com

Alsop Design Ltd.
46 Broadwick Street
London WF 7AF
United Kingdom
Tel.: +44 207 287 8456
Fax: +44 207 287 8455
www.alsoparchitects.com

Antenna Design New York Inc.
119 West 23rd Street, Suite 800
New York, NY 10011
United States
Tel.: +1 212 229 1106
Fax: +1 212 229 1681
info@antennadesign.com
www.antennadesign.com

ARM - Ashton Ragatt McDougall
522 Flinders Lane, Level 11
Melbourne 3000
Australia
Tel.: +61 3 9629 1222
Fax: +61 3 9629 4220
www.a-r-m.com.au
arm.melb@a-r-m.com.au

Atelier Poisson
Avenue de Morges 33
1004 Lausanne
Switzerland
Tel.: +41 21 311 59 60
Fax: +41 21 312 12 48
www.atelierpoisson.ch
giorgio@atelierpoisson.ch

AV62 Arquitectos SL
Girona 62, bajos derecha
08009 Barcelona
Spain
Tel.: +34 932 312 266
Fax: +34 932 313 734
www.av62arquitectos.com
info@av62arquitectos.com

Base
Manacor 3
08023 Barcelona
Spain
Tel.: +34 933 908 750
Fax: +34 934 189 556
www.basedesign.com
basebcn@basedesign.com

BBK Studio
648 Monroe Avenue NW Suite 212
Grand Rapids, MI 49503
United States
Tel.: +1 616 459 4444
Fax: +1 616 459 4477
www.bbkstudio.com
yang@bbkstudio.com

Cato Purnell Partners
254 Swan Street
Richmond, Victoria 3121
Australia
Tel.: +61 3 9429 6577
Fax: +61 3 9427 7241
www.cato.com.au
melbourne@cato.com.au

DAAM
1a Berry Place
London EC1V OJD
United Kingdom
Tel.: +44 20 7490 3520
Fax: +44 20 7490 3521
www.daam.co.uk
info@daam.co.uk

Diseño Shakespear
Dardo Rocha 2754 2º
B1640FTN Martínez, Buenos Aires
Argentina
Tel.: +54 11 4836 1333
Fax: +54 11 4836 1333
www.shakespearweb.com
ronald@shakespearweb.com

Doshi Levien Design Office
5 Tenter Ground
London E1 7NH
United Kingdom
Tel.: +44 20 7375 1727
Fax: +44 870 460 1681
www.doshilevien.com
mail@doshilevien.com

Finn Nygaard Design AS
Paludan Müllers Vej 5
3480 Fredensborg
Denmark
Tel.: +45 7026 0809
www.finnnygaard.com
design@finnnygaard.com

Fumita Design Office
1F+B1F Fukuda Building, Minami Aoyama
107-0062 Minato-ku, Tokyo
Japan
Tel.: +81 3 5414 2880
Fax: +81 3 5414 2881
www.fumitadesign.com
info@fumitadesign.com

Hara Design Institute
1-13-13 Chou Daiwa Building, Ginza
104-0061 Chuo-ku, Tokyo
Japan
Tel.: +81 3 3567 3524
Fax: +81 3 3567 3521
www.ndc.co.jp/hara/home_e

Hat-trick Design Consultants
3 Morocco Street, 3rd Floor
London SE1 3HB
United Kingdom
Tel.: +44 020 7403 7875
Fax: +44 020 7403 8926
www.hat-trickdesign.co.uk
info@hat-trickdesign.co.uk

Hundred Design Inc.
2-1-8/6F Shimamachi Chuo-ku
540-0034 Osaka
Japan
Tel.: +81 6 6946 7698
Fax: +81 6 6941 6815
www.100design.com
studio@100design.com

Imaginary Forces
530 West 25th Street, 5th Floor
New York, NY 10001
United States
Tel.: +1 646 486 6868
Fax: +1 646 486 4700
www.imaginaryforces.com
information@imaginaryforces.com

Interbrand
Luchana, 23 4.º
28010 Madrid
Spain
Tel.: +34 914 458 683
Fax: +34 913 103 876
www.interbrand.com
info@interbrand.com

Jordi Casadevall
Avenida Diagonal, 339 3.º 2.ª
08037 Barcelona
España
Tel.: +34 934 883 472
Fax: +34 934 874 207
kasadevall@coac.es

Klein Dytham Architecture
1-15-7 AD Building 2nd Floor, Hiro
150-0012 Shibuya-ku, Tokyo
Japan
Tel.: +81 3 5795 2277
Fax: +81 3 5795 2276
www.klein-dytham.com
kda@klein-dytham.com

KPF - Kohn Pedersen Fox Associates
111 West 57th Street
New York, NY 10019
United States
Tel.: +1 212 977 6500
Fax: +1 212 956 2526
www.kpf.com
info@kpf.com

Lichtwitz Büro für Visuelle Kommunikation
Mariahilferstrasse 101/3/55
1060 Vienna
Austria
Tel.: +43 1 595 48 98 0
Fax: +43 1 595 27 27 27
www.lichtwitz.com
mail@lichtwitz.com

Lippa Pearce Design Ltd.
358a Richmond Road
Twickenham, London TW1 2DU
United Kingdom
Tel.: +44 020 8744 2100
Fax: +44 020 8744 2770
www.lippapearce.com
mail@lippapearce.com

Liska & Associates Inc.
515 North State Street, 23rd Floor
Chicago, IL 60610 4322
United States
Tel.: +1 312 644 4400
Fax: +1 312 644 9650
www.liska.com
liska@liska.com

Magma Büro für Gestaltung
Bachstraße 43
76185 Karlsruhe
Germany
Tel.: +49 721 929 19 70
Fax: +49 721 929 19 80
www.magma-ka.de
magma@magma-ka.de

Maite Torrent & Natalia Tubella
Córcega, 299 4.º 2.ª
08008 Barcelona
Spain
Tel.: +34 932 171 706
llavamar@llavamar.com

Marc Chataigner
18 Rue Ernest Renan
75015 Paris
France
Tel.: +33 6 09 69 71 03
Fax: +33 1 42 19 01 55
chataigner.marc@free.fr

Martín Ruiz de Azúa
Rambla del Prat, 8 2.º 2.ª
08012 Barcelona
Spain
Tel.: +34 932 182 914
Fax: +34 932 182 914
www.martinazua.com
mrazua@Tel.eline.es

Massimiliano Fuksas
Piazza del Monte di Pietà 30
00186 Rome
Italy
Tel.: + 39 06 68 80 78 71
Fax: + 39 06 68 80 78 72
www.fuksas.it
office@fuksas.it

Milton Glaser Inc.
207 East 32nd Street
New York, NY 10016
United States
Tel.: +1 212 889 3161
Fax: +1 212 213 4072
www.miltonglaser.com
studio@miltonglaser.com

NB Studio
24 Store Street
London WC1E 7BA
United Kingdom
Tel.: +44 20 7580 9195
Fax: +44 20 7580 9196
www.nbstudio.co.uk
email@nbstudio.co.uk

Niall O'Flynn Designers
Pallars 94-96, 2.º 1.ª
08018 Barcelona
Spain
Tel.: +34 933 093 362

Philip Foeckler
Friedrich Herschel Straße 17
81679 Munich
Germany
Tel: +49 89 989 286
www.foeckler.com
me@foeckler.com

Realities United
Leipziger Straße 50
10117 Berlin
Germany
Tel. +49 30 20 64 66 30
Fax +49 30 20 64 66 39
www.realities-united.de
info@realu.de

Why Not Associates
22c Shepherdess Walk
London N1 7L B
United Kingdom
Tel.: +44 020 7253 2244
Fax: +44 020 7253 2299
www.whynotassociates.com
info@whynotassociates.com

Wow! Branding
101-1300 Richards Street
BC V6B 3G6 Vancouver
Canada
www.wowbranding.com
bememorable@wowbranding.com

x2.0 Comunicació Visual
París, 143 entresuelo
08036 Barcelona
Spain
Tel.: +34 933 632 145
Fax: +34 933 633 884
www.x2punt0.com

Zona Comunicació
Gran Via, 646 5.º 3.ª
08007 Barcelona
Spain
Tel.: +34 934 123 567
Fax: +34 934 127 106
www.zonacomunicacio.com
zona@zonacomunicacio.com

Special thanks

Diseño Shakespear Argentina

Ronald Shakespear
Lorenzo Shakespear
Juan Shakespear
Bárbara Shakespear
Cecilia Bonnefon
Laura Cecilia Litvin
Conrado Lopez Soutric
Ana Belen Pagani
Florencia Fernandez Madero

Gonzalo Daniel Strasser
Maria Adriana Lwoff
Clara Maria Mendez Casariego
Pablo Jose Amadeo
Juan Jose Aguilo
Milagros Rueda
Joaquin Viramonte Noguer
Fernando Strasser Arq.
Juan Hitters
Maria Shakespear